POINTS OF VIEW

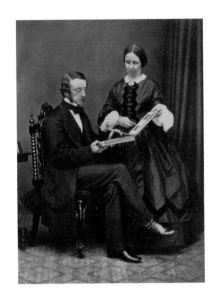

POINTS OF VIEW

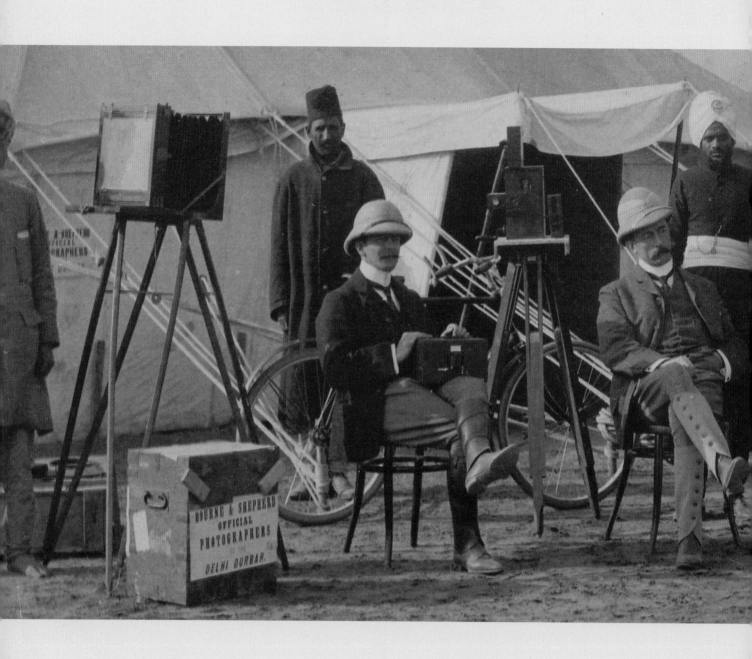

Capturing the 19th Century in Photographs

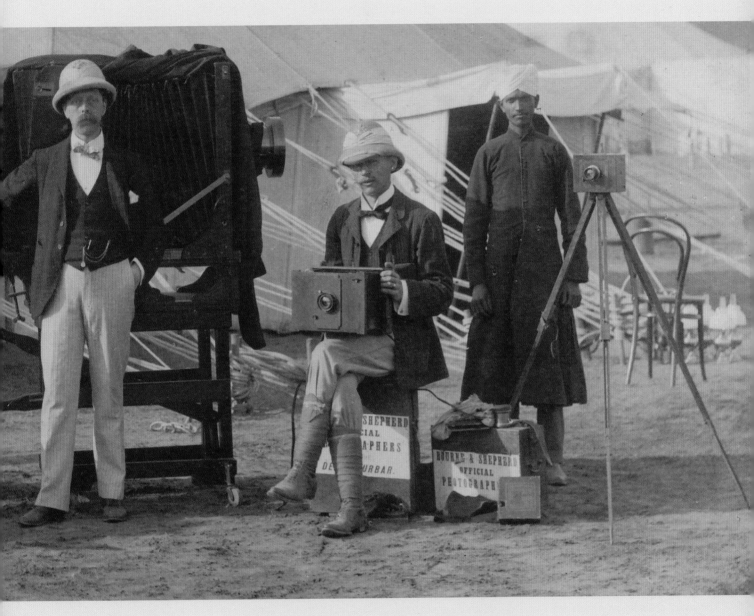

John Falconer and Louise Hide

The British Library

First published in 2009 by
The British Library
96 Euston Road
London NW1 2DB

On the occasion of the exhibition at the British Library:

'Points of View: Capturing the 19th Century in Photographs'
30th October 2009 – 7th March 2010

British Library Cataloguing-in-Publication Data
A catalogue record is available from the British Library
ISBN 978 07123 5081 5 (hb)
ISBN 978 07123 5082 2 (pb)

Designed and typeset by Andrew Shoolbred
Colour reproductions by Dot Gradations
Printed in Italy by Printer Trento S.r.l.

FRONTISPIECE
Carte de visite portrait of Dr and Mrs Forbes
examining a portrait album
(James Charles Somerville, *c.*1864)
page 97

PAGES 2–3
Bourne & Shepherd photographers at the Delhi Durbar 1902–3
(Bourne & Shepherd, 1902–3)
page 78

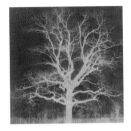
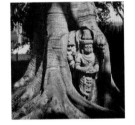

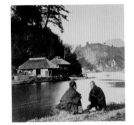
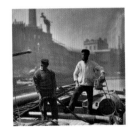

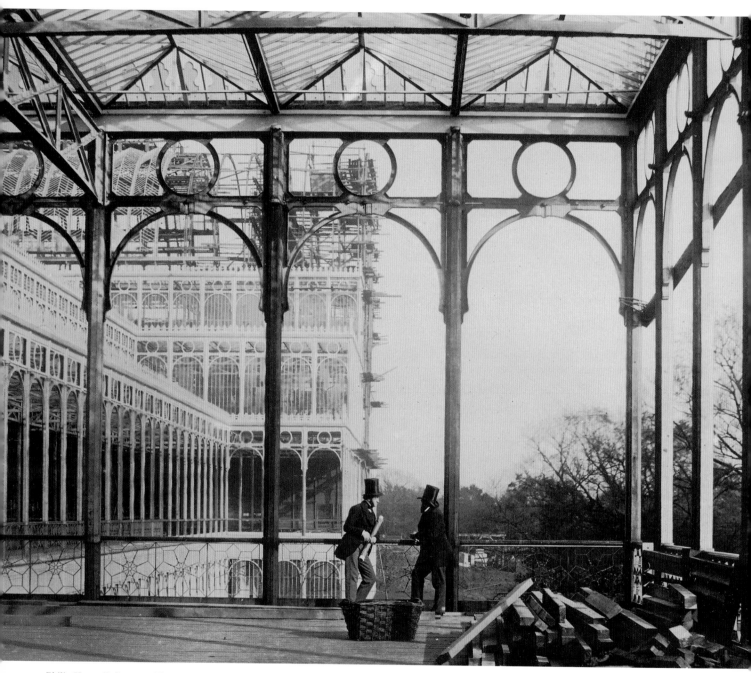

Philip Henry Delamotte, *The open colonnade, garden front, Crystal Palace,*
Sydenham, 1852–4 [detail]

Albumen print, 14.5 x 21.8 cm

P.H. Delamotte, *Photographic views of the progress of the Crystal Palace,*
Sydenham ([London,] 1855), plate 34

Tab, 442.a.5

INTRODUCTION

We are now making history, and the sun picture
supplies the means of passing down a record of what
we are, and what we have achieved in this nineteenth
century of our progress.

John Thomson, 1891

Almost exactly half a century separates the public
announcement of two practical photographic processes
in 1839 and the introduction of George Eastman's No. 1
Kodak camera in 1888. In the decades which elapsed
between these events, photography established itself as the
dominant visual medium of the age, a tool for art, science
and simple amusement, which provided a seemingly
miraculous means of accurately envisioning, recording and
reflecting the physical world. Technological developments
in the late nineteenth century – not least the introduction
of Eastman's snapshot camera – brought photography
within the reach of even the least technologically
sophisticated, and by the start of the twentieth century,
a medium previously restricted to those with at least some
technical ability had become truly democratic, allowing
almost anyone of even relatively modest means to become
a producer as well as a consumer of photography. The
family photograph album as a repository of memory became
a widespread phenomenon of twentieth-century life in the
west, and the shift from film to digital imagery in recent
years has only served to emphasise the centrality of the
photographic image to almost every aspect of modern
life. Whether as images on a mobile phone or computer, in
newspapers, advertising hoardings or fine art galleries, the
uncountable millions of photographs in existence define
and influence our sense of the world and our place in it.

Photography in the British Library

This book aims to illustrate a broad range of photographs
accumulated by the British Museum – whose historical
collections form the core of the British Library's holdings –
from the first days of photography up to the early years of
the twentieth century. This was a period in which photo-
graphy's visual vocabulary was refined from initial wonder
at the very possibility of creating an accurate mechanical
reflection of the physical world to a sophisticated industry
operating at almost every level of society. It should be
stressed that this selection, while presented in a broadly
chronological arrangement which traces some of the
major historical and technical landmarks in the nineteenth
century, makes no claim to providing a history of photo-
graphy during the period. The perils of attempting this can
be seen in any number of photographic histories presented
through the distorting lens of institutional collections.
Such archives, created as they generally are by chance,
personal whim and the specific collecting criteria and
interests of the museums, archives and libraries concerned,
inevitably provide a partial view. At an international level,
histories of photography reflect a similar bias, projecting
national developments as representative of worldwide prac-
tice. Perhaps the most obvious example is the prominence
given to the two earliest processes, the daguerreotype
and the calotype, whose relative merits and importance
are commonly assessed very differently, depending on the
prominence of one or the other in the country concerned.
Apart from a handful of exceptions, such as photographic
societies and those museums which have collected photo-
graphy specifically to illustrate its technical and artistic
development, few major institutional collections can
attempt to do more than illustrate elements of the
promiscuously varied nature of the medium.

The British Library's collections are no different in
this respect. In the course of the nineteenth century the
British Museum acquired, as part of its normal collecting
policies, a fascinating range of significant photographic
items, but evidence of any specific engagement with the
medium, in terms of collecting photography for its own
sake, is almost entirely lacking. While for a period in the
1850s Roger Fenton was employed by the Museum to
document its collections and galleries, early attempts to
embed photography as part of the museum's documentary
activities were largely unproductive and soon abandoned.

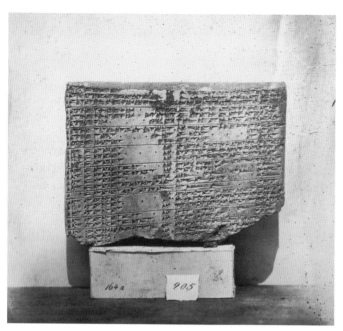

Roger Fenton, *Cuneiform tablet K-205 in the Kouyunijk Collection,*
British Museum, 1854
Salted paper print, 11.9 x 20.1 cm
Talbot Photo 22 (208)

The overwhelming bulk of photographs acquired during
the nineteenth century was in fact a by-product of the
Museum's book-collecting activities, and this remains
the source of many of the most important photographs in
the British Library's collections. These photographically-
illustrated works found their way into the British
Museum's collections by virtue of publication in book
form rather than from any articulated desire to treat photo-
graphy as a unique and separate form of communication,
which might be considered worthy of collecting in its own
right. While some important material found its way into
the British Museum's Prints and Drawings Department
in the course of the nineteenth century, photography as a
whole was considered to be more properly the province
of the South Kensington Museum (now the Victoria and
Albert Museum). Similarly, while the Museum's Map
Library amassed a considerable and important collection
of photographic views, these appear to have been acquired
for their value as topographical records, a continuation
of the collections of engraved views, rather than from
any sense that photography was of unique value in itself.
Despite this failure to collect photography proactively, the

sheer quantity of material that nonetheless found its way
into the Museum's collections further serves to highlight
how completely photography was absorbed into the
mainstream of nineteenth-century society.

Consequently, the British Library's photographic
archives cannot be isolated as a discrete collection, but are
integrally enmeshed in the wider fabric of its nineteenth-
century holdings – contained in photographically illustrated
books and portfolios and in collections of topographical
views and manuscripts. One important exception to this
general dispersal of material is the photograph collection
forming part of the India Office Library and Records, a
latecomer to the British Library and only transferred to
its keeping since 1982. This archive contains perhaps the
single most important institutional collection of nineteenth-
century photography from India and other Asian countries
in the world, reflecting the East India Company's early
sponsorship of the medium as a documentary and
administrative tool from the mid-1850s.

A number of important collections have also been
acquired in recent years, with the aim of consolidating
and expanding the core nineteenth-century collections.
Two of these, which form the opening and closing chapters
of this book, merit individual mention. The first, a major
collection of photographs, correspondence and manuscripts
relating to the photographic inventor William Henry
Fox Talbot, was acquired through the singular generosity
of the photographer's descendants. From the end of the
nineteenth century onwards, the Kodak Archive, received
in 2009, charts the growth of photography as a popular,
democratic medium, open to all with the means to pursue it.

Prehistories and 'inventions'

The year 1839, which brought photography into the public
arena with the announcement of two separate processes
on either side of the English Channel, has become
generally embedded as the year of its 'invention'. Despite
the undoubted significance of the date, marking the point
at which the medium became available for anyone with
the technical expertise to produce photographic images,
photography's 'birth' was the product of a much longer
period of gestation. Disputes about paternity emerged
from its infancy and have never entirely subsided.

Many of the optical and chemical requirements for

successful photography had been common scientific knowledge for centuries. The optical principles of the camera obscura (dark room), by which light passing through a small opening will project an image onto the facing wall, were known in antiquity. The use of the portable camera obscura as an artist's aid in tracing topographical views became commonplace in the eighteenth century, and by the early nineteenth century hand-held devices of much the same design as those used in Daguerre and Talbot's early work were widely available. Photography's debt to earlier traditions of graphic repre-

sentation is also highlighted by the talents and experiences of Louis-Jacques-Mandé Daguerre and William Henry Fox Talbot, the two figures most responsible for establishing the medium. Daguerre's success as an artist and painter of astonishingly convincing 'dioramas' is clearly connected with his striving to create a mechanically produced mirror of the world. By a pleasing irony, it was Talbot's confessed lack of ability as a draughtsman which first suggested to him the possibility of using the camera obscura to capture, in permanent form, 'the inimitable beauty of the pictures of Nature's painting which the glass lens of the camera throws upon the paper in its focus – fairy pictures, creations of a moment, and destined as rapidly to fade away'.

The light-sensitive properties of silver salts, on which both Daguerre's and Talbot's processes relied, had already

Théodore Maurisset, *La Daguerréotypomanie, 1839*

Lithograph, published by Bauger, Paris

Library of Congress, Lot 13402, no. 23

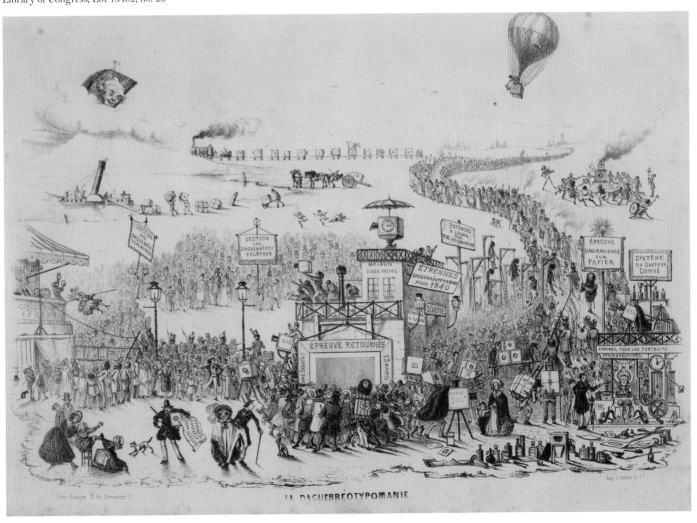

LA DAGUERREOTYPOMANIE.

been established by the German professor Johann Schulze's experiments in the mid-1720s and subsequently formed the basis of practical experimentation which preceded the investigations of both Daguerre and Talbot. The most significant of these – acknowledged by Talbot himself as an important foundation of his own researches – were the experiments carried out by Thomas Wedgwood and Sir Humphry Davy in the 1790s and published in the *Journal of the Royal Institution* in 1802. Using leather or paper coated with silver nitrate, they succeeded in creating images of drawings on glass and impressions of other objects, such as leaves and insects' wings. But Wedgwood and Davy did not succeed in preventing the continued action of light from ultimately destroying the image thus created. As Davy noted, and as Talbot himself was to achieve four decades later,

> Nothing but a method of preventing the unshaded parts of the delineation from being coloured by exposure to the day is wanting, to render the process as useful as it is elegant.

In France, the inventor Joseph-Nicéphore Niépce began his own experiments in creating permanent photographic images from around 1816, developing a process using the light-hardening properties of bitumen of Judea, which he named *Héliographie*. This led to the creation in 1827 of what is acknowledged as the earliest surviving photographic image. Niépce subsequently formed a partnership with Louis Daguerre, who went on to become the dominant partner and, after Niépce's death in 1833, made his first successful daguerreotype in 1837. The announcement of Daguerre's process in early 1839 swiftly aroused excitement at these marvellously detailed transcriptions of the physical world: Théodore Maurisset's 1839 satirical lithograph *La Daguerréotypomanie*, caricaturing the public response, shows the extent to which the daguerreotype had captured the public imagination (see p. 9). Crowds clamour round the studio offering daguerreotype portraits for the new year of 1840, while in the right foreground a sitter is seen imprisoned in clamps and braces to ensure immobility during the long exposure. Baggage in the form of cameras is loaded onto a steamship, a locomotive with camera-shaped carriages passes in the distance, while the scene is viewed from above by a hot-air balloon whose basket is also a camera. Meanwhile, gibbets are being rented out for

the engravers and draughtsmen displaced by Daguerre's discoveries.

In England, matters proceeded at a quieter pace. From his first experiments made in making negative images on paper in 1834, William Henry Fox Talbot had by the following year conceived of the possibility of using the original negative image as a matrix to produce a positive image. In the following years, Talbot's other activities took precedence over these experiments, but in January 1839 came the announcement of Daguerre's discoveries. Hurried into disclosure of his own researches, Talbot's photogenic drawings were certainly less immediately impressive than his rival's process. Further experimentation led to the realisation that the 'latent image' imprinted on the negative could be brought out by development after exposure and this process, patented as the calotype in 1841, formed the basis for photography on paper for the next decade.

Daguerre's discovery attracted huge publicity, and Daguerre himself was fêted and rewarded by the French government. The calotype received little official attention. Indeed, in August 1846, fully five years after its announcement, Talbot's photographer friend the Rev. Calvert Richard Jones lamented to him in a letter that 'the general ignorance of the art is wonderful', having shown some of Talbot's prints to a group of friends who proved totally unaware of photography's existence. Talbot's decision to patent the process (apart from amateur use) also attracted growing hostility from the photographic community in the following years (although the daguerreotype was also protected by patent in England). His action was considered to have stunted the growth of photography, and while there was undoubtedly some truth in this accusation, it is also the case that the commercial market for photography, which to all intents and purposes meant portraiture, was always more attracted to the sharply defined and elegantly cased daguerreotype, than to the softer and hazier image of the paper print. But it was to be Talbot's process, by which any number of prints could be produced from the original negative, which was to form the basis of photography for the next century and a half, while the daguerreotype was all but extinct within twenty years.

While Talbot's process never brought commercial rewards to its inventor – indeed it seems likely that overall Talbot lost substantial sums in his attempts to popularise the calotype – its use in the 1840s by a gifted group of

amateurs saw it mature into a sophisticated and expressive tool. Talbot himself abandoned active photography in around 1846, but in the space of five years produced a remarkable body of work, particularly in the field of land-scape and architecture. Other members of his family and social circle contributed to the rich legacy of work which emerged in the course of the decade, while in Scotland (where professional use of the calotype was not restricted by Talbot's patent), the studio of Hill and Adamson created between 1843 and 1847 perhaps the single most outstanding body of work produced by the process.

Expanding horizons

While the artistic achievement of the calotypists of the 1840s had been impressive, it is hard to argue that it fully lived up to photography's claims to hold up a mirror to the whole breadth of British life. Practised largely by members of a leisured class imbued with notions of the picturesque and the rural pastoral, the work of the 1840s understand-ably ignored the social and industrial realities which were already in the course of transforming the country. This seems to have been recognised by Roger Fenton in his address to the Royal Society of Arts in 1852, in which he characterised English photography as being largely directed towards 'representations of the peaceful village; the unassuming church, among its tombstones and trees; the guarded oak, standing alone in the forest'. But even as these thoughts were being expressed, photography was already moving away from these parochial concerns and developing a more commercial orientation. Much of the enthusiasm of the 1840s, a decade largely dominated by the efforts and experiments of amateurs anxious to lay the technical and aesthetic foundations of photography, became jaded in the course of the following decade. The photo-grapher Jabez Hughes, in 'A tribute to the amateurs', published in *The photographic news* in 1863, looked back on the early days of photography as an era of heady excitement, when all was new and photographic advances were often the result of trial-and-error research carried out in a spirit of personal enthusiasm. Professional photo-graphy was, in contrast, he claimed, innately conservative in its response to technical change and aesthetic attitude. But if the loss of photography's original pioneering ethos was dispiriting to some, the consolidation of its professional

status and its growth into a major industry in the following decades created new opportunities and subject matter.

The Great Exhibition of 1851 had for the first time brought an international selection of photography (and photographic equipment) to the attention both of the photographic community and of the masses who visited the Crystal Palace, emphasising the medium's place in the modern world. If the British exhibits fared less well in the judges' eyes than their continental and American counter-parts, this acted as a further spur to national pride, while the subsequent illustration of the *Reports by the Juries* with original photographs, served to underline photography's documentary potential in the modern world.

Of more direct practical and far-reaching significance was the announcement in the same year of Frederick Scott Archer's wet collodion process. The use of a glass instead of a paper negative produced images whose sharpness matched the daguerreotype. Exposure times were also shortened, opening up new photographic possibilities, while the recently introduced glossy albumen print quickly found favour with an expanding photographic market. The introduction of cheap and popular formats like the stereo-graphic card and the *carte de visite* portrait stimulated the growth of professional studios during the 1850s, a growth which in most major metropolitan centres continued unabated for the rest of the century. This development was not restricted to Europe and America. The colonial expansion of European nations had brought photography in its wake, uncertainly in the 1840s, but with increasing confidence from the 1850s onwards. In India, Great Britain's most important imperial possession, the permanent presence of professional photographers had become firmly established by the late 1850s. When Samuel Bourne arrived in 1863, keen to exploit this market, he found Calcutta to be the centre of flourishing activity, where *carte de visite* portraits were as much in demand as in Europe, and where 'professional photographers … appear to be doing a good stroke of business.'

Such developments distressed some of photography's most ardent early devotees, who felt that photography's increasingly broad reach was in danger of compromising the high artistic hopes expressed for it in its early years. Influential publications such as *The art journal* were particularly vociferous. For a number of years in the late 1850s, the magazine used the Photographic Society's annual exhibition as an opportunity for scathing reviews

bemoaning the lack of any appreciable scientific or artistic advances in photography. It reserved particular scorn for the practice of attaching prices to the photographs on display, an indication that a gentleman's pursuit was increasingly being overtaken by the 'commercial element'.

A more considered assessment of the state of photography in the late 1850s was offered by Lady Elizabeth Eastlake, in her review of the history of the 'new and mysterious art', published in the April 1857 issue of *The quarterly review*. This conveys a more positive response to photography's achievements and potential, even if she also placed limits on the medium's ability to compete with the artist on equal terms. Arguing that the relaxation of Talbot's patent restrictions had led to a growth in the commercial market since 1855, she noted that 'photographers have a heading to themselves [in the London directories] and stand at 147'. This represented only the tip of the iceberg. Below the 'higher representatives of art' who ran the fashionable studios were 'the legion of petty dabblers,' whose work even 'our lowest servants' could afford, and while 'the large provincial cities abound with the sun's votaries, the smallest town is not without them.' The democratic republic of photography, she idealistically asserts, now numbered tens of thousands, 'following a new business, practising a new pleasure, speaking a new language, and bound together by a new sympathy'. In short, photography, both in its producers and consumers, had permeated society to become an integral component of daily life at every level. It had become,

> A household word and a household want; it is used alike by art and science, by love, business, and justice; is found in the most sumptuous saloon, and in the dingiest attic – in the solitude of the Highland cottage, and in the glare of the London gin-palace – in the pocket of the detective, in the cell of the convict, in the folio of the painter and architect, among the papers and patterns of the mill-owner and manufacturer, and on the cold brave breast on the battle-field.

But if photography was now fully absorbed in the bedrock of society, Lady Eastlake was also anxious to frame the limits of its ambitions. Some of her arguments that photography could not compete with painting as an artistic medium were based on technological limitations which would in time be solved. But ultimately, she argued, the

very accuracy of the camera suited it to factual representation which might undertake, but could not supplant, some of the tasks previously reserved for the painter. In this role,

> Photography takes her legitimate stand. Her business is to give evidence of facts, as minutely and as impartially, as, to our shame, only an unreasoning machine can give. In this vocation we can as little overwork her as tamper with her.

The distinction made between photography's unmatchable recording accuracy and its inability to exercise artistic expression, rests on the assumption that the two are mutually incompatible, an assertion still from time to time advanced by critics of the medium.

Notwithstanding the deprecations of writers and photographers concerned with calculating photography's exact position in the hierarchy of the arts – and in general assigning it a subservient status – photography itself paid little heed to what was an irrelevancy in the face of the medium's growing ubiquity and commercial success.

The photographically illustrated book

While photography became ever more present in Victorian society through studios and print-selling shops, the printed book also offered a particularly effective way of distributing images in collective form and accompanied by explanatory commentary. It took only a short time from the announcement of photography for entrepreneurs to exploit the book form to bring the medium before a wider audience. Drawing on the long tradition of works illustrated by other graphic media such as engraving and lithography, the printed book was soon taken up as a vehicle for the commercial dissemination of photography and as an adjunct, illustration or amplification of written descriptions. While the unique daguerreotype image was unusable in its original state for book illustration, in France and Germany experimentation with methods of duplicating the image began almost as soon as Daguerre's process became available. In 1840 Professor Josef von Berres of Vienna produced the first published examples of illustrations made from etched daguerreotype plates, in his *Phototyp nach der Erfindung des Professor Berres*. While recognisably photographic in origin, such etchings were at one remove

from the original image, and moreover the plates were too delicate to withstand more than a limited print run. A more ambitious attempt to use the daguerreotype as the basis for illustrated publication was published by Noël-Marie-Paymal Lerebours between 1841 and 1844, under the title *Excursions daguerriennes. Vues et monuments les plus remarquables du globe.* This extensive series of views used a number of different methods to reproduce daguerreotypes of architecture and landscape from Europe, the Middle East and America. While its reproductive technique involved considerable alteration of the original photographic view, the use of photography to bring distant scenes to the metropolitan centres of Europe was to become a standard component of photographically illustrated books in the following decades.

It was Talbot's calotype process, permitting unlimited paper prints to be produced from a single negative for insertion alongside printed texts, which was to make original photographs an integral part of thousands of books from the 1850s. And it was Talbot himself who established the format. Between 1844 and 1846, *The pencil of nature*, illustrated with original salted paper prints from calotype negatives, served both as a manifesto for the varied uses to which photography could be applied and simultaneously pioneered the appearance of photographs in book form. In 1845, while *The pencil of nature* was still in production, Talbot issued a further photographic work by private subscription, *Sun pictures in Scotland,* and this publication too pointed the way towards the photographically illustrated travel works which were to flower in the following decades. In the short-term, however, problems with fading images and the difficulties of producing prints in sufficient quantities for a substantial edition dogged these early attempts to establish the photographically illustrated book as a viable commercial product. Nevertheless, by the 1850s – and particularly after use of the wet collodion negative and the albumen print became widespread – the production of photographically illustrated

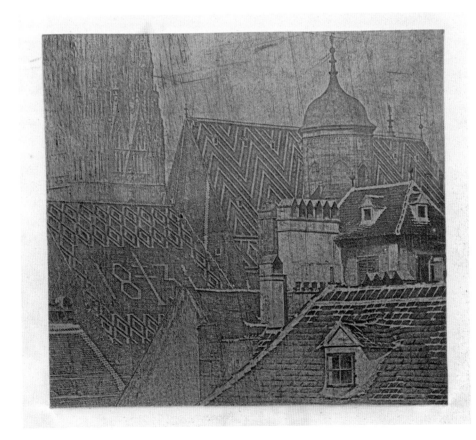

Christian Josef von Berres, *St Stephen's Cathedral, Vienna, 1839–40*

Print from an etched daguerreotype, 7.6 x 8.4 cm

C.J. von Berres, *Phototyp nach der Erfindung des Professor Berres in Wien* (Vienna, 1840)

1269.e.26

works became commonplace, varying from expensively produced folio volumes aimed at a luxury market, to more modest collections of views.

A particularly rich vein of work emerged from French photographers in the early 1850s. In Lille, the photographer Louis-Désiré Blanquart-Évrard attempted to succeed where Talbot had failed, in bringing industrial production methods to photographic book production. In 1851 he established his photographic printing works, introducing the development of prints rather than relying on the vagaries of sunshine alone to bring out the picture. Among the significant works produced by this improvement was Maxime du Camp's *Égypte, Nubie, Palestine et Syrie*, published in 1852 and containing the results of the photographer's travels in the Middle East with the novelist Gustave Flaubert. Although Blanquart-Évrard's process produced prints of an unappealing coldness of tone, his method produced much more stable and permanent results than were achieved in Talbot's published works.

Du Camp was followed to Egypt in 1851–2 by Félix Teynard, whose own record of antiquities and landscapes, *Égypte et Nubie* (1858), formed a photographic continuation of the encyclopedic project to document the antiquities of the country, instituted by the scholars and antiquarians who had accompanied Napoleon's occupying army in 1798. The scarcity of surviving copies suggests that it appeared in a very limited edition, aimed at a small scholarly market. A more complex mixture of motivations directed Francis Frith to Egypt and the Holy Land in the late 1850s. While the varied formats of his photographic publications clearly indicate the commercial underpinning of his travels, the evidential value of photography in furnishing objective records of biblical history in the cradle of Christianity was clearly of fundamental importance to his work.

Travel (often accompanied by more or less amateur archaeological investigations) continued to be a staple of the photographically illustrated book for many decades, but photography was also rapidly introduced into fields as diverse as medicine, art reproductions and portraiture. Medical textbooks used photography to illustrate the symptoms and treatment of diseases (both physical and mental), as well as for instruction in anatomy. The use of photography to reproduce the wonders of the microscope was also pursued both as a scientific aid and for popular amusement and instruction. Pride in the triumphs of modern engineering was reflected in publications like

Philip Henry Delamotte's *Photographic views of the progress of the Crystal Palace, Sydenham* (1855), perhaps the first attempt to trace the whole process of an architectural and engineering project through photography, while at a less elevated scale, the photographic book belatedly addressed the social realities of working-class life and urban poverty in John Thomson's *Street life in London*, which first appeared in twelve monthly parts from 1877–8.

Thomson's earlier career in Asia, and his authorship of works which skilfully combined images and text to imbue his photographs with a moral message in addition to their descriptive function, form a particularly clear example of the way in which the photographic image is never a neutral visual document, but part of the larger web of historical, social and cultural forces which bring it into existence. While possessed of lively human sympathy in his encounters with the Chinese, the commentary accompanying many of his photographs in *Illustrations of China and its people* (1873–4) invites the reader to contrast the present state of the country with the potential benefits of European civilization and commerce. A later work, *Through Cyprus with the camera in the autumn of 1878*, is still more explicit, promising 'a faithful souvenir' of an island 'woefully wrecked by Turkish maladministration'. The photographs themselves would 'afford a source of comparison in after years, when, under the influence of British rule, the place has risen from her ruins'. Photography was to form a vehicle for this strain of imperial pride for the remainder of the nineteenth century, reaching its apogee in 1897, the year of Queen Victoria's Diamond Jubilee. A publication such as H.O. Arnold-Forster's *The Queen's Empire* is representative of many a self-congratulatory overview, in which photography was used to illustrate Great Britain's 'work of civilizing, of governing, of protecting life and property, and of extending the benefits of trade and commerce'.

While both the salted paper print and its successor, the albumen print, were prone to fading over time (and sometimes remarkably swiftly), the development of more permanent processes gave the photographically illustrated book a new lease of life in the 1870s. Both the woodburytype and the carbon print required the same labour-intensive production methods, but while almost indistinguishable from original photographs to the untrained eye, they remained immune from the fading inherent in the processes involving salts of silver. Both processes were widely employed in book production to the

end of the century and beyond, particularly in the field of portraiture. Likenesses of prominent figures in the arts, dignitaries of church and state, royalty and heroes formed a clearly lucrative field for photographic publishers, in a genre which began in the 1850s and continued through to the last decades of the century in such publications as *Men of mark*, *Men and women of the day* and *Dignitaries of the church*. These luxury productions, generally sold in parts and by subscription, survived the development of cheaper printing methods for some years, but by the turn of the twentieth century, such works were rapidly becoming a thing of the past. The introduction of the half-tone screen, and its widespread use from the 1880s, allowed photographs to be cheaply printed and incorporated with text in books, journals and newspapers, leading to the deluge of imagery which has continued unabated ever since.

In an 1859 article in *The Atlantic monthly*, the American writer Oliver Wendell Holmes speculated on photography's potential to provide an almost limitless repository of images for study and amusement, marvelling at 'the incidental glimpses of life and death' which photography was so suited to capture ('the very things which an artist would leave out'). The stereoscope was his particular fascination (although his remarks applied equally to all forms of photography) and he looked forward to the time when there would,

> soon be such an enormous collection of forms [photographs] that they will have to be classified and arranged in vast libraries, as books are now. The time will come when a man who wishes to see any object, natural or artificial, will go to the Imperial, National or City Stereographic Library and call for its skin or form, as he would for a book at any common library … This is a mere hint of what is coming before long.

Holmes's vision has never been fully realised – although even he would perhaps have been surprised at the sheer quantity of photographs produced in the nineteenth century alone – but the breadth of the surviving corpus of photography from the Victorian age, scattered as it is through libraries, museums and archives across the world, allows us an insight into the past unavailable through any other medium. The British Library's own collection represents a small, if endlessly intriguing, facet of this achievement.

Neither a comprehensive nor historically objective view of the nineteenth century can be claimed for its reflection seen in the camera lens, which mirrored the points of view, assumptions and public and private agendas of both producers and consumers of the photographic image. The state of early photographic technology also influenced the ways in which pictures were constructed and composed, and up until the last years of the century imposed limits on what could effectively be photographed. Our own familiarity with the ways in which photography is used with ever-increasing subtlety to persuade and influence us, has rightly taught us to approach its images with a knowing wariness. From the mid-nineteenth century, photography was developing into a major commercial industry, and photographs were taken for a purpose, just as they are in our own time: self-presentation, escapism, the celebration of industrial progress, national and imperial propaganda, artistic expression, scientific curiosity, social control, moral prescription and consumer expectations. These and many other motives played their interlocking roles in building the huge body of surviving images which have shaped and defined our sense of the high Victorian age and its legacy. The camera itself cannot lie, presenting us as it does with the visible results of the complex interactions between known optical and chemical laws. Whether these results are 'true' beyond this mechanical veracity is another matter, and require us to read the images of another era with particular sensitivity. Concepts of realism, accuracy and truth shift over time: the not uncommon nineteenth-century practice of rearranging scenes of battle and tragedy after the event has counterparts in our own time. This is now commonly considered ethically questionable. But the selection of a point of view at any given moment directs both what we see and how we respond to it. And to the nineteenth-century photographer it would have seemed natural and justifiable, artfully to heighten drama and to create a narrative from the camera's mechanical record.

Time changes our view of the past. This is entirely appropriate when viewing the products of a medium such as photography which, in simultaneously embodying a celebration of the moment preserved and an elegy for what is altogether lost, reminds us that it is as much concerned with time as with the veneer of the visual with which it is cloaked.

1

THE INFANCY OF INVENTION

In early 1839, two transformational new discoveries in the visual arts were announced almost simultaneously on either side of the English Channel. Working quite independently of each other, Louis-Jacques-Mandé Daguerre and William Henry Fox Talbot had discovered a means of uniting chemistry and optics to create representations of the physical world, bypassing the fallible hand of the artist.

For centuries, men of science had been seeking more accurate ways of representing reality than drawing and painting. When the daguerreotype and Talbot's photogenic drawing process (later to be refined into the more practical calotype) were announced, the notion of being able to produce an image mechanically caused a sensation that swept across artistic and scientific circles. But if these two earliest photographic processes both claimed to show a true reflection of the world, they could not have been more different in visual effect. The captivating detail visible in the mirrored metal surface of the daguerreotype plate has still not lost its capacity to enchant. In contrast, Talbot's early images, printed from paper negatives, were considered by many to be hazy and ill-defined, their expressive power apparent perhaps only to the more perceptive viewer.

These distinctions, inherent in the nature of the processes themselves, were reflected in their relative commercial success. Bright and immensely detailed, the daguerreotype quickly established itself as the superior vehicle for portraiture among a burgeoning middle class.

Within a few years, an entire industry was spawned, both in Europe and America. Talbot was less fortunate. Despite struggling for years to profit financially from his discoveries, the commercial success he sought ultimately eluded him, and the calotype was never able to compete successfully with the daguerreotype. In addition to its perceived limitations, patent restrictions imposed by Talbot himself prevented its free use, except by amateurs. Of this group, however, many felt that the calotype rendered images in a more subtle and nuanced way, bringing light and shade into play, alluding to different layers of interpretation – all techniques used by artists of the day in engravings, watercolours and drawings. And it was this amateur body of practitioners – particularly in Britain and France – that exploited the expressive potential of the medium most fully in its early years.

Debate inevitably raged around the status of photography. Some – perhaps most vocally the very artistic community which felt most threatened by the new medium – argued that it was little more than an unselective documentary tool, fit only for record making. But the discoveries of Daguerre and Talbot were products of their time. Immediately, it was clear that photography could fulfil numerous cultural, social and political needs. For example, rather than admire romantic views of landscapes, scientists from emerging disciplines were keen to study topography using more precise representations of terrain. And, as the wealth and patronage of the church and the aristocracy in the arts dwindled, members of the bourgeoisie who had not necessarily received a classical education wanted images they could understand and to which they could relate.

Despite the unique and quite distinct beauties of the two processes, both the daguerreotype and the paper negative had been superseded by the end of the 1850s. A growing public preference for the precise detail and sharp contrast of the wet collodion glass negative, printed on glossy albumen paper, was accompanied by a massive expansion of the commercial photographic market. Many of the early pioneers of the medium, for whom such developments signalled a fatal vulgarisation, lost faith in photography and, unable to adapt to its growing democratisation, abandoned the art altogether. But in the two decades of their widespread use, the daguerreotype and the calotype had created a body of work which established photography's growing status as the century's dominant mode of visual expression.

William Henry Fox Talbot (1800–1877)

William Henry Fox Talbot was born into a landed but impoverished family that had occupied Lacock Abbey in Wiltshire for generations. The early brilliance of this shy but determined youth, with a passion for botany, mathematics, optics and astronomy, swiftly became apparent during his schooldays at Harrow. At Cambridge he gained a first in mathematics, and as John William Ward (first Earl of Dudley) noted presciently in 1821, 'He has an innate love of knowledge and rushes towards it as an otter does to a pond. He bids fair to be a distinguished man.' A privileged background and wide-ranging intellectual achievements smoothed his path into the most elevated scientific and political circles: he was elected a fellow of the Royal Society in 1831 and to Parliament in 1832.

It was while he was holidaying at Lake Como in 1833 that the seeds of his most famous achievement first germinated. Frustrated by his inability to draw, even with the help of artistic aids such as the camera lucida, he started to consider the possibility of permanently fixing the image produced by its lens.

On his return to Lacock, Talbot set to work. By 1834 he was producing the first of what he originally termed 'sciagraphs' (shadow drawings) but which were later called 'photogenic drawings'. By placing items, such as botanical specimens, upon sheets of paper impregnated with light-sensitive silver chloride and exposing them to sunlight, he was able to create negative silhouettes of natural objects. In the following year he produced his first camera negative, in the tiny home-made boxes referred to by his wife as 'mousetraps'. Talbot soon realised that these negatives could in turn be exposed against sensitised paper to produce positive impressions, thus establishing the principles of almost every pre-digital photographic process.

Talbot's photographic investigations lapsed over the next few years as other areas of scientific enquiry and the demands of a dutiful parliamentary attendance intervened. But in January 1839, he was shocked to discover that the French panorama painter, Louis-Jacques-Mandé Daguerre, had also succeeded in fixing a photographic image in the camera obscura, naming his invention the 'daguerreotype'. Knowing nothing of the possible similarities between their processes and concerned to establish his claim to primacy, Talbot was galvanised into action. Within weeks he presented a hastily written account of his own photogenic drawing process to the Royal Society.

Talbot refined his photogenic drawing process in the course of the following year. By increasing the sensitivity of his negatives he shortened exposure times, making the calotype – as he named the process in 1840, from the Greek 'kalos' or beautiful – suitable for portraiture and for use in dull conditions. In contrast to Daguerre, Talbot received very little recognition or reward for his invention at the time of its announcement. Yet despite significant contributions to disciplines as diverse as mathematics, astronomy and Assyriology, the creation of new ways of seeing and interpreting the world remains his enduring legacy.

William Henry Fox Talbot

Talbot's first recorded note on the possibility of creating photogenic drawings, October 1833

Talbot Notebook 'L', p. 73

Antoine Claudet

*Portrait of William Henry
Fox Talbot, early 1840s*

Daguerreotype, 6.5 x 5.3 cm

Talbot Photo 4 (2)

'... This led me to reflect on the inimitable beauty
of the pictures of Nature's painting which the glass
lens of the camera throws upon the paper in its focus –
fairy pictures, creations of a moment, and destined
as rapidly to fade away.

It was during these thoughts that the idea occurred
to me ... How charming it would be if it were
possible to cause these natural images to imprint
themselves durably, and remain fixed upon the paper!'

W.H.F. Talbot, *The pencil of nature part 1, introduction*

William Henry Fox Talbot

*West front of Lacock Abbey,
early 1840s*

Salted paper print from
a calotype negative,
15.9 x 19.5 cm

Talbot Photo 2 (308)

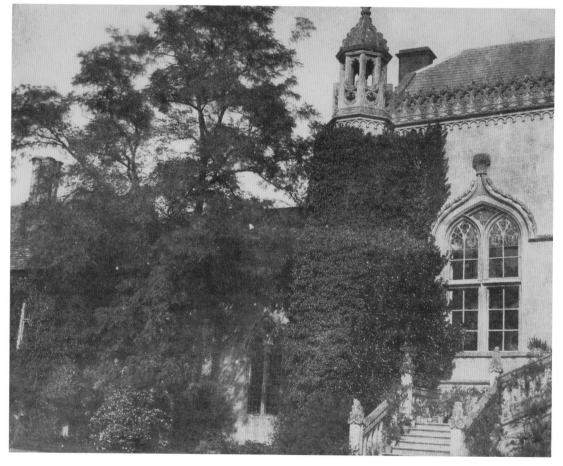

'Drawings of shadows'

Talbot's 1839 demonstration of his photogenic drawing process had presented the world with striking and intriguing images, suggestive of his discovery's creative potential, but undeniably crude in comparison with the daguerreotype. Crucially, the long exposures required to imprint a visible image on a sheet of sensitised paper – often in excess of an hour – severely limited its practical utility, particularly in the field of portraiture. A period of intense experimentation over the course of the next eighteen months bore fruit in September 1840, when Talbot discovered the concept of the 'latent image'. After even relatively brief exposure in the camera, chemical reactions invisible to the naked eye had in fact been registered on the paper negative, which could then be made visible by development in gallic acid. Talbot patented the improvements to his process in February 1841, noting, in a communication to *The literary gazette*, that he proposed calling the process calotype, a neologism from the Greek meaning 'beautiful image', with the hope that the 'term … will not be found to have been misapplied.' Talbot's hopes for his process were amply justified. Shortened exposure times, allied to the creation of a more chemically robust negative from which any number of positive prints could be made, now made the calotype a viable competitor to the daguerreotype. Mainly in the hands of British and French photographers, the following twenty years witnessed the growth and maturing of a uniquely photographic vocabulary, which owed its origins to the 'alliance of science with art', which Talbot had set in motion.

Deceptively simple in its basic procedures, the variables of the calotype process were both daunting and liberating. Varieties of chemical procedure, exposure times, paper sizing and thickness, all offered an almost infinite range of choice which influenced the contrast, definition and tone of the final print. While these factors meant that the calotype could be frustratingly arbitrary in its effects, it also endowed the process with a far richer palette of expressive possibility – 'ample room for the exercise of skill and judgment,' in Talbot's words – than was ever available to the daguerreotype.

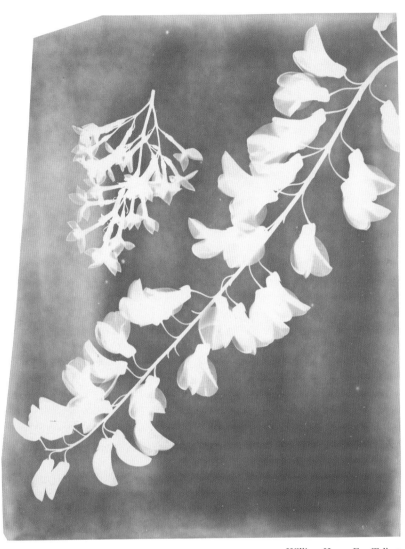

William Henry Fox Talbot

Photogenic drawing of botanical specimens, 1839

Cameraless photogenic drawing negative, 22.1 x 17.4 cm

Talbot Photo 14 (2)

William Henry Fox Talbot

An oak tree in winter,
c. 1842–3

Calotype negative,
19.5 x 16.6 cm

Talbot Photo 1 (97)

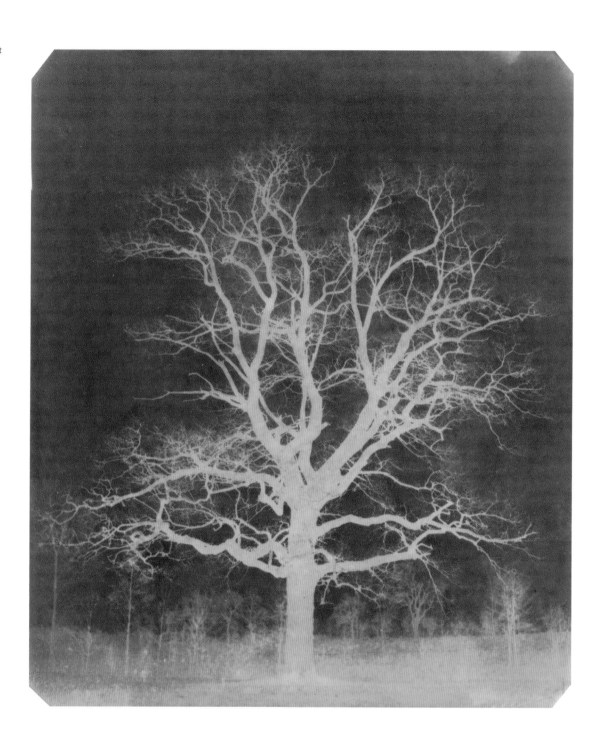

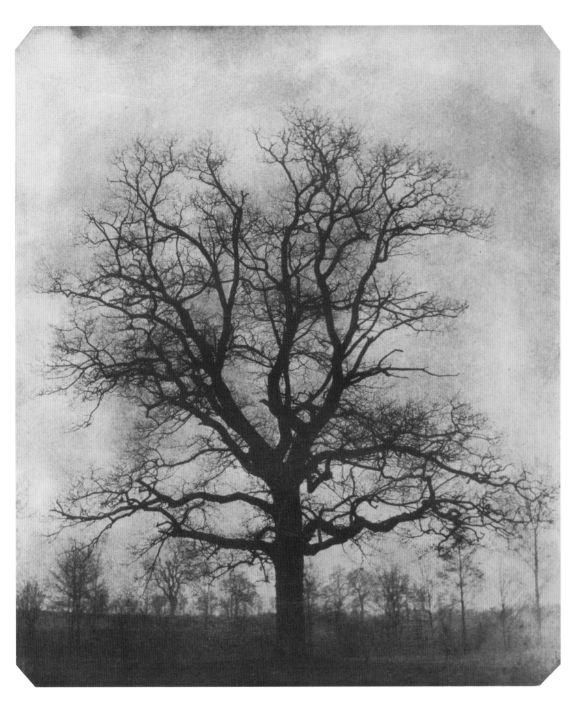

William Henry Fox Talbot

An oak tree in winter,
c. 1842–3

Salted paper print from
a calotype negative,
19.5 x 16.6 cm

Talbot Photo 2 (757)

Competing technologies: the calotype and the daguerreotype

These two images, coincidentally taken in Paris within a month of each other, illustrate many of the essential differences between the competing processes. The print from Talbot's paper negative, which looks out from an upper window of the Hôtel de Douvres, was praised in *The Spectator* as being 'almost equal in distinctness of detail to a Daguerreotype.' It cannot, however, compete in clarity and sharpness with Chevalier's daguerreotype, where a magnifying glass makes it possible to read the wording of the posters fixed to the piers of the bridge.

But the texts of these posters, which are back to front, also reveal the lateral reversal of the image, which was one of the process's limitations. Although optical solutions to this problem, which was most apparent in architectural or topographical work, soon became available, their effect on image quality restricted their use.

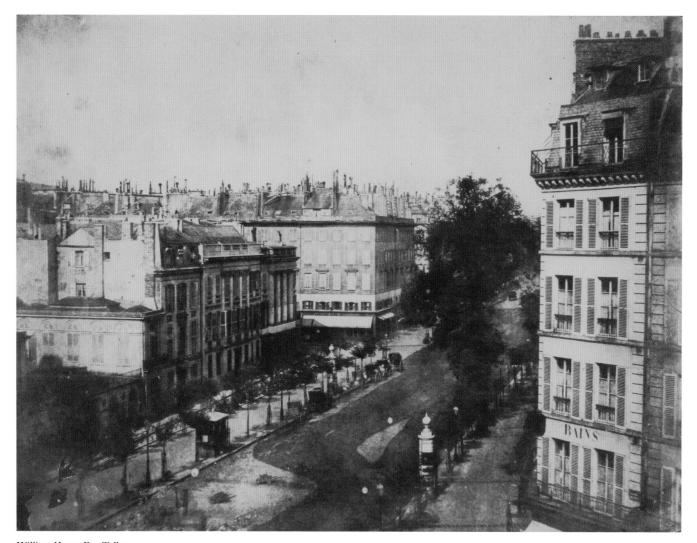

William Henry Fox Talbot

View of the boulevards at Paris, May–June 1843

Salted paper print from a calotype negative, 16.2 x 21.4 cm

Talbot Photo 2 (5)

Difficulties in viewing the daguerreotype's highly reflective metal surface, allied to the unique nature of its image, which could not be easily reproduced, as could the calotype, were also finally to place the future in the hands of Talbot's negative–positive process and its successors.

By 1843, exposure times for both the daguerreotype and the calotype had been significantly reduced. The Parisian optician and instrument maker Charles Chevalier, who sent this daguerreotype to Henry Talbot, also supplied him with cameras and lenses; a note on the reverse records that it was taken at 11 a.m., with an exposure time of 28 seconds. While moving figures in both this scene and Talbot's own view have become blurs, both processes were by now capable of a wide range of photographic activity.

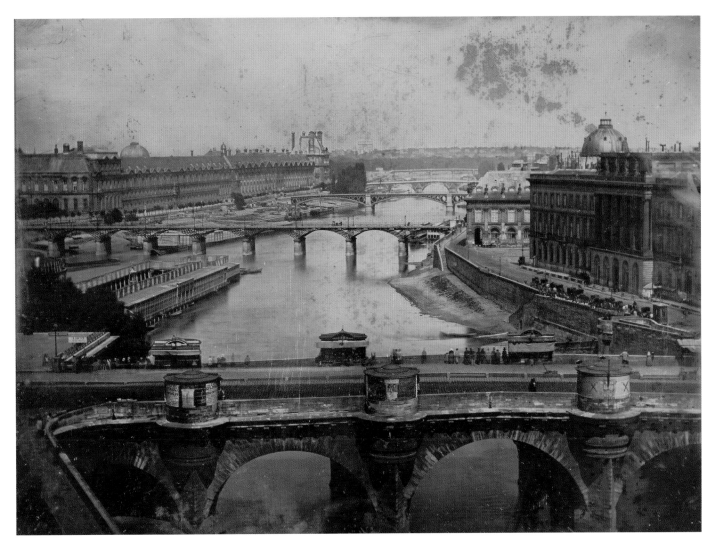

Charles Chevalier

View of the Seine at Paris,
15 May 1843
Daguerreotype,
13.9 x 19.1 cm

Talbot Photo 4 (10)

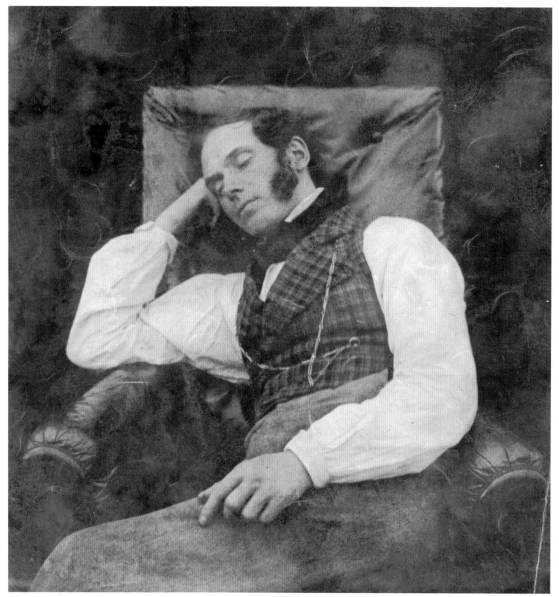

William Henry Fox Talbot
(possibly with **Antoine Claudet**)

Nicolaas Henneman, asleep,
1844–5

Modern print from original
calotype negative,
15.3 x 14.6 cm

Talbot Photo 1 (117)

William Henry Fox Talbot

The bust of Patroclus,
9 August 1843

Salted paper print from
a calotype negative,
13.7 x 12.8 cm

Talbot Photo 2 (426)

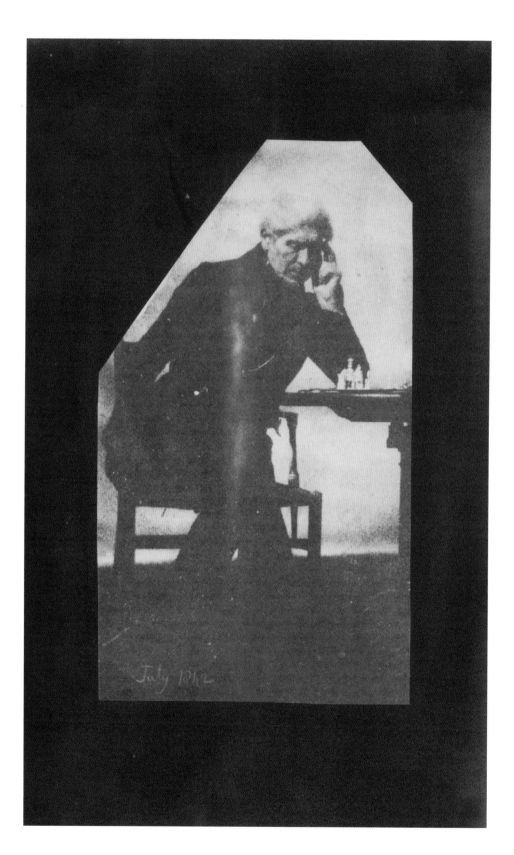

William Henry Fox Talbot

*Portrait of Sir David
Brewster playing chess,
July 1842*

Salted paper print from
a calotype negative,
12.7 x 7.3 cm

Talbot Photo 26

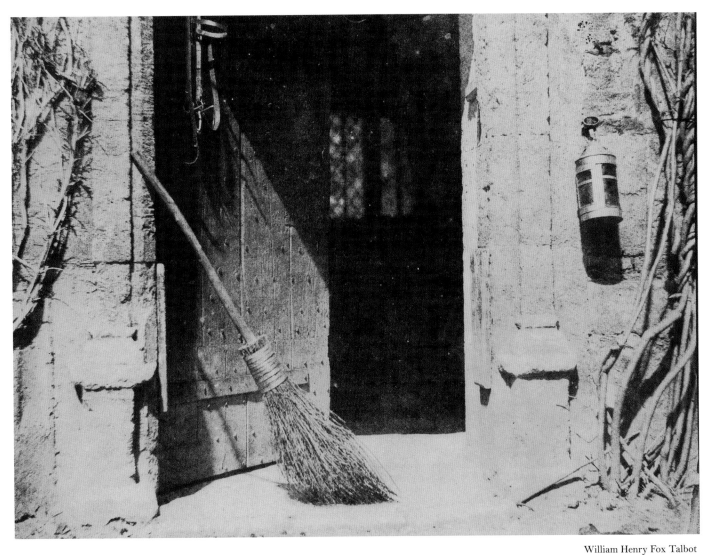

William Henry Fox Talbot
The open door, April 1844
Salted paper print from
a calotype negative,
14.2 x 19.3 cm
Talbot Photo 2 (23)

'The chief object of the present work is to place on record some of the early beginnings of a new art. This is one of the trifling efforts of its infancy, which some partial friends have been kind enough to commend. We have sufficient authority in the Dutch School of art for taking as subjects of representation scenes of daily and familiar occurrence. A painter's eye will often be arrested where ordinary people see nothing remarkable. A casual gleam of sunshine or a shadow thrown across his path, a time-withered oak, or a moss-covered stone may awaken a train of thoughts and feelings, and picturesque imaginings.'

William Henry Fox Talbot, *The pencil of nature*, fascicle 3, letterpress accompanying plate 6.

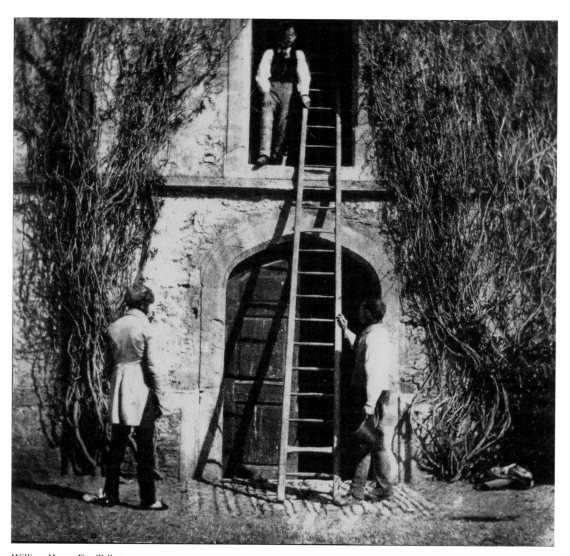

William Henry Fox Talbot

The ladder, April 1844

Salted paper print from
a calotype negative,
17.1 x 18.3 cm

Talbot Photo 2 (49)

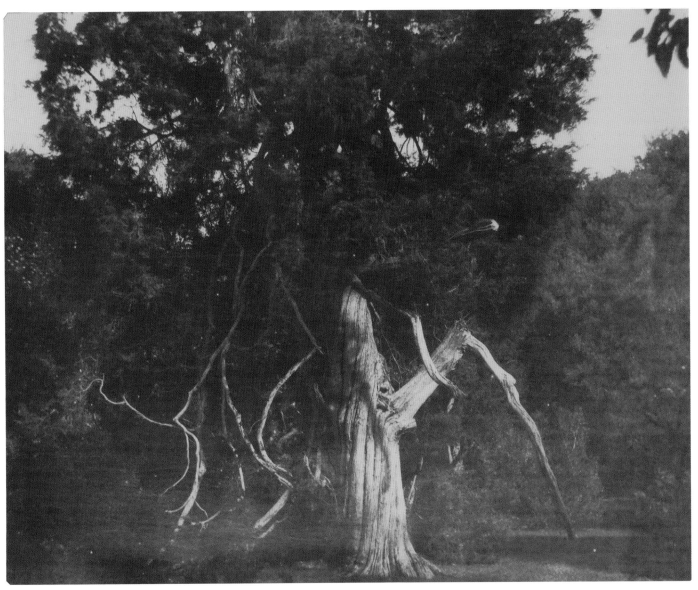

William Henry Fox Talbot

An aged red cedar in the grounds of Mount Edgcumbe, Plymouth, c. 1841

Salted paper print from a calotype negative, 15.8 x 19.5 cm

Talbot Photo 2 (231)

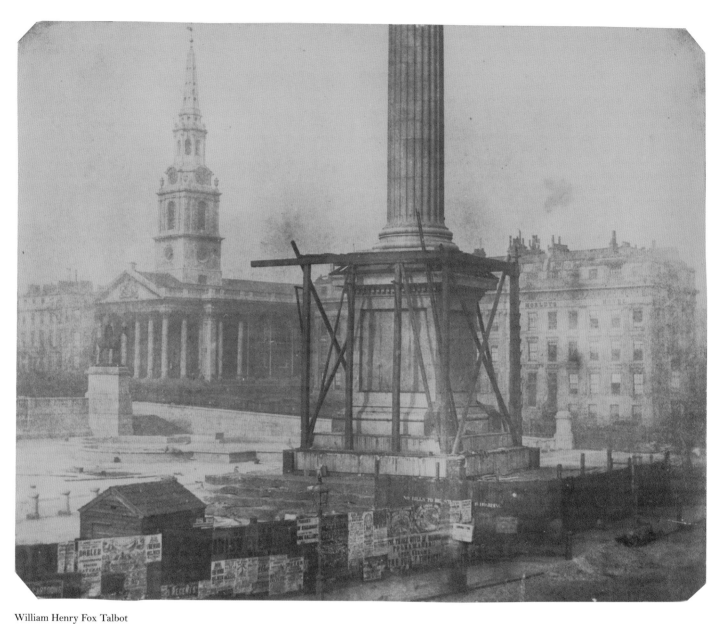

William Henry Fox Talbot

*Nelson's Column under
construction, Trafalgar
Square, London, April 1844*

Salted paper print from
a calotype negative,
17 x 21 cm

Talbot Photo 2 (330)

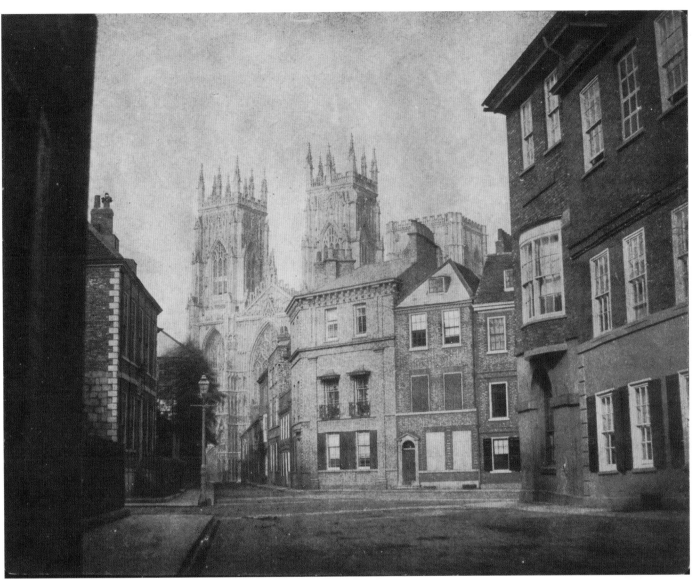

William Henry Fox Talbot

*A scene in York: York Minster
from Lop Lane, 28 July 1845*

Salted paper print from
a calotype negative,
16.1 x 20.2 cm

Talbot Photo 2 (351)

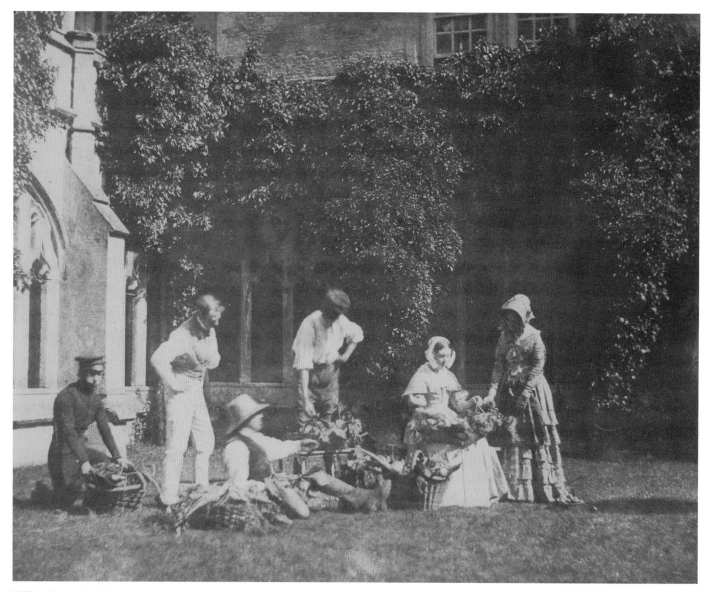

William Henry Fox Talbot
The fruit sellers, early 1840s
Salted paper print from
a calotype negative,
17.1 x 21.1 cm
Talbot Photo 2 (324)

Country house pursuits

Unlike the daguerreotype, which quickly established itself in the portrait market, development of calotype photography in England rested largely in the hands of amateurs. Widespread use was further hindered by the lack of detailed manuals, which did not start to appear for some years. Technical details of working procedures and improvements were instead transmitted through informal personal and family networks, or through amateur clubs such as the Calotype Society. Dissociating themselves from any connotation of 'trade', which had soon attached itself to the daguerreotype community, these early amateurs (among whom were a number of distinguished women) were generally representatives of the upper and middle classes, united by interests in the arts and sciences and with the leisure and means to pursue them.

Talbot's written exchanges with novice calotypists illustrate the extent to which technical advice was good-naturedly but inefficiently disseminated by personal correspondence. As late as 1845, Nevil Story-Maskelyne, later to become a distinguished mineralogist, felt obliged to write to Talbot in search of reliable guidance on the calotype process. Other friends such as the Rev. George Wilson Bridges and the Rev. Calvert Richard Jones constantly sought Talbot's advice (as well as supplies of paper and chemicals) during their Mediterranean travels in 1846.

Of this circle, Calvert Jones proved to be the most assured calotype artist, both in his Mediterranean views and his studies of English scenes. He is also exceptional in his concern to commercialise the process. As a cleric of very slender means at this period, he saw the selling of his travel views as a potential source of income, and for a time entered into a business arrangement with Talbot, suggesting, among other schemes, the hand-colouring of views to add to their attraction.

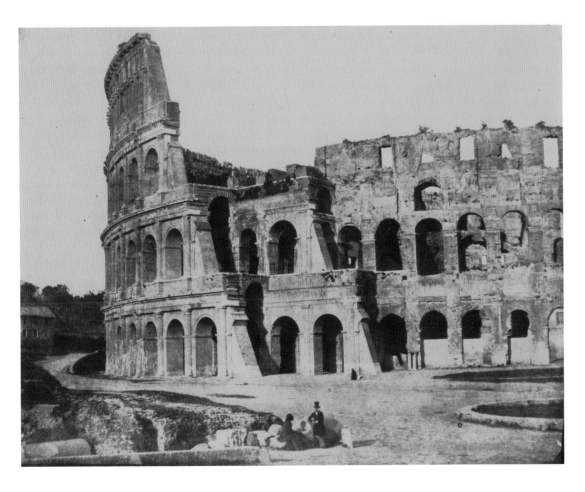

The Rev. Calvert Richard Jones

The Colosseum, Rome, 1846

Salted paper print from a calotype negative, 18.4 x 22.3 cm

Talbot photo 2 (581)

The Rev. Calvert Richard
Jones

*Portraits of sailors and pilots
at Ilfracombe and Swansea,
c. 1846–7*

Modern prints from original
calotype negatives,
each 9 x 11 cm or reverse

Talbot Photo 1 (219, 220, 228)

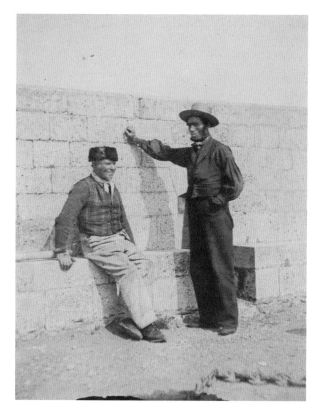

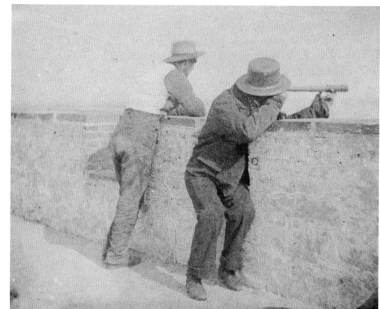

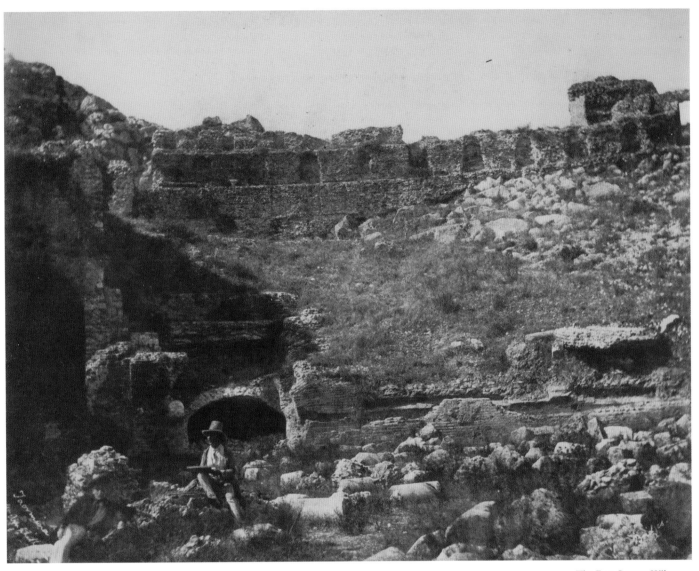

The Rev. George Wilson
Bridges

The Amphitheatre,
Taormina, Sicily, 1846

Salted paper print from
a calotype negative,
16.6 x 21.1 cm

Talbot Photo 2 (624)

Nevil Story-Maskelyne (?)

*Portrait of Nevil
Story-Maskelyne, c. 1850*

Modern print from original
calotype negative,
17.9 x 14.7 cm

Photo 1194/1 (1)

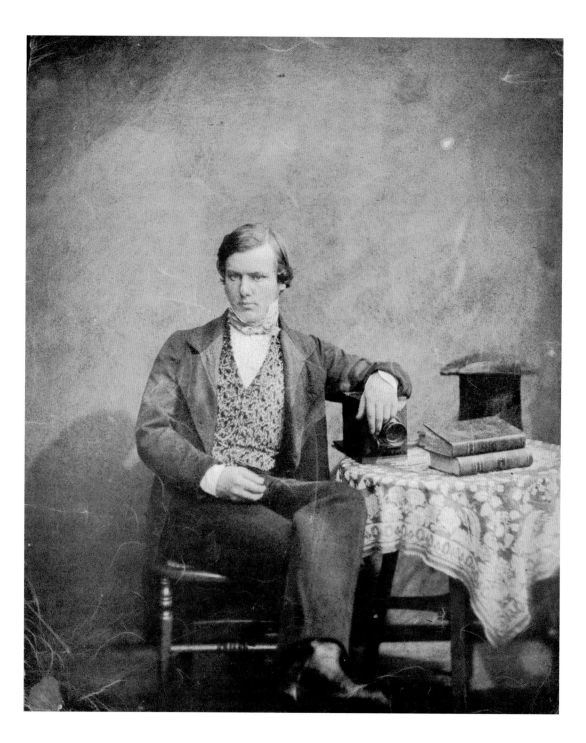

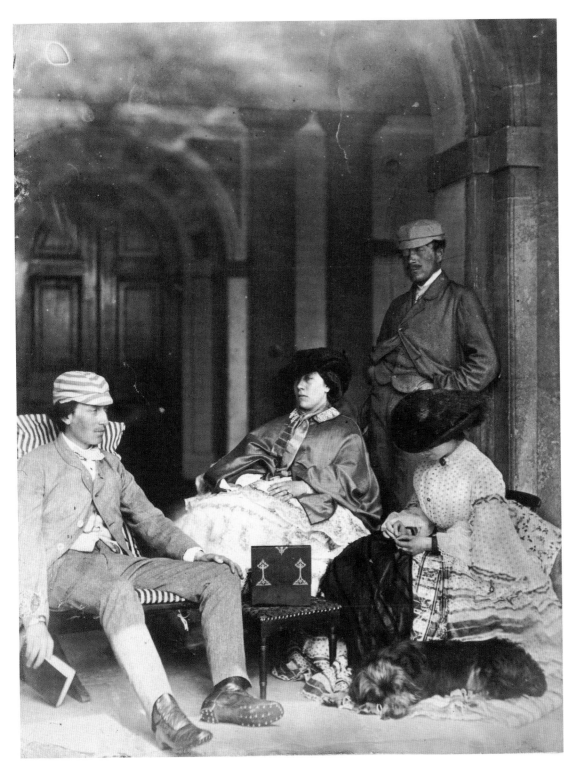

Nevil Story-Maskelyne

*Group of the Suffolk family
at Charlton Park, early 1850s*

Albumen print from
a collodion negative,
17.9 x 13.8 cm

Photo 1194/3 (67)

Don Juan Carlos,
Count of Montizón

*The hippopotamus at the
Zoological Gardens, Regent's
Park, London, 1852*

Salted paper print from
a collodion negative,
11.1 x 11.8 cm

*The photographic album
for the year 1855*
(London [1855]), plate 9

C.43.i.7

Antoine Claudet

The chess game, c. 1845

Salted paper print from
a calotype negative,
19.8 x 14.8 cm

Talbot Photo 2 (264)

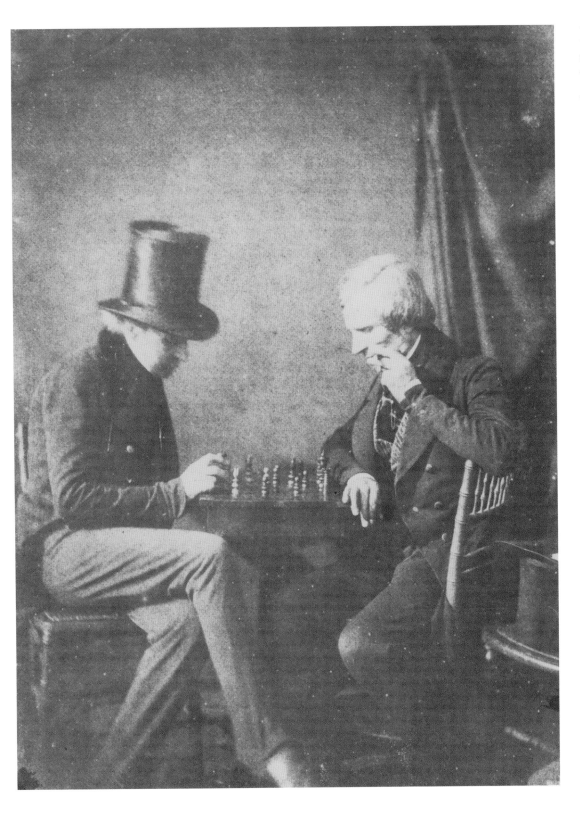

The pursuit of profit

By personal inclination, Henry Talbot was ill-suited to the world of commerce, yet he was anxious both to see the calotype widely adopted and to make some return on his invention. The daguerreotype had been aggressively marketed as a medium for portraiture by early entrepreneurs, and throughout the first half of the 1840s Talbot struggled to break this stranglehold and emulate its success.

The daguerreotype, however, was too firmly entrenched for Talbot's efforts to make much impact and sitters proved unwilling to exchange the bright precision of the daguerreotype for the softer paper image of the calotype. From 1841 to 1844, the miniature painter turned photographer Henry Collen operated an exclusive licence from Talbot for calotype portraiture in his London studio, but with consistently disappointing results. Talbot's subsequent partnership with the talented French daguerreotypist Antoine Claudet in 1844 looked more promising. Yet Claudet's commitment and energy in promoting the calotype process, in whose practical advantages and artistic possibilities he believed, were never reflected in the accounts of his studio. In little more than a year, Claudet had withdrawn from the arrangement and returned exclusively to the daguerreotype, acknowledging that the calotype had little hope of a successful assault on the daguerreotype's grip of the market.

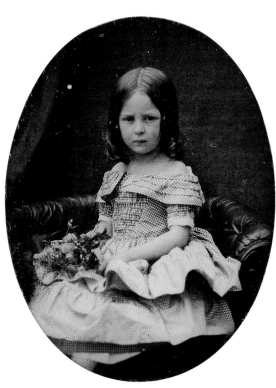

William Henry Fox Talbot

Portrait of Matilda Talbot,
c. 1843

Salted paper print from
a calotype negative,
9.4 x 6.7 cm

Talbot Photo 2 (464)

Antoine Claudet

Portrait of Matilda Talbot,
c. 1843

Daguerreotype,
6.8 x 5.5 cm

Talbot Photo 4 (4)

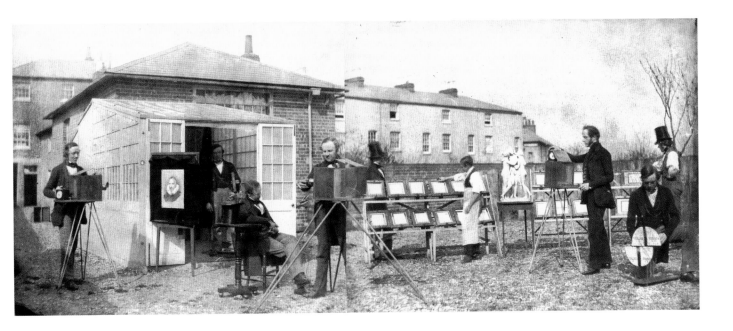

The Reading establishment (1843–7)

The calotype's major advantage over the daguerreotype lay in the unlimited number of positive images that could be produced from a single negative. Despite his unhappy attempts at promoting the calotype in the studios of London, the commercial possibilities of reproducible photographs led Talbot to establish the world's first large-scale photographic printing establishment at Reading in early 1844. Based in a former schoolhouse, the Reading establishment was managed by Talbot's Dutch manservant Nicolaas Henneman. In the three years of its existence it attempted to create a market for photographic prints, both by individual sales and through the production of photographically illustrated books. The prints for two of Talbot's own works, *The pencil of nature* (1844–6) and *Sun pictures in Scotland* (1845), were produced at Reading, as well as those for the first photographically illustrated book of art reproductions, William Stirling's *Annals of the artists of Spain* (1848).

The two-part view of the operations of the printing works seen above was carefully composed to illustrate the range of activities undertaken at the works, including a sitter having his portrait taken, the copying of works of art and, in the right background, prints being made by the action of sunlight. But given the number of prints required for book publication (over 6,000 had to be produced for promotional distribution in the June 1846 issue of the *Art Union*), it is unsurprising that consistent quality was almost impossible, in a process dependent on unreliable water supplies and the vagaries of the weather. The variable quality of work produced at Reading and its disturbing propensity to fading, ultimately destroyed any hope of long-term success. This over-ambitious attempt at the mass production of a process still highly dependent on individual craft skills, was greater testimony to Talbot's faith in photography's future, than to his commercial acumen. In early 1847, the Reading printing works closed and Henneman moved to London to establish a calotype portrait studio. Talbot's continuing support of his former servant, whose business survived precariously until 1856, represented his final attempt to promote the calotype, by now rapidly falling into disuse.

William Henry Fox Talbot and Nicolaas Henneman

The Reading printing establishment, 1846

Gelatin silver prints (printed later) from calotype negatives, 17.6 x 42.6 cm

Talbot Photo 2 (354,355)

The pencil of nature

In 1844, in an attempt to popularise an art 'likely in all probability to be much employed in the future', Talbot embarked on the production of *The pencil of nature*, the first commercial publication to be illustrated by photography. Intended both to popularise photography and to enumerate its possibilities, *The pencil of nature* comprised a visual prospectus of the medium's unique artistic and commercial potential, with subjects selected largely from architecture, sculpture and the visual arts. Ironically, portraiture, while acknowledged as 'one of the most attractive subjects of photography', is conspicuous by its absence. This implicit acknowledgement of both the difficulties of the genre and the dominance of the daguerreotype in this field, also perhaps hints at Talbot's own awareness of his uncertain mastery of a subject which might have given the work more popular appeal.

In the event only six parts, containing a total of 24 original photographs with accompanying letterpress, were finally issued; by April 1846, in the face of the dwindling sales of each successive issue, Talbot was forced to acknowledge the commercial failure of *The pencil of nature* and the project was abandoned.

Despite this dispiriting start, the use of original prints for book illustration remained the only practical method of incorporating photography in published works, until the half-tone process became established in the 1880s. The decades following the 1840s saw the production of thousands of such books, from major works on travel, biography and art, produced for the luxury market, to more modest illustrated gift books.

William Henry Fox Talbot

Cover of fascicle 3 of
The pencil of nature
(London, 1844–6)

Talbot Photo 8

LONGMAN, BROWN, GREEN AND LONGMANS.

LONDON, 1844.

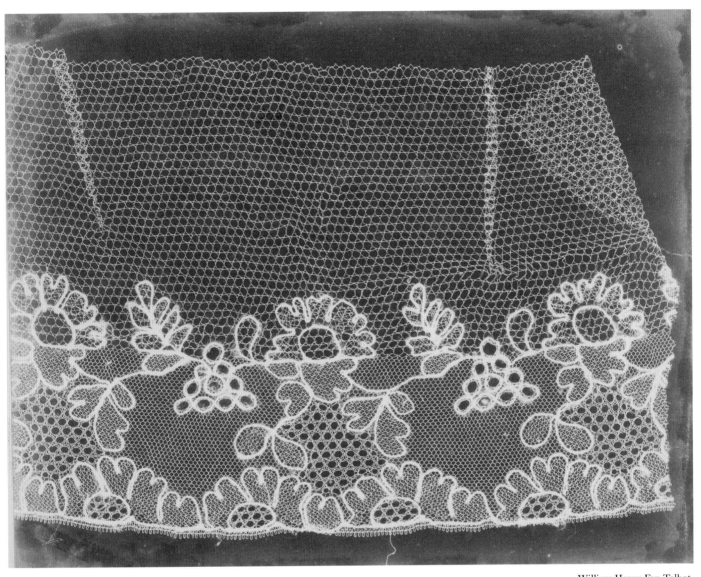

William Henry Fox Talbot

Lace, c. 1845

Cameraless photogenic
drawing negative,
17.3 x 22 cm

William Henry Fox Talbot,
The pencil of nature
(London, 1844–5),
fascicle 5, plate 20,
issued July 1845,

Talbot Photo 6 (20)

**David Octavius Hill and
Robert Adamson**

*Elizabeth Johnstone Hall,
Newhaven fishwife: 'It's no
fish ye're buying, it's men's
lives,' 1843–7*

Salted paper print from
a calotype negative,
19.3 x 14.2 cm

D.O. Hill and R. Adamson,
One hundred calotype sketches
(Edinburgh, 1848), plate 91

C.128.k.10

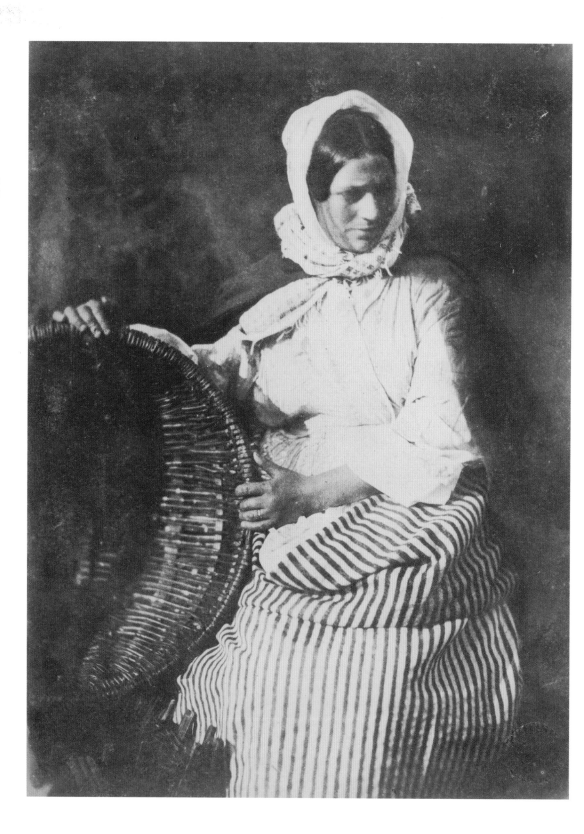

Hill and Adamson

The expressive power of early photography is perhaps most evocatively illustrated in the creative collaboration between the Scottish artist David Octavius Hill and Robert Adamson, founder of Scotland's first calotype studio in 1843. In the same year Hill was introduced to photography when he sought Adamson's assistance in producing reference portraits for a group painting of the 450 ministers of the newly formed Free Church of Scotland. Talbot's process was not protected by patent in Scotland, leaving Hill and Adamson free to make professional use of the calotype process. Their collaboration produced portraits, landscapes and architectural studies of the greatest delicacy and sophistication. Most strikingly, their portraits are characterised by naturalism and human sympathy, expressed through a masterful use of posing, light and tonality.

Nowhere is this command of the medium more clearly seen than in their detailed study of the small fishing village of Newhaven. Originally intended as the first of a series of publications illustrating aspects of Scottish life and landscape, the Newhaven series presciently and uniquely anticipates photography's social documentary role. Rejecting the picturesque genre study, Hill and Adamson instead created a complex and intimate visual essay examining a whole way of life, through the inhabitants of a distinct and close-knit community.

By a happy combination of artistic talent and technical skill, their partnership – which lasted only from 1843 until Adamson's early death in 1848 – produced over 3000 calotype studies. These represent, arguably, the single most outstanding achievement of paper photography in Britain during the 1840s.

David Octavius Hill and Robert Adamson

D.O. Hill and nieces at the Dennistoun Monument, Greyfriars, Edinburgh, 1843–7

Salted paper print from a calotype negative, 20.8 x 15.4 cm

D.O. Hill and R. Adamson, *One hundred calotype sketches* (Edinburgh, 1848), plate 75

C.128.k.10

David Octavius Hill and Robert Adamson

Asleep among the grass. Master Hope Finlay, 1843–7

Salted paper print from a calotype negative, 15.5 x 21.2 cm

D.O. Hill and R. Adamson, *One hundred calotype sketches* (Edinburgh, 1848), plate 51

C.128.k.10

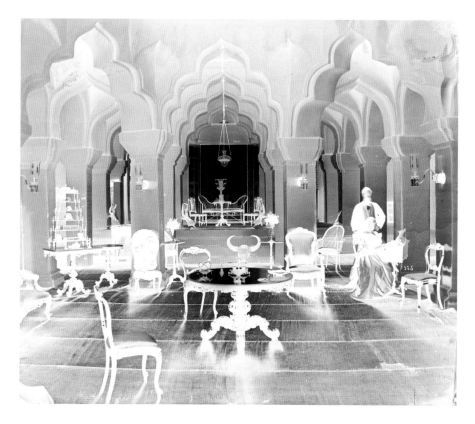

Edmund David Lyon

*Interior of the Tuncum,
Madurai, India, 1868*

Wet collodion negative
and albumen print,
each 22.9 x 27.5 cm

Neg 1000/29 (2975);
Photo 212/2 (35)

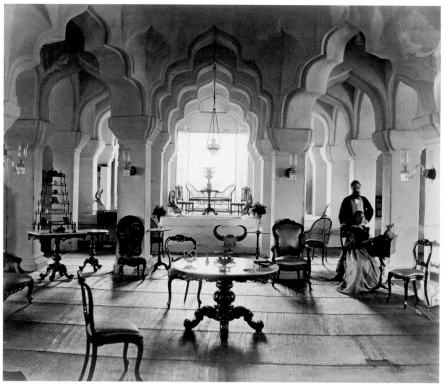

The wet collodion process

Both Daguerre's and Talbot's photographic discoveries inevitably became obsolete, as photographic technology developed in the course of the 1840s. Frederick Scott Archer's wet collodion process, published without patent protection in 1851, united many of the virtues of both technologies. Archer's process used collodion in a liquid suspension to coat a glass plate and to carry the light-sensitive chemicals. The use of glass achieved a resolution unobtainable with paper negatives, while the process also allowed much shorter exposure times than were obtainable with either the daguerreotype or the calotype.

These improvements came at a cost. The wet collodion process required the completion of the coating, exposure and development in a single sequence, since the negative lost sensitivity as it dried. This demanded considerable skills from photographers working in the field, often in extreme climates, as well as the transportation of stocks of heavy glass plates and a battery of chemicals. Experiments with lightweight alternatives to glass, such as mica, never gained popularity, owing to its fragility, and throughout the 1850s a number of photographers continued to use the more portable paper negative in demanding circumstances. Despite these drawbacks, the wet collodion process, freely available to all, was to dominate photography until the 1880s.

Nevil Story-Maskelyne

Portrait of the Oriental scholar Dr Max Müller, Oxford, c. 1851

Wet collodion on mica negative and modern print, each 12.1 x 10 cm

Photo 1194/2 (1);
Photo 1194/3 (77)

William Henry Fox Talbot

Dandelion seeds, 1852–7

Photoglyphic engraving,
5 x 7.5 cm

Talbot Photo 24 (1730)

William Henry Fox Talbot

Folded crepe, 1853–7

Photoglyphic engraving,
6.4 x 10 cm

Talbot Photo 24 (1659)

The quest for permanence

The early realisation of the inherent chemical instability of photographic prints and their consequent fading imperilled the reputation of the medium. Disheartened by this threat to the long-term viability of his discovery, Talbot himself largely abandoned active photography in the mid-1840s. For the rest of his life he devoted much of his scientific researches towards devising a process in which the accuracy and tonal range of the photographic print could be reproduced mechanically – and permanently – in printer's ink.

The results of this work, which he termed 'photoglyphic engraving', were published in two patents (registered in 1852 and 1858), which established him as the inventor of both photogravure and the half-tone screen. Thousands of the experimental prints and many of the printing plates produced by Talbot in the 1850s survive, with subjects ranging from reproductions of photographic prints to botanical specimens. Of major significance for the study of the development of a hugely influential printing process, many of these also possess their own incidental beauty.

In addition to Talbot's own work, the mid-nineteenth century proved to be a remarkably fertile period for alternative solutions to the problem of printing the photographic image in permanent form. A bewildering array of ingenious and complex processes, unrivalled for tonal fidelity, were to be introduced between the 1850s and 1870s. Prominent among these were the carbon print, the woodburytype and the collotype, which enjoyed wide commercial use, particularly for book illustration, up to the end of the nineteenth century and in some cases beyond.

Joseph Cundall and
Robert Howlett

*Crimean Braves, privates of
the Coldstream Guards, 1856*

Photogalvanographic
engraving, 24.7 x 19.8 cm

Photographic art treasures
(London, 1856–7), plate 6

X.1240

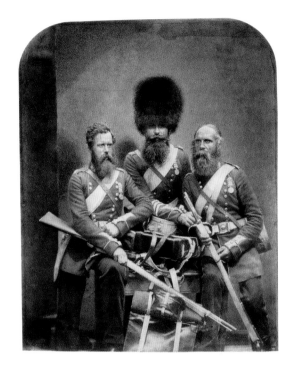

Unknown photographer
(possibly Francis Bedford)

Kenilworth Castle, c. 1865

Carbon print, 23 x 29 cm

Talbot Photo 35 (1)

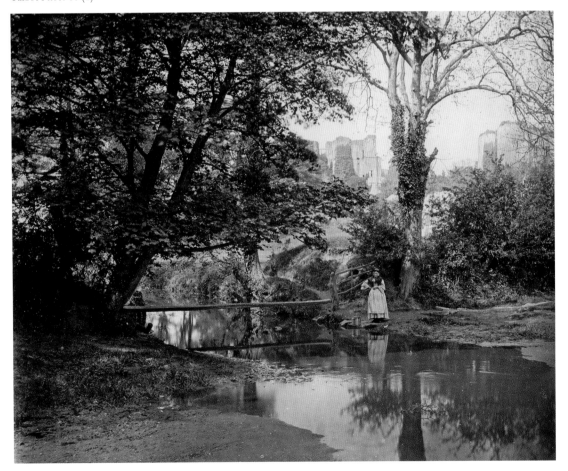

2
TO THE ENDS
OF
THE EARTH

By the 1850s, photography was beginning to make the world feel a smaller place. For the first time, accurate and trustworthy representations of distant lands and peoples, unmediated by the artist's hand, were enthusiastically explored in parlours and drawing rooms across the western world. Subsequent decades were to witness a huge explosion in photographic production as new international markets for the technology appeared.

The invention of photography coincided with the start of an unprecedented period of European colonial and mercantile expansion. The development of a worldwide network of transport routes, spearheaded by the steam-ship and the railway, provided new opportunities for exploration, trade and settlement. Large tracts of land could be traversed by train in hours rather than days. By 1851, more than half the world's shipping was British, while from the 1870s cross-continental communication became possible with the laying of deep-sea cables. Medical advances, such as the widespread use of quinine as an anti-malarial agent, helped to open up Africa to exploration, trade and settlement. In India, where the suppression of the Rebellion of 1857–8 was ultimately to lead to the proclamation of Queen Victoria as Empress of a major slice of the subcontinent, photography was enthusiastically employed as an administrative tool, creating an expanding visual archive of its material culture and racial diversity.

The development of commercial photography directly reflected the fortunes of European expansion, following in the wake of colonial campaigns and establishing studios in the developing metropolitan centres. Early photographic studios in Asia and America in the 1840s–50s had often been short-lived, their owners moving on, or finding other occupations, as limited markets were exhausted. But imperial consolidation, growing populations and commercial growth created a sustainable demand for photography. The 1860s and 1870s, in particular, saw a huge worldwide growth in photographic studios, managed not only by European photographers, but also by local entrepreneurs, catering for both European and indigenous clienteles. Photographers in major centres throughout the world could now rely on a substantial resident market and many studios flourished for decades, supplying portraits and views to residents and a growing number of tourists.

In Europe, many yearned to venture beyond the drawing room and experience travel at first hand. The most immediate commercial response was the development of an organised tourist industry, which brought the possibility of travel, previously restricted to the leisured classes, to an increasingly prosperous bourgeoisie. In 1841, almost contemporaneously with the public announcement of photography, Thomas Cook founded his travel company. By 1855, he was escorting his first group of tourists to continental Europe, and by 1869 to Egypt. In 1872 Cook embarked on his first conducted world tour. Photography played a dynamic role in the development of this industry, both stimulating demand for foreign travel and, in the era before widespread amateur photography, benefiting from its growth through the sale of tourist souvenirs. In such ways photography was tourism's ideal handmaiden.

Daguerrean excursions

French photographers and entrepreneurs quickly grasped the commercial possibilities of the photographic travel book. By the autumn of 1839, the Parisian optician and instrument maker Noël-Marie-Paymal Lerebours was commissioning and purchasing daguerreotype views for this purpose, not only from Europe, but also from as far afield as North America, Russia and the Middle East. Of over 1,000 daguerreotypes, 110 were published between 1841 and 1844 in the first major compilation of photographic travel views, entitled *Excursions daguerriennes. Vues et monuments les plus remarquables du globe.*

Despite its importance, Lerebours's work highlights the principal disadvantage of the unique daguerreotype image as a vehicle for the widespread dissemination of photographic views. Various processes were employed to produce the published prints, including aquatint, lithography and even a few examples of direct printing from etched daguerreotype plates. But the copying and reworking of the originals (including the adding of figures or cloudscapes to a scene) inevitably compromised photography's ambition to present a uniquely accurate and objective record of the physical world.

Unknown Photographer

Moscow, c. 1840

Tinted lithograph after a daguerreotype, 15.5 x 20.9 cm

Noël-Marie-Paymal Lerebours, *Excursions daguerriennes* (2 vols., Paris, 1841–4), vol. 1, plate 51

1899.ccc.18

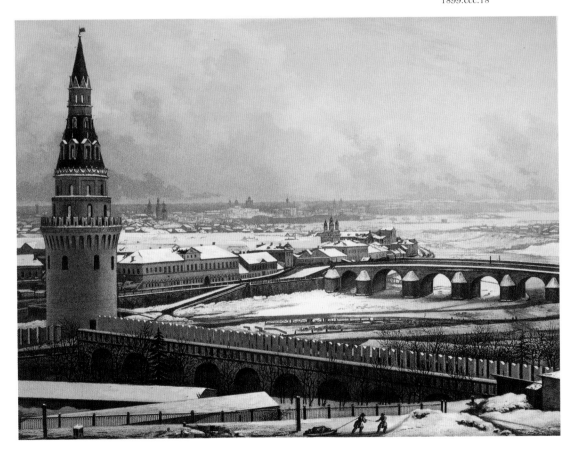

Félix Teynard

Doum palm and mimosa,
Kalabsha, 1851–2

Salted paper print from
a calotype negative,
30.5 x 25.3 cm

Félix Teynard, *Égypte et*
Nubie, (2 vols., Paris, 1858),
vol. 2, plate 120

Cup.652.m.2

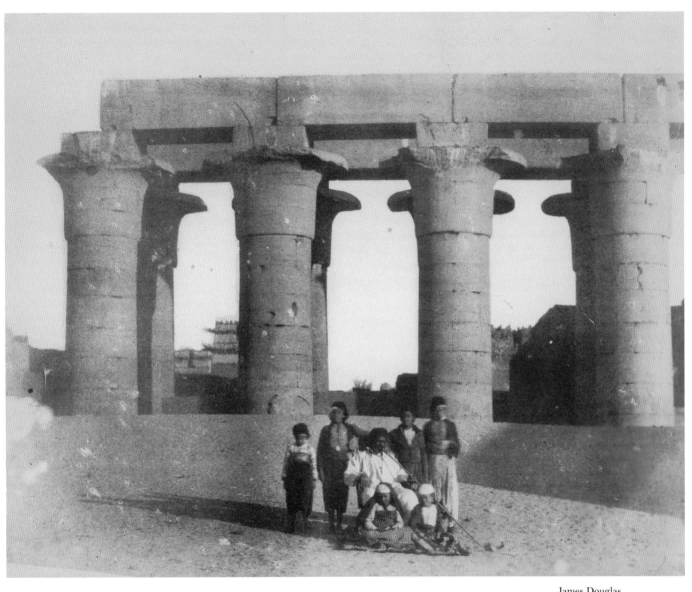

James Douglas

*Mustapha Aga, British
Vice-Consul at Luxor, 1860–1*

Albumen print from a
waxed paper negative,
21.3 x 26.3 cm

James Douglas, *Photographic
views taken in Egypt... during
the winter of 1860–1* (2 vols.,
Quebec, 1862), vol. 1, plate 33

1786.b.33

Francis Frith (1822–98) in Egypt

Following in the footsteps of French photographers like Maxime du Camp and Félix Teynard, the businessman turned photographer Francis Frith became the most commercially successful purveyor of photographic views of the Middle East. Between 1856 and 1860, Frith made three extended journeys through Egypt and the Holy Land, the results of which were published in a series of volumes accompanied by descriptive historical texts. While the publication of photographs in book form was becoming commonplace by the end of the 1850s, *The art journal* in 1858 correctly prophesied that this 'experiment in photography … will pave the way to other publications on a scale not hitherto attempted.'

Frith was deeply religious and his documentation of Egypt and the Holy Land was clearly based on his belief in the evidential value of photography in illustrating the birthplace of Christianity. As *The art journal* noted, 'his subjects in Palestine and Egypt impress us with a consciousness of truth and power which no other art-production could produce.' The most direct examples of this sense were the lavish editions of the Bible, illustrated at appropriate points by Frith's photographs, which appeared in 1862. Piety was, however, accompanied by a hard-headed grasp of commercial opportunity. The same scenes were photographed and published in various formats, from mammoth 20 x 16-inch plates for the luxury market, down to small stereoscopic views, affordable to those of more modest means.

In the years subsequent to his Middle Eastern travels, Frith's studio, firmly hitched to the growth of mass tourism, became one of the largest suppliers of topographical views on a worldwide scale, surviving as a family business until 1960.

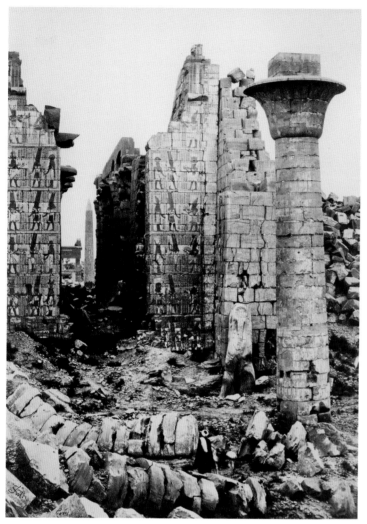

Francis Frith

*The court of Shishak,
Karnak, 1857*

Albumen print,
22.3 x 15.9 cm

Francis Frith, *Lower Egypt,
Thebes and the Pyramids*
(London, [1863]), plate 37

Wf1/4625

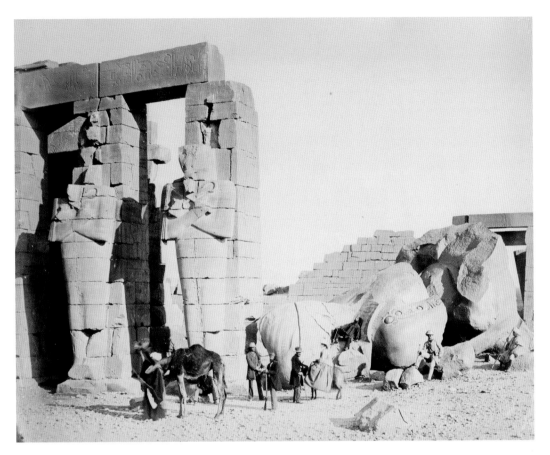

Francis Frith

The Rameseum of El-Kurneh, Thebes. First view, 1857

Albumen print, 38.7 x 48.4 cm

Francis Frith, *Egypt, Sinai and Jerusalem. A series of twenty photographic views* (London, 1860), plate 4

1899.115

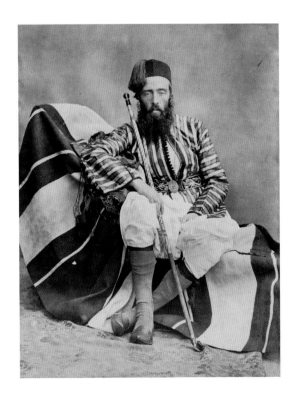

Francis Frith

Turkish summer costume [self-portrait], *1857*

Albumen print, 17.2 x 13.1 cm

Francis Frith, *Egypt, Sinai, and Palestine. Supplementary volume* (London, 1860), title page

Wf1/4620

Charles Clifford

Patio de los Leones, Palacio del Infantado, Guadelajara, Spain, 1856

Albumen print,
34.5 x 27.3 cm

Album of Spanish Views,
plate 91

1704.d.9

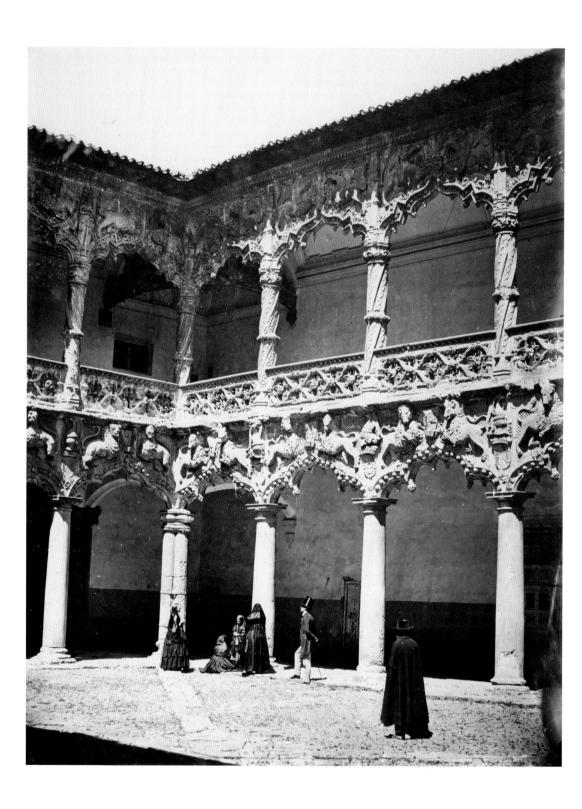

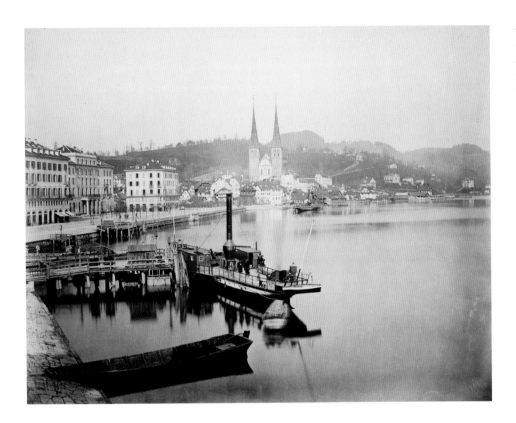

Adolphe Braun

Lucerne, c. 1866

Albumen print,
37.1 x 47.4 cm

Maps 184.s.1 (13b)

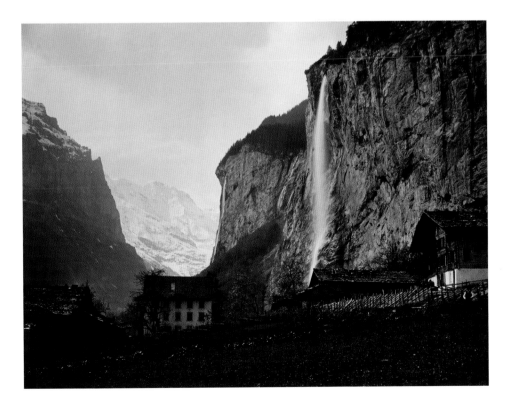

Adolphe Braun

*The Staubbach Falls and
the Lauterbrunnen Valley,
c. 1866*

Carbon print,
36.2 x 47.3 cm

Maps 184.s.1 (11)

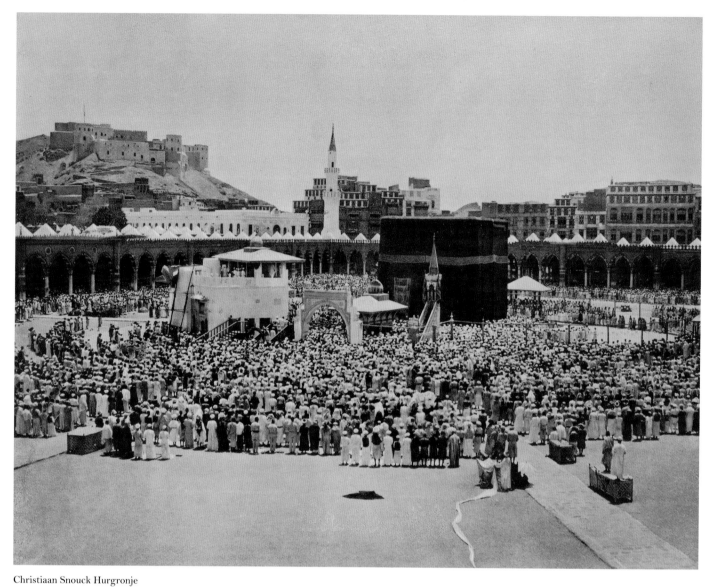

Christiaan Snouck Hurgronje

The Kaaba at Mecca,
Saudi Arabia 1880s

Collotype, 18.5 x 23.8 cm

Christiaan Snouck Hurgronje,
Bilder aus Mekka (Leiden,
1889), plate 1

X.463

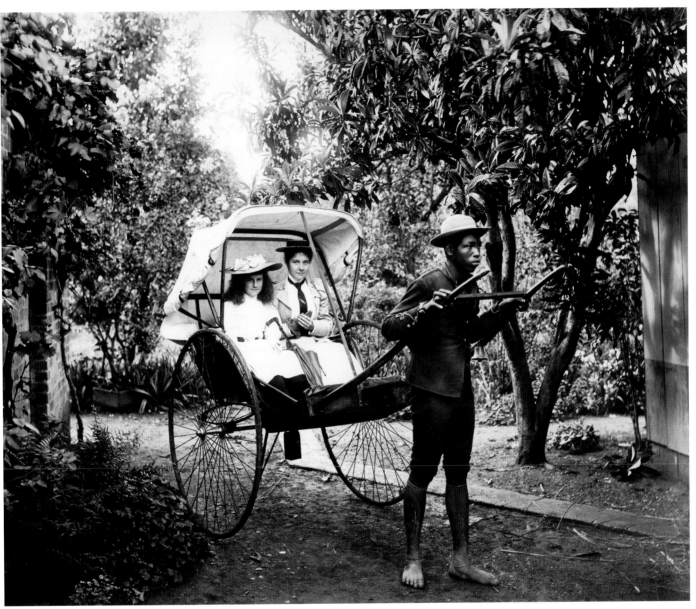

Photographer for George
Washington Wilson

*Jinricksha, Durban, Natal,
South Africa, 1890s*

Albumen print,
23.7 x 28.3 cm

Photo 1153 (20)

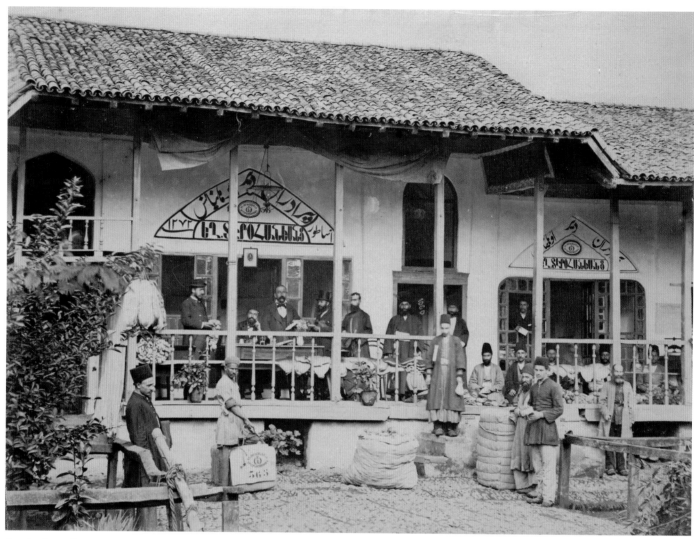

Antoine Sevrugin

Caravanserai at Rasht, Iran,
1890s

Albumen print,
16.7 x 22 cm

Add. 70650A, fol.48

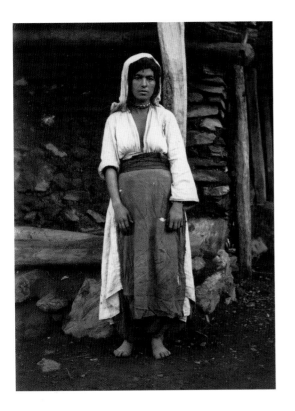

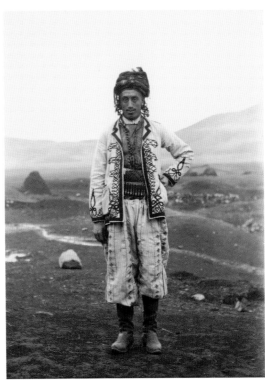

Herbert Finnis Blosse
Lynch

*Young Kurd woman at Gotni,
Mush Plain, Turkey, 1893*

Printing-out paper print,
15.4 x 10.8 cm

Photo 430/7 (17)

Herbert Finnis Blosse
Lynch

*Kurd of Köshk in gala dress,
Turkey, 1893*

Printing-out paper print,
15.3 x 10.8 cm

Photo 430/7 (14)

Herbert Finnis Blosse
Lynch

*Ruins of Arjish on Lake Van,
from the north, Turkey, 1893*

Printing-out paper print,
11.3 x 15.5 cm

Photo 430/7 (16)

Unknown Photographer

Russian couple at Tiflis
[Tbilisi], Georgia, c.1890

Albumen print,
26.4 x 20.6 cm

Mss Eur C313/33 (1)

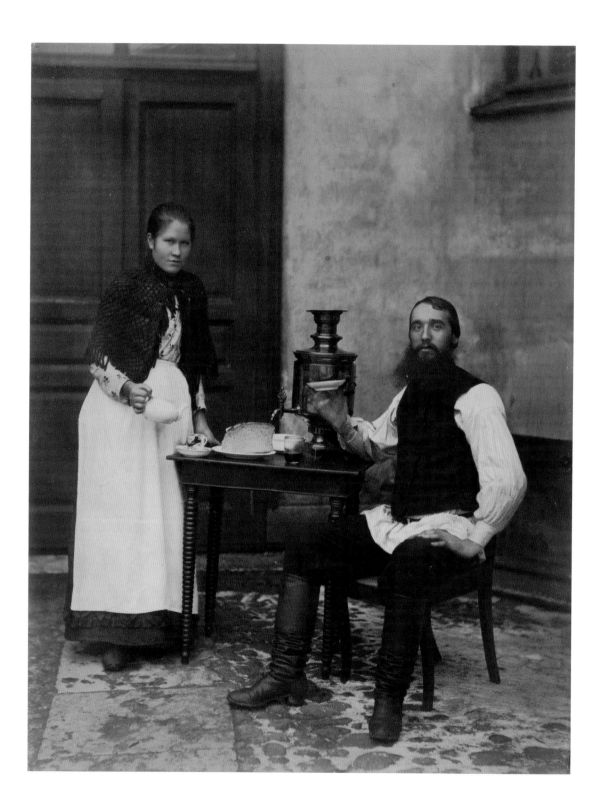

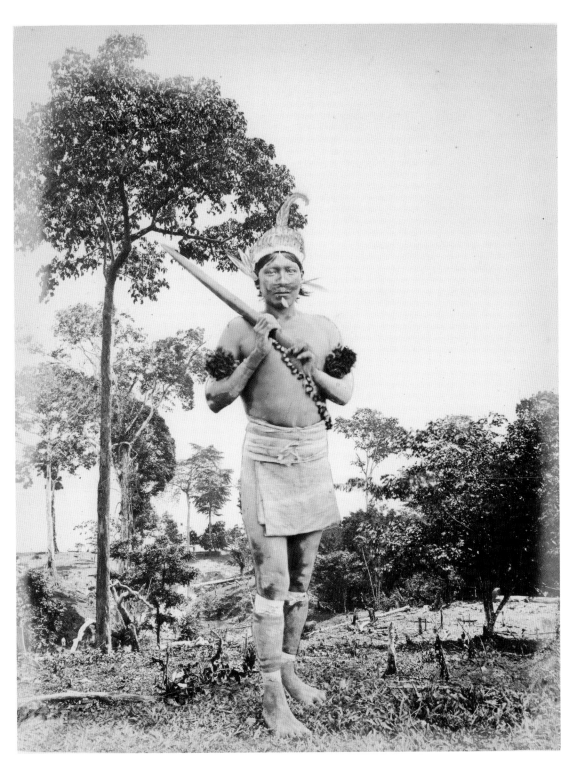

Albert Frisch

Amauas Indian of the Amazon Basin, c. 1865

Albumen print,
23.7 x 18.5 cm

A. Frisch, *Resultat d'une expédition sur le Solimões ou Alto Amazonus et Rio Negro* (Rio de Janeiro, 1869)

1783.cc.20 (print 32)

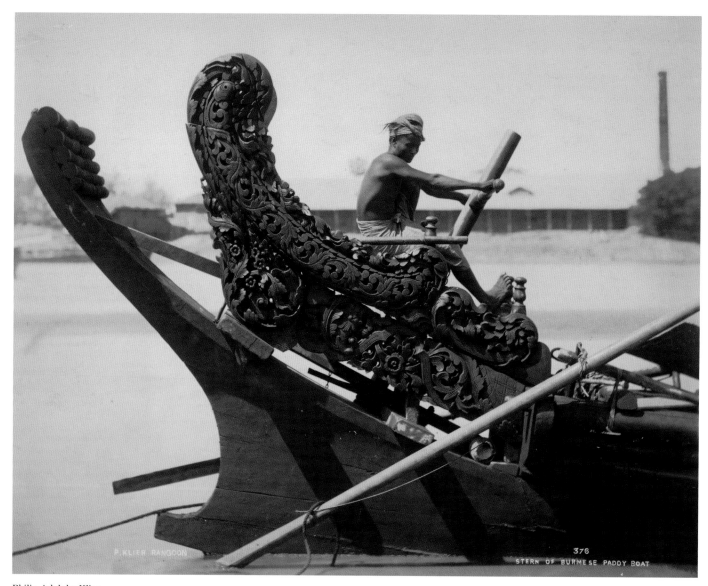

Philip Adolphe Klier

*Stern of a 'laung-zat' or
rice boat, on the Irrawaddy,
Rangoon, Burma, 1880s*

Albumen print,
20.8 x 26.1 cm

Photo 88/1 (24)

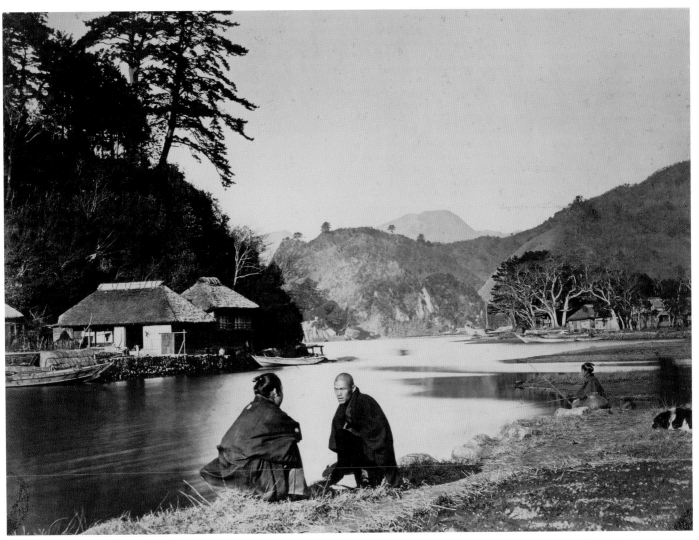

Wilhelm Burger

*Village near Yokohama,
Japan, c. 1869*

Albumen print,
13.4 x 18.3 cm

Maps 8.d.24 (print 45)

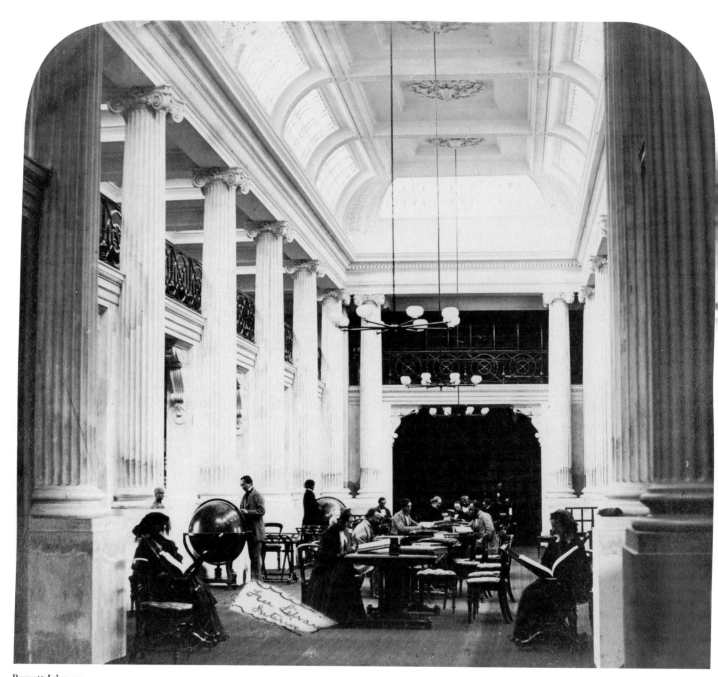

Barnett Johnson

Interior of the Free Library,
Melbourne, Australia, 1859

Albumen print,
16.5 x 18.3 cm

Photo 1145 (3)

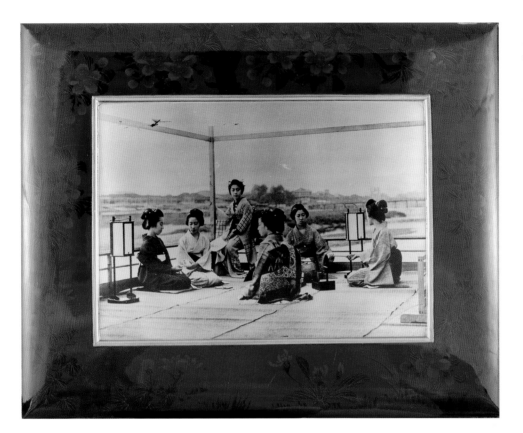

Kohzaburo Tamamura

Album cover, incorporating gold process photograph, c. 1890

Lacquerwork and gold process photograph, 31.5 x 40.5 cm

Photo 1164

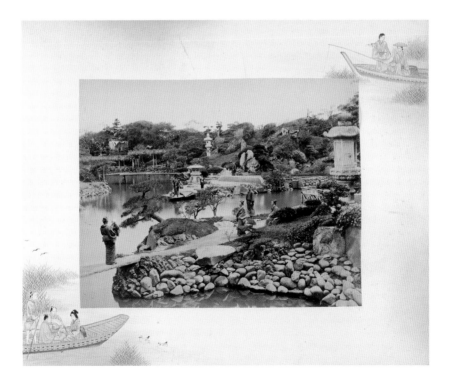

Kazuma Ogawa

The Hotsuta Garden, Tokyo, 1880s

Hand-coloured albumen print, with watercolour vignettes, 19.8 x 25.2 cm

Photo 1164 (1)

John Thomson (1837–1921): pictures and words

During a varied career of travel and photography, the Scottish-born John Thomson managed a succession of studios in Singapore, Hong Kong and London. But his reputation rests primarily in the production of a series of photographically illustrated books of travel and social documentation.

While a journey to Cambodia in 1866 led to the first photographic documentation of the great temple complex of Angkor Wat, his most celebrated work remains the four-volume *Illustrations of China and its people* (1873–4). Illustrated with 200 collotype reproductions and with a descriptive text by the photographer, it was enthusiastically received on its publication as the most thorough visual record to date of the human and physical diversity of the Chinese empire. At the end of the following decade, travels through the newly acquired colony of Cyprus resulted in his final major work of travel photography, the two-volume *Through Cyprus with the camera in the autumn of 1878*, published in the following year.

Thomson's published works display an unusually sophisticated awareness of the photographically illustrated book as more than merely a vehicle to carry pictures. Alert to technological developments, he moved from the use of unstable albumen prints to more integrated processes such as collotype and other photomechanical techniques, as these became more commonly available for book production. Thomson was also a perceptive and able writer who, perhaps more than any of his contemporaries, successfully realised the marriage of text and photograph in the production of illustrated travel books. As well as foreign subjects, his acute eye was also directed nearer home, in his photographic documentation of the London poor (see pages 152 and 157).

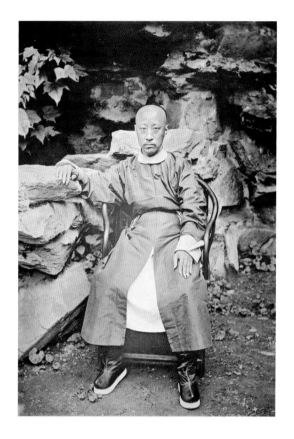

John Thomson

Prince Kung, Peking c. 1870

Collotype, 29.2 x 20 cm

John Thomson, *Illustrations of China and its people* (4 vols., London, 1873–4), vol. 1, plate 1

1787.d.7

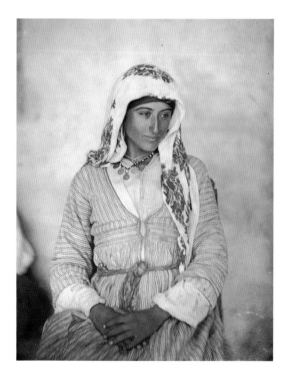

John Thomson

A Cyprian maid, Cyprus, 1878

Woodburytype, 11.3 x 8.6 cm

John Thomson, *Through Cyprus with the camera in the autumn of 1878* (2 vols., London, 1879), vol. 1, plate 8

10076.i.2

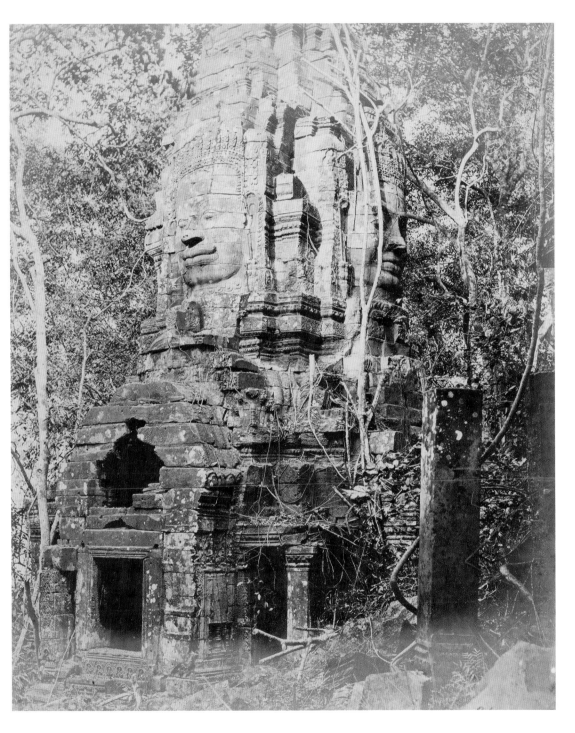

John Thomson

Tower of Prea Sat Ling Poun, Bayon Temple, Angkor Thom, Cambodia, 1866

Albumen print,
25.5 x 20.2 cm

John Thomson, *The antiquities of Cambodia. A series of photographs taken on the spot with letterpress description* (Edinburgh, 1867), plate 15

Photo 983

The imperial gaze: photography in India

While the scarcity of surviving work from India during the first decade of photography suggests that activity was not widespread, later decades present a remarkable contrast. Spearheaded by amateurs who had mastered the use of the paper negative processes in tropical conditions, the 1850s saw a remarkable flowering of work. Much of this was focused on documenting the architectural and archaeological heritage of the subcontinent, a choice of subject inspired by the growth of archaeology as a discipline and by the active support of the East India Company. Dedicated amateurs like Dr John Murray produced magnificent studies of the Mughal

architecture and topography of northern India, while the army officer Linnaeus Tripe was commissioned by the authorities to photograph in the south. The establishment of photographic societies in the mid-1850s reflected and stimulated a growing interest in the medium, at both amateur and professional levels; by the early 1860s, India was seen as a potentially lucrative field for professional activity.

Official interest in photography, first manifested in the field of archaeology, soon expanded to embrace other areas of activity, where its possibilities as a tool of social control were explored. The benefits of

Frederick Fiebig

A gentleman's residence, Madras, 1852

Hand-coloured salted paper print from a calotype negative, 18.1 x 24 cm

Photo 248 (61)

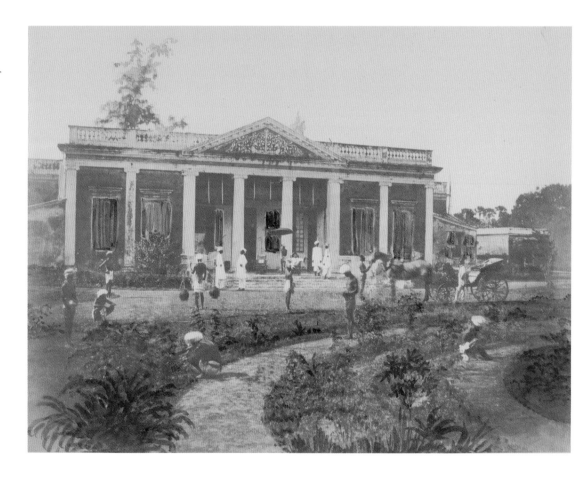

photography for recording India's convict population were widely discussed and intermittently employed, while the creation of a photographic archive of racial types was enthusiastically pursued. The most important result of such government-backed projects was the publication of the eight-volume *The people of India* (1868–75). Ostensibly a scientific visual record of the ethnic variety of the subcontinent, the accompanying texts reveal it to be as much a handbook for identifying the social loyalties and political allegiances of the indigenous population.

Whether taken for commercial sale, personal amusement or documentary record, photography in India, as in other colonial situations, implicitly reinforced a vision of western superiority and progress. Urban development, roads, railways and other civil engineering projects were all presented by the camera as evidence of the benefits of British rule. The propaganda potential of the medium was most fully understood by the Viceroy Lord Curzon, who ensured that at the Delhi Durbar of 1902, itself a skilfully manipulated and theatrical celebration of British rule, a host of photographers were present to document the event for worldwide dissemination.

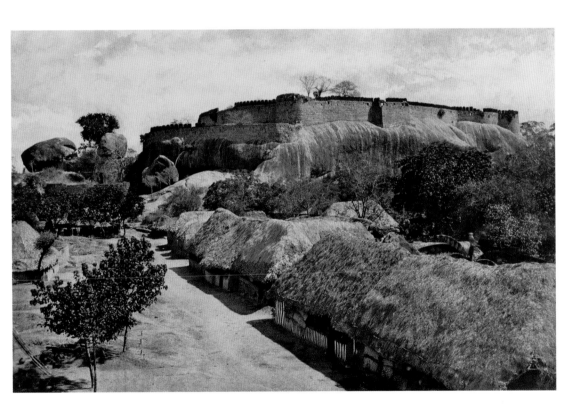

Linnaeus Tripe

View of the hill fort at Trimium from top of the gateway of the outer wall, 1858

Albumen print from a calotype negative, 24.3 x 27.6 cm

Linnaeus Tripe, *Photographic views of Poodoocottah* (Madras, 1858), plate 7

Photo 952 (7)

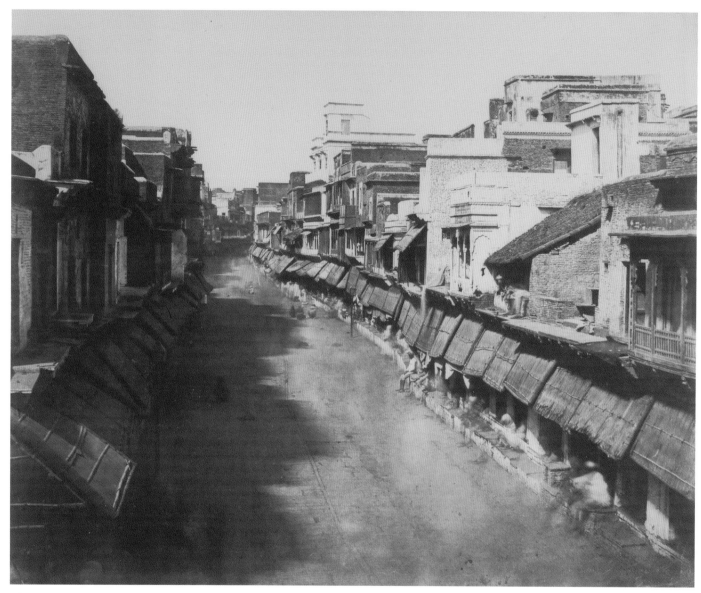

John Murray

The principal street of Agra,
c. 1857

Salted paper print from
a calotype negative,
37.5 x 46.5 cm

Photo 101 (13)

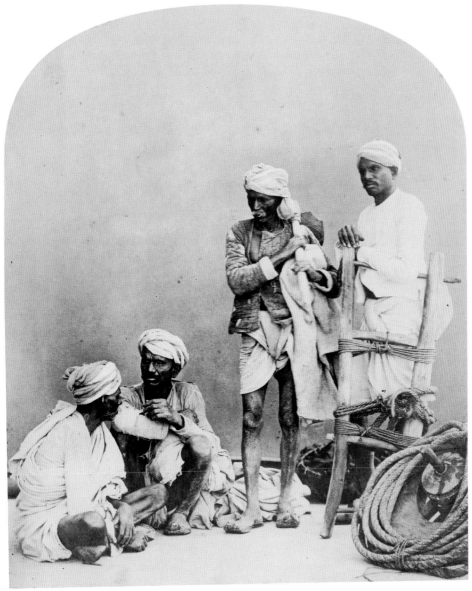

Shepherd & Robertson

Lodhas, low caste Hindu tribe, Rajputana, 1862

Albumen print,
20.4 x 16.7 cm

John Forbes Watson
and John Kaye,
The people of India
(8 vols., London, 1868–75),
vol. 7, plate 352

Photo 972/7

Samuel Bourne (1834–1912) in India

With the consolidation of British rule after the Rebellion of 1857–8, India began to attract an increasing number of professional photographers. Of these, Samuel Bourne (and the firm of Bourne & Shepherd) was undoubtedly the most influential, establishing a successful studio and creating in his work a picturesque vision of the Indian landscape, which was to be assiduously imitated by other photographers for the remainder of the nineteenth century. During his seven-year residence in India between 1863 and 1870, Bourne produced over 2,000 landscape views from all parts of the subcontinent, which continued to be sold well into the twentieth century.

Bourne's most celebrated work was made during three major photographic expeditions to the lower Himalayas between 1863 and 1866, in the course of which he produced a collection of landscape views of unsurpassed technical skill and compositional elegance. Between 1865 and 1870, Bourne published a lengthy series of articles in the *British journal of photography* describing these journeys. These not only bolstered his commercial reputation in India and Europe, but also served as a manifesto, articulating his vision of photography's role in asserting the civilizing role of Christianity and colonial rule.

Samuel Bourne

A 'peep' at the south end of the lake, Naini Tal, c.1867

Albumen print,
23.7 x 29.4 cm

Photo 11 (85)

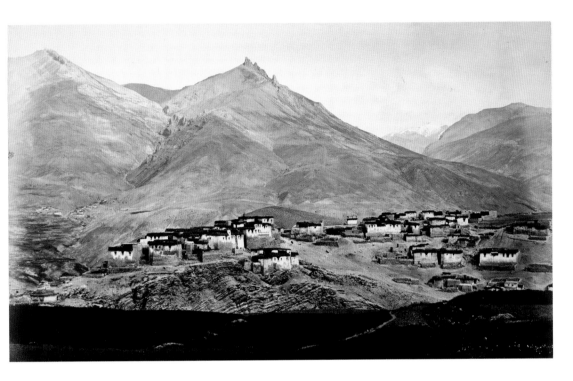

Samuel Bourne

*The village of Kibber,
with Chikim in the distance,
Spiti, 1866*

Albumen print,
19.2 x 31.1 cm

Photo 94/4 (8)

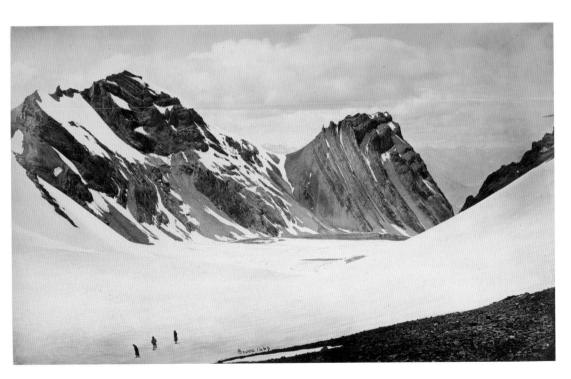

Samuel Bourne

*View at the top of the
Manirung Pass, 18,600 feet,
1866*

Albumen print,
19.3 x 31.8 cm

Photo 125/3 (80)

Unknown photographer

Photographs demonstrating Thugee method of assassination, c. 1871

Albumen prints, each 12.5 x 19 cm

Mss Eur D951/32 (1, 3)

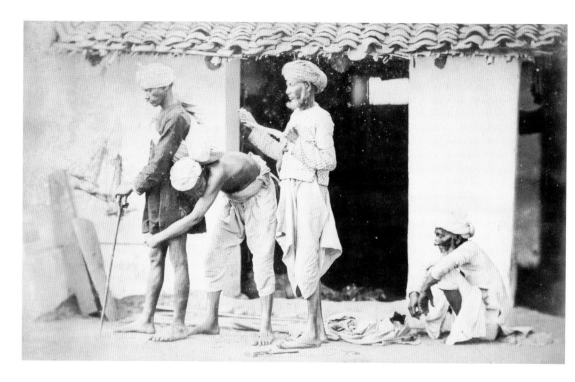

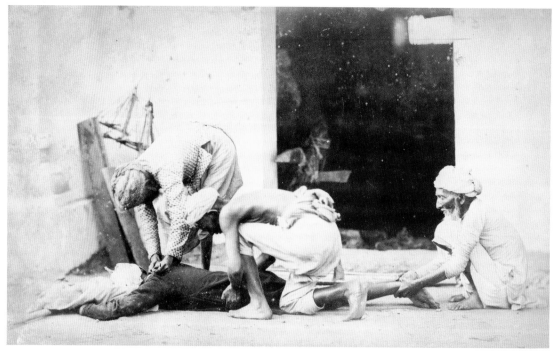

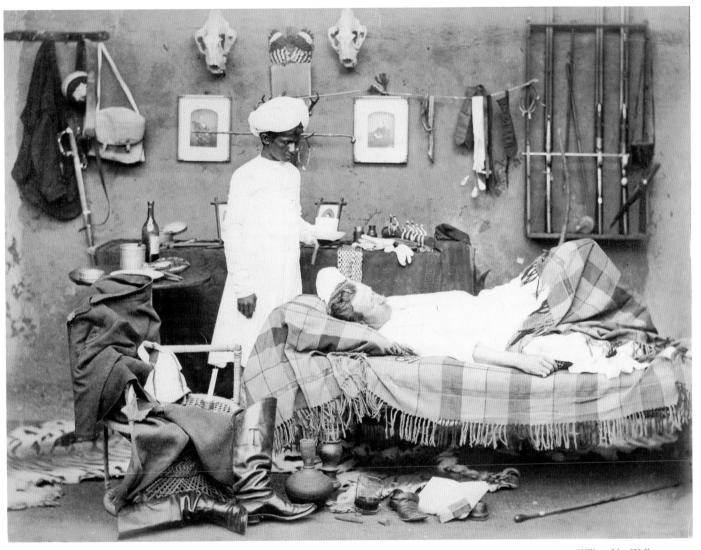

Willoughby Wallace
Hooper

*Indian servant and master,
Madras, 1870s*

Albumen print,
18.1 x 24.2 cm

Photo 447/3 (58)

Bourne & Shepherd

The dais and amphitheatre at the Imperial Assemblage, Delhi, 1 January 1877

Albumen print, 18.4 x 31.6 cm

Photo 430/80 (9)

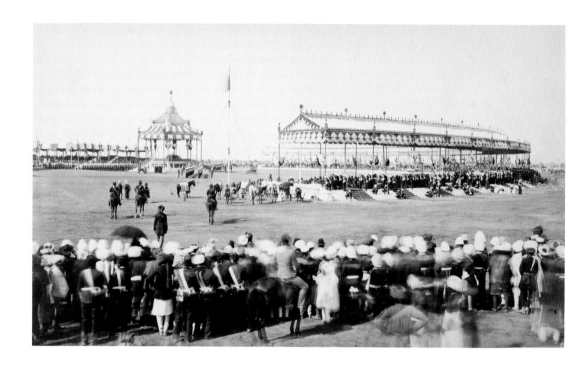

Bourne & Shepherd

Bourne and Shepherd photographers at the Delhi Durbar, 1902–3

Platinum print, 21.4 x 28.8 cm

Photo 440/2 (45)

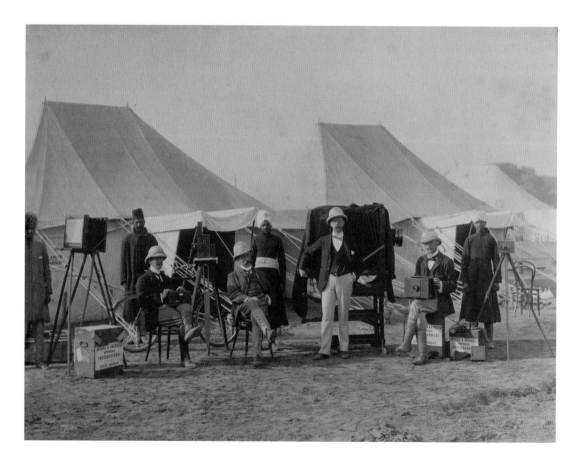

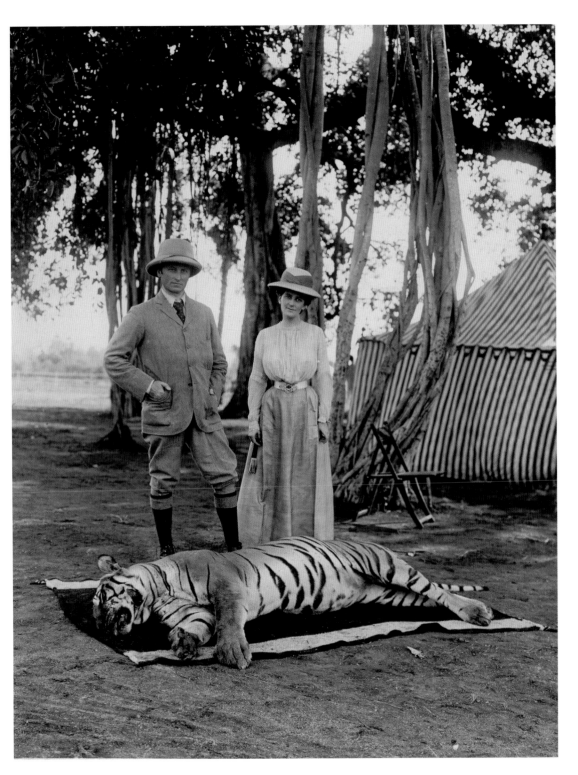

Lala Deen Dayal

The Viceroy Lord Curzon and Lady Curzon tiger hunting in Hyderabad, 1902

Printing-out paper print, 26.2 x 20.8 cm

Photo 556/3 (61)

Adolphe Braun

View from the quay, Naples,
1868

Albumen print,
22.8 x 48.4 cm

Maps 184.q.1 (26b)

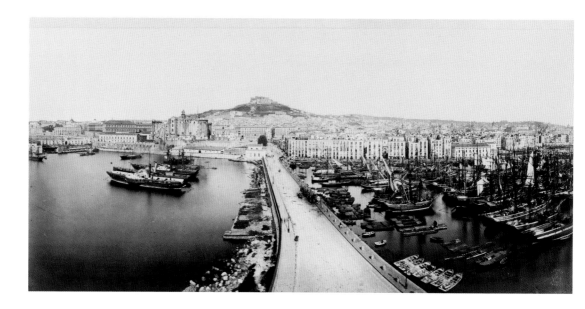

Unknown photographer

Interior of Hagia Sofia,
Istanbul, c. 1870

Albumen prints,
54 x 76.5 cm

Photo 925

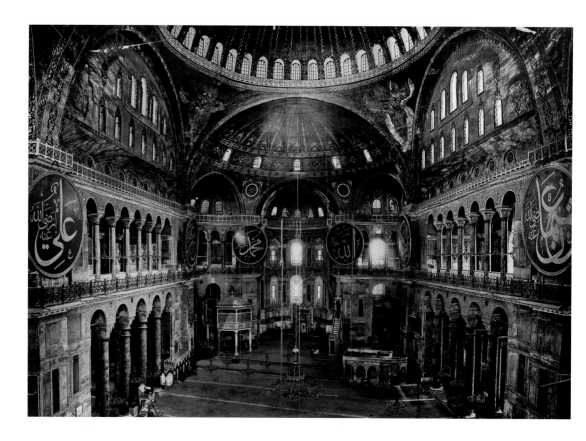

Taking the long view: the photographic panorama

Drawing on the popularity of painted panoramas, photographers employed a number of strategies to circumvent the limitations of the standard photographic view. Indeed, the genre of painted panoramic views is intimately linked with the early history of photography, since Louis Daguerre had an early career as a panorama painter.

Joining two or more adjacent images was the simplest expedient. This straightforward solution remained popular with commercial photographers throughout the nineteenth century, often carried to its ultimate conclusion of creating 360-degree panoptic views of popular or historical topographical locations. A rarer and technically more demanding approach is seen in an anonymous view of Hagia Sofia in Istanbul, where the scale of the massive interior space is re-created in an overlapping jigsaw of images.

An alternative solution lay in cameras specifically designed to incorporate a panoramic perspective. Many ingenious models began to appear from the early 1840s, but few saw widespread commercial use. One exception was Johnson and Harrison's 'pantoscopic' camera. Patented in 1862, the pantoscopic used a clockwork motor to rotate the camera across the field of view, while at the same time the glass plate moved in synchronism past an exposure slot in the back of the camera. This camera was used for the extensive series of views in France, Switzerland and Italy produced by Adolphe Braun in 1868.

The panoramic format took on a new lease of life with the arrival of the Kodak Panoram camera in 1899. Directed towards the amateur user, this swing-lens camera used roll film, and was as portable and easy to use as other Kodak cameras. Several models were released, the most popular being the Kodak Panoram No. 1, introduced in 1901, which took in a view of 120 degrees. Specially designed albums for the Panoram were produced by Kodak, and the camera remained popular throughout the Edwardian period and continued to be manufactured into the 1920s.

Unknown photographer (probably Thomas Higham)

Kodak 'Panoram' album, containing views of Murree, 1900s

Printing-out paper prints, each 9.2 x 30.2 cm

Mss Eur F267/14 (8–9)

3

DOCUMENTING ART

Organised under the enthusiastic patronage of Prince Albert, the Great Exhibition of 1851 constituted an exuberant display of Victorian self-confidence. Revolutionary in the airy design of its buildings and in the ambitious reach of its contents, the Crystal Palace housed a huge diversity of objects from the world of science, industry and the decorative and plastic arts, drawing visitors of all types and classes. It also represented the first international showcase for photography: when, two years later, the formation of a 'Photographical Society' was suggested, the proposal acknowledged that photography 'seems to have advanced at a more rapid pace during and since the exhibition', as enthusiasts from 'all parts of Europe were brought into more immediate and frequent communication'.

A more immediate result was the decision to illustrate the massive four-volume *Reports of the juries* with original photographic prints, giving tangible expression to photography's value as a tool of record. In all, 154 prints were published, illustrating views of the buildings, industrial and agricultural machinery and a significant quantity of sculptural studies. The displays of photography in 1851, and in the many subsequent international exhibitions of the nineteenth century, brought many genres of the medium before the public gaze, significant among them being an introduction to the art productions of the world.

To most modern viewers, many of the vast numbers of photographic reproductions of works of art which were made in the second half of the nineteenth century – produced either for book illustration or for sale as loose prints – are of limited interest. To the Victorians, however, photography's ability to bring moral instruction and the enjoyment of the arts to a wide public formed one of its most important social functions – a continuation of an existing print-selling tradition, but made available to a much broader audience. Indeed, one of the earliest photographically illustrated books, William Stirling's 1848 *Annals of the artists of Spain*, had been just such a work, and they continued to be widely produced in large quantities for the rest of the century. Knowledge of architecture was also disseminated through photographic publications, while from the mid-1850s the expanding field of archaeological investigation quickly assimilated photography as a tool of record and as a means of distributing information to both a scholarly and a general audience.

While a good many of these productions are indeed primarily of academic interest, in the hands of the finest photographers, such studies became works of art in their own right. Charles Clifford's inventory of pieces in the Royal Armoury in Madrid is transformed by skilful lighting and composition into an elegant series of still lifes. And while Ludwig Belitski's huge commission to photograph the collections of Baron Alexander von Minutoli had the entirely practical aim of making examples of various types of artefact available to craftsmen, the images themselves – particularly the wonderfully delicate studies of glassware – entirely transcend their original purpose. In the days before colour photography, the most advanced printing technology was also used to illustrate *objets d'art*. The astonishingly realistic photochrome reproductions of metals, jewellery and ceramics in the Louvre, produced by Léon Vidal for *Le Trésor artistique de la France* (1880), remain unsurpassed.

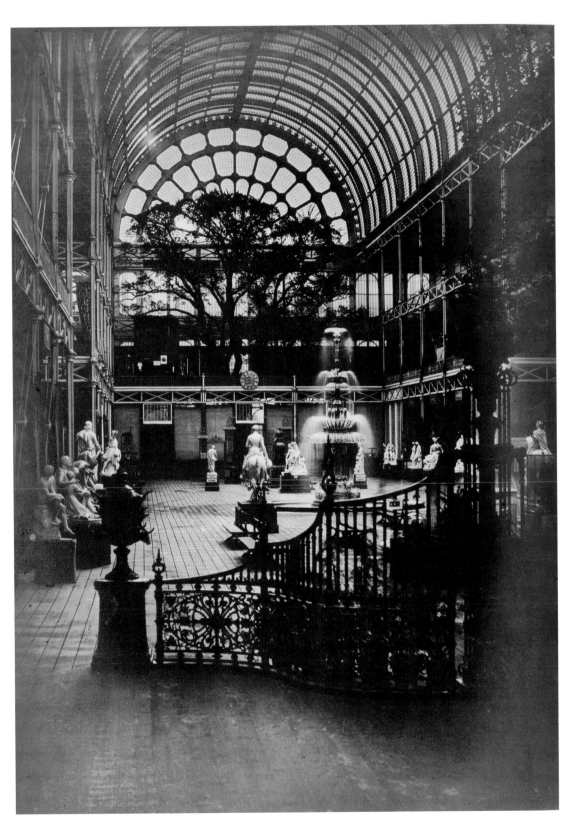

Claude-Marie Ferrier

View of transept, looking south, Great Exhibition, 1851

Salted paper print from a glass negative, 21.1 x 15.6 cm

Reports of the Juries (4 vols., London, 1852), vol. 2, p. 763.

X.1067

Claude-Marie Ferrier

*Agricultural implements at
the Great Exhibition, 1851*

Salted paper print from
a glass negative,
15.5 x 21 cm

Reports of the Juries,
(4 vols., London, 1852),
vol. 2, p. 501

X.1067

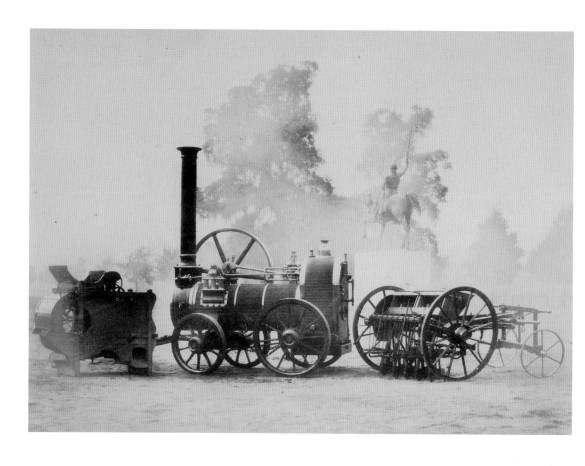

Claude-Marie Ferrier

*Philosophical instruments at
the Great Exhibition, 1851*

Salted paper print from
a glass negative,
17.8 x 14.9 cm

Reports of the Juries
(4 vols., London, 1852),
vol. 2, p. 567

X.1067

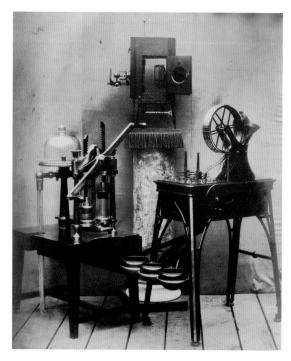

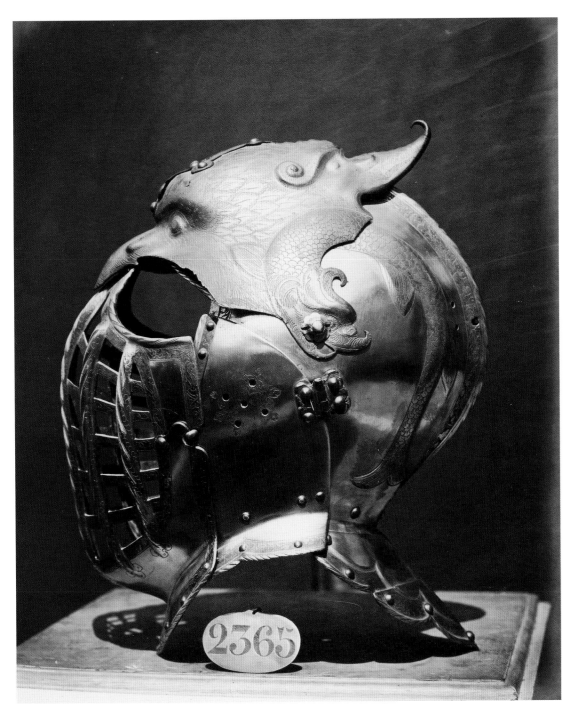

Charles Clifford

*Helmet of the Emperor
Charles V, in the Royal
Armoury, Madrid, c.1862*

Albumen print,
30.9 x 26 cm

*Photographs from the
collection of the Royal
Armoury, Madrid,* plate 58

1704.a.15

Leonida Caldesi

*Western end of the
Hellenic Gallery of the
British Museum, c. 1873*

Albumen print,
27.8 x 36 cm

Leonida Caldesi,
*Photographs ... of ancient
marbles, bronzes, terracottas,
etc ... in the British Museum*
(2 vols., London, 1873–4),
Miscellaneous series, no. 11

1704.d.10

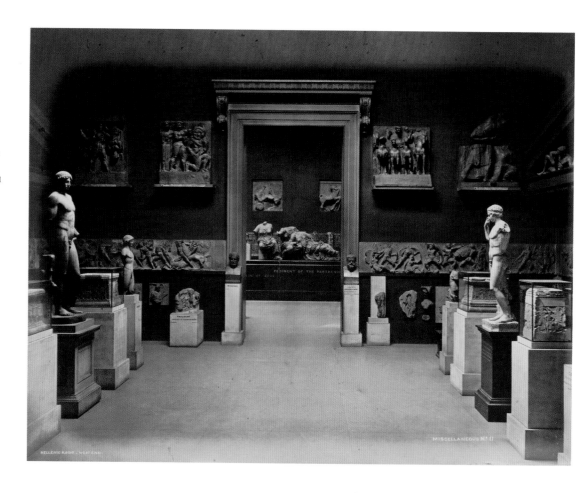

Leonida Caldesi

*Sculptured head of a horse
from the chariot of Selene
on the east pediment of the
Parthenon, c. 1873*

Albumen print,
26.4 x 36.1 cm

Leonida Caldesi, *Photographs
... of ancient marbles, bronzes,
terracottas, etc ... in the
British Museum* (2 volumes,
London, 1873–74),
Parthenon series, no. 15

1704.d.10

Ludwig Belitski

Engraved crystal glassware from a Venetian workshop, c. 1856

Albumenised salted paper print, 17.3 x 20.1 cm

Baron Alexander von Minutoli, *Vorbilder für Handwerker und Fabrikanten aus den Sammlungen des Minutolischen Insituts* (8 vols., Liegnitz [Legnica], 1855), vol. 2, plate 19

1800.b.15

Léon Vidal

Ewer of Charles V in the Louvre, c. 1880

Photochrome print, 25.8 x 19.7 cm

Charles Dalloz, *Le Trésor artistique de la France* (2 vols., Paris, 1880), vol. 1, plate 6,

Tab.1283.a.1

Médéric Mieusement

*The Orléans Courtyard,
Château of Chambord,
c.1868*

Albumen print,
36.2 x 24 cm

Auguste Millot, *Les Grands
Édifices de la Renaissance.
Le Château de Chambord*
(Paris, 1868), plate 9

1782.d.18

Hermann Emden

South side of the nave of Mainz Cathedral, c.1858

Salted paper print, 20.2 x 14.3 cm

Hermann Emden, *Der Dom zu Mainz* (Mainz, 1858), plate 3

1264.ee.16

Pierre Ambroise
Richebourg

*Portico of St Isaac's
Cathedral, with a distant
view of the Admiralty,
St Petersburg, 1859*

Albumen print,
32.6 x 31.1 cm

Théophile Gautier, *Trésors
d'art de la Russie ancienne
et moderne* (Paris, 1859),
plate 4

N. Tab.2006/9

Corporal J. McCartney R.E.
View of the colossal lion at
Cnidus, after being raised,
with Corporal Jenkins R.E.
and Charles Newton, 1858

Albumen print,
23.9 x 28.7 cm

Add. 31980 fol.196

Ordnance Survey
photographer

*Trilithons B and C from
the south-west, Stonehenge,
c. 1867*

Albumen print,
22.8 x 18.5 cm

Sir Henry James, *Plans and
photographs of Stonehenge
and Turusachan in the Island
of Lewis* (Southampton,
1867), plate 6

10351.i.2

Isidore van Kinsbergen

Deification stele with figure of Harihara, in the Residency Garden, Kediri, East Java, 1866–7

Albumen print, 26.2 x 22.2 cm

Isidore van Kinsbergen, *Oudheden van Java* (Batavia [Jakarta,], 1867), plate 211

Photo 184 (211)

Désiré Charnay

*Great Hall of the Palace
at Mitla, Mexico,
February 1860*

Albumen print,
27 x 40.4 cm

Eugène Viollet-le-Duc,
Cités et ruines américaines
(Paris, 1862), plate 10

14000.k.4

4

THE PORTRAIT

For the general public in Europe and America, portraiture was immediately seized upon as photography's most seductive application, soon replacing the more expensive painted miniature. The commercial possibilities of the medium quickly attracted entrepreneurs. The former coal merchant Richard Beard negotiated exclusive rights for the daguerreotype in England, establishing the first portrait studio in London in early 1841 and subsequently licensing several provincial studios.

In these early years, having one's portrait taken could be a distinctly uncomfortable experience, often likened to a visit to the dentist and the subject of much contemporary satire. Studios were generally located at the top of buildings,

in order to maximize the amount of light they received. Even so, exposures lasted many seconds and the sitter, having climbed the stairs, would be required to remain immobile during this time, his or her head supported by a headrest. Who could wonder that the end results, much to the disappointment of many customers, seemed stiff and forbidding?

But by the end of the 1850s, marketing and technical developments had raised the production of photographic portraits to industrial proportions, with studios in every major city and large town. The profession attracted individuals from a wide diversity of backgrounds, including portrait and miniature painters, put out of work by the new technology. Outside the studio, photography became available at a local level through itinerant photographers, who travelled the countryside, setting up in local fairs, market squares and seaside resorts. The market was further stimulated by a seemingly endless stream of innovations and crazes, from photographic jewellery to the *carte de visite*.

Photographic portraiture rapidly percolated through the social scale as new formats and processes were introduced, such as the collodion positive or ambrotype, which imitated the daguerreotype in both appearance and presentation, but was both quicker and cheaper to produce. In the studio, the ingenious and theatrical use of props such as columns, plants and furniture played an important role in composition. Painted backdrops, often incorporating classical statuary and columns, supported an iconographical fantasy of social aspiration, suggesting a leisured and wealthy lifestyle. By such means, the popularity of portraiture reflected wider social and cultural trends, seeking to fix in a photographic image the unstable social identities created by mass population shifts into urban areas.

Nor was portraiture restricted to securing the image of oneself or one's loved ones. From the mid-1850s until the end of the century a flourishing market in celebrity portraits was created by astute photographers. The market was flooded with portraits of royalty, aristocracy, politicians, military heroes and artists – models of probity, heroism and enterprise, whose image served to emphasise social cohesion, bolster national pride and offer an inspirational role model to all levels of society.

'Cartomania'

Patented by the French photographer André Disdéri in 1854, the *carte de visite* made a sensational entrance onto the photographic stage, transforming the portrait market into an industry based on economies of scale. Instead of a large single image, the *carte de visite* portrait was taken with a multi-lensed camera, generally producing eight small portraits, which were then cut up and pasted onto individual card mounts of a similar size to a visiting card. The special cameras required soon found their way from fashionable to more modest studios, thereby making cheap portraits available to all levels of society. Likenesses of celebrities were bought as enthusiastically as personal portraits. In England their popularity was hugely stimulated from 1860, when Queen Victoria – herself an avid collector – permitted the sale of royal portraits. Between 1861 and 1867, it has been estimated that over 300 million cartes were produced every year. Specially designed albums were widely sold, their contents often arranged to reflect the prevailing social hierarchy, beginning with portraits of the royal family and, in the words of *The art journal* in 1861, 'enshrining our Sovereign and her family in the homes of her people'.

By the end of the 1860s their popularity was waning, the demise of the format signalled by the introduction of the larger cabinet portrait in 1866, which retained its popularity until the early twentieth century.

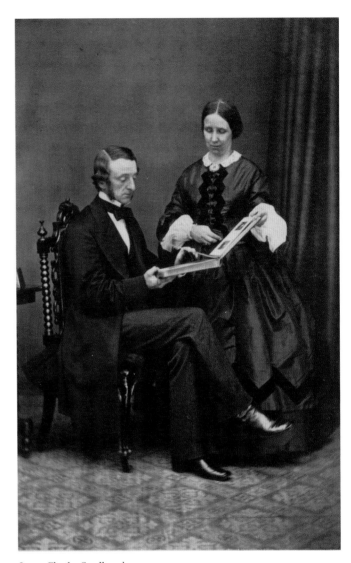

James Charles Smallcombe

Carte de visite portrait of Dr and Mrs Forbes examining a portrait album, c. 1864

Albumen print, 9.1 x 5.8 cm

Photo 1016/1 (149)

Lady Alice Mary Kerr

Portrait of Wilfrid Scawen Blunt, c.1865

Albumen print,
19.7 x 14.3 cm

Add. 54085B fol.14

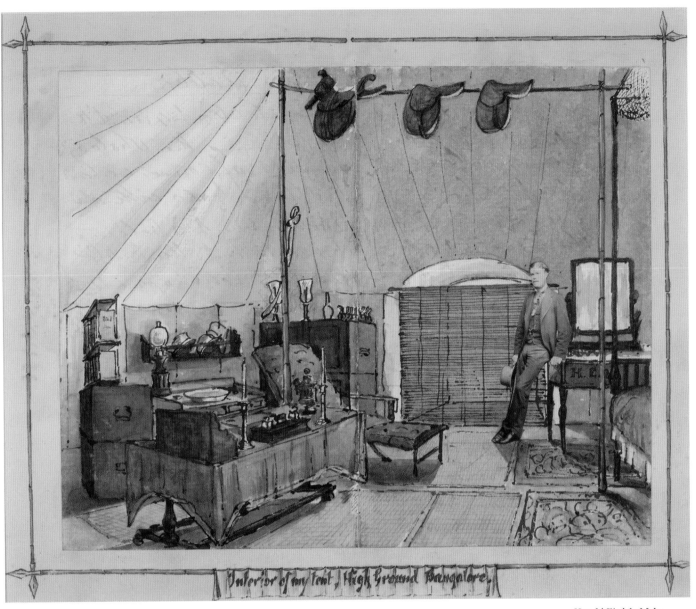

Interior of my tent, High Ground Bangalore

Harold Eisdale Malet

Interior of my tent, High Ground, Bangalore, 1863–8

Albumen print and watercolour collage, 17.8 x 22.7 cm

WD 4394

Unknown photographer

*Portrait of an unidentified
young woman, 1860s*

Ambrotype, 5.4 cm x 4.2 cm

Mss Eur E267/204 (4)

Unknown photographer

*Locket portrait of an
unidentified woman, 1860s*

Albumen print, 2.3 x 2 cm

Mss Eur E267/204 (5)

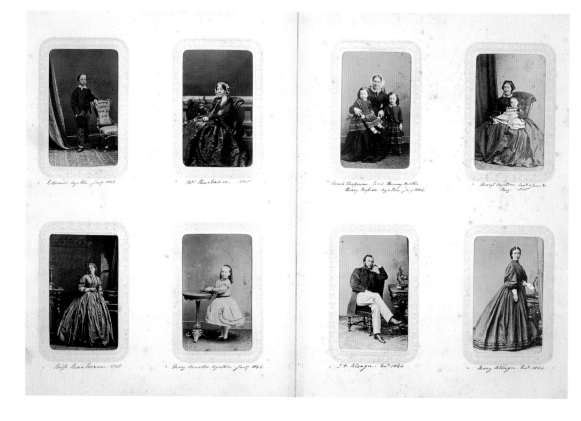

Various photographers

*Carte de visite portrait album
of the Ayrton family, 1864–5*

Albumen prints, open
volume 30.5 x 45 cm

Add. 52357, fol.1v–2r

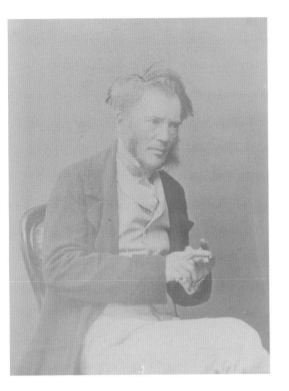 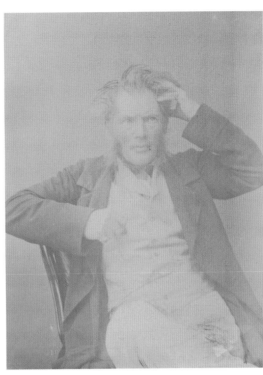

Richard Cockle Lucas

Four self-portraits: the idea conceived; an earnest attempt to comprehend; the doubts begin to dissipate; understood, 1859

Albumen prints, each 19 x 14.5 cm

R.C. Lucas, *Photographic studies. A collection of photographic portraits, landscapes, groups, etc* [c.1859]

Tab.442.a.13 (prints 85–88)

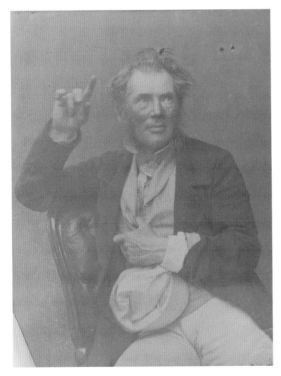 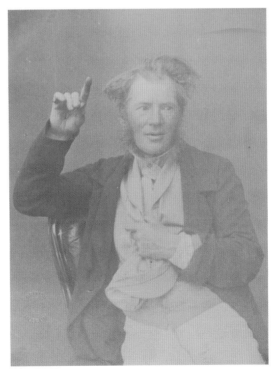

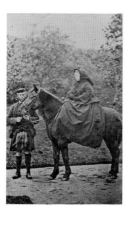 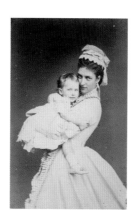 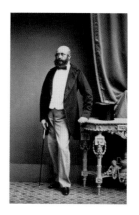 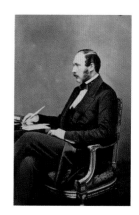

The *carte de visite* portrait: George Washington Wilson, *Queen Victoria and John Brown, 1863* (Photo 1016/1 (2));
James Russell and Sons, *Princess Alexandra, with Princess Louise c. 1868* (Add. 71934 (19)); Maull and Polyblank,
The Duke of Cambridge, c. 1862 (Add. 71934 (73)); John Jabez Edwin Mayall, *Prince Albert, c. 1860* (Add. 71934 (46));
Maull and Co., *Lord Napier of Magdala, c. 1870* (Photo 1016/1 (167)); W. and D. Downey, *Lord Gladstone, c. 1870*
(Add. 71934 (13)); Maull and Polyblank, *Giuseppe Garibaldi, 1864* (Add. 71934 (7)); Camille Silvy, *Emperor Maximilian I
of Mexico, c. 1864* (Add. 71934 (58)); Unknown Photographer, *Alfred Lord Tennyson,* 1880s (Add. 71934 (42));
Henry Hering, *The cellist Alfredo Piatti, c. 1862* (Add. 71934 (63)); Unknown photographer, *Algernon Charles Swinburne,
1870s* (Add. 71934 (48)); Barraud, *Ellen Terry, c. 1880* (Add. 71934 (22)).

Albumen prints, each about 9 x 5.8 cm

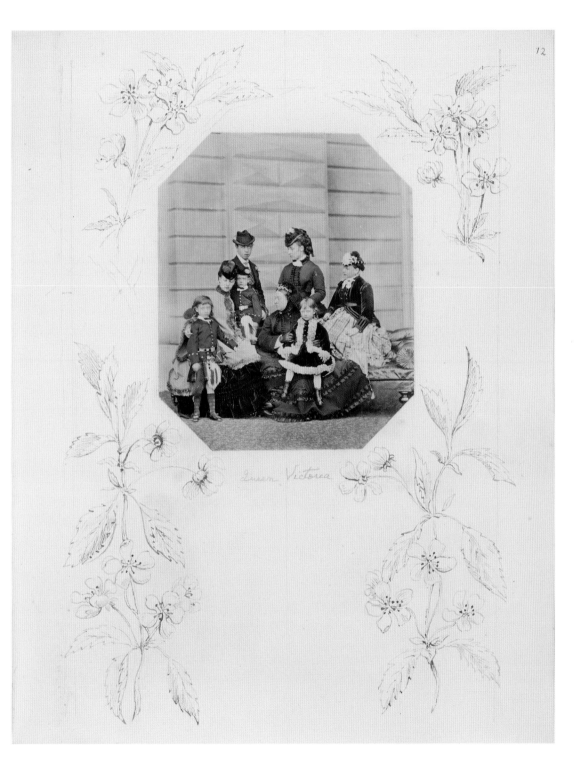

Jabez Hughes

Queen Victoria and family group, Osborne House, Isle of Wight, April 1870

Albumen print, 11.3 x 9.4 cm

Add. 60751 fol.12

Roussie-Khan

Portrait of a Bakhtiari Chief,
Iran, c. 1900

Gelatin silver print,
21.9 x 15 cm

Add. 70650A fol. 379

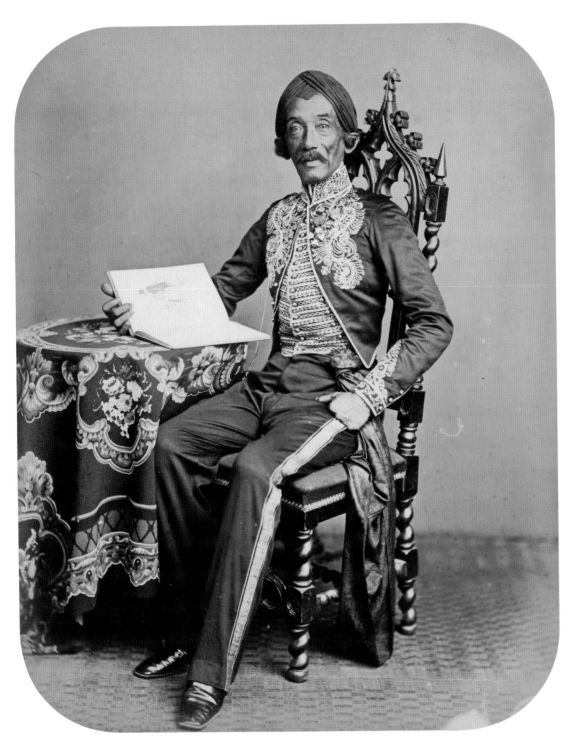

Woodbury and Page

Portrait of the artist Raden Saleh, Java, c. 1870

Albumen print,
22.9 x 17.6 cm

Photo 1183 (10)

The cult of celebrity

The use of photography to market images of the famous to the general public is almost as old as photography itself, and from the mid-1850s it formed a significant portion of the income of many of the major portrait studios. The public appetite was spurred on from the mid-nineteenth century by faster communications, the growth of the newspaper industry and increased literacy. As people became more able both to afford and to read newspapers, the demand for portraits of famous and newsworthy figures grew. Responding to this lucrative market, photographers displayed images of celebrities in their studios and showrooms, in some cases paying their sitters and offering a share in the profits from sales. In addition to payment, such arrangements allowed the famous to exercise a measure of control over the presentation of their public image. Charles Dickens, for instance, sat for the Watkins studio on several occasions and was able to select which portraits of himself were released for public sale. Published collections or 'galleries' of portraits of the eminent in various fields – particularly popular in England and France – also appeared throughout the second half of the century, most often sold in parts and accompanied by biographical notes. Some of the most popular photographers concentrated on particular sectors of society, André Disdéri becoming noted for his portraits of Parisian society, while in New York Napoleon Sarony was associated with theatrical portraiture from the mid-1860s.

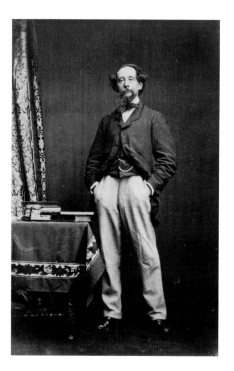

Watkins Studio

Carte de visite portraits of Charles Dickens, 1861

Albumen prints, each 9.2 cm x 5.8 cm

Dexter Collection, vol. 3, part 2, 126

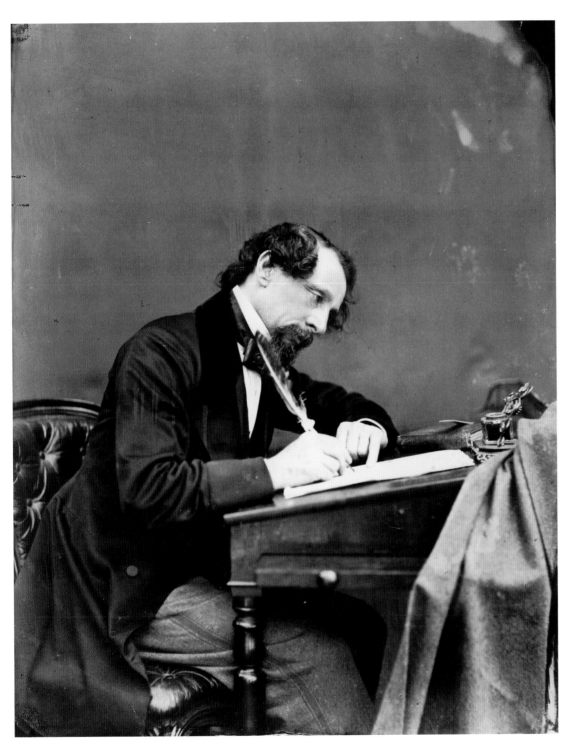

Watkins Studio

Portrait of Charles Dickens,
1861

Albumen print,
20 x 16 cm

Dexter Collection, vol. 3,
part 2, 129

Napoleon Sarony

Portrait of Oscar Wilde,
New York, 1882

Gelatin silver print,
32.3 x 22.8 cm

Add. 81785 (1b)

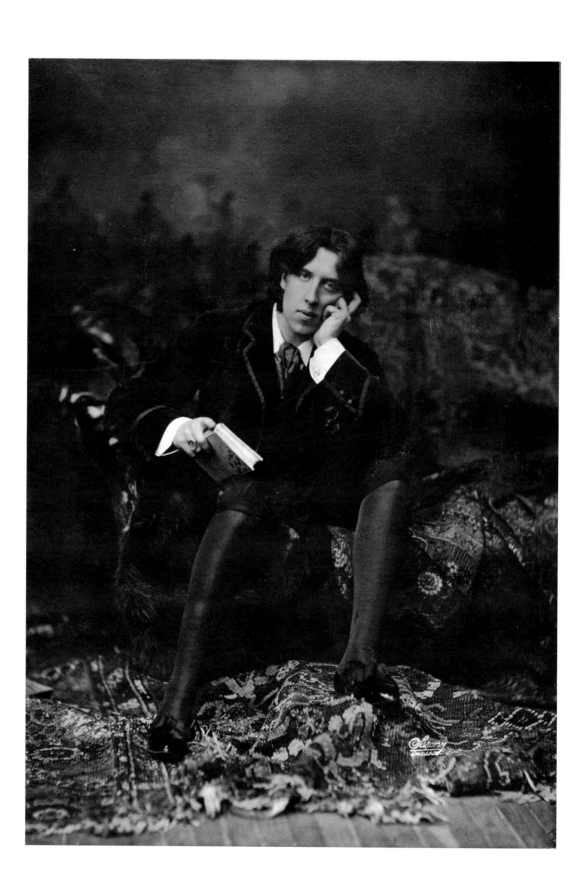

George Bernard Shaw and photography

Among the playwright George Bernard Shaw's many interests, photography was an abiding passion. He not only practised it as a keen amateur, but also wrote extensively about the medium, vigorously defending its status as an art form. In the field of portraiture, in particular, he argued that the camera was uniquely positioned to capture both fleeting physical gestures and the protean nature of human personality, writing that while the painter 'can give you only one version … the camera, with one sitter, will give you authentic portraits of at least six apparently different persons and characters.' Shaw was an enthusiastic collaborator in the photographic process itself and was portrayed by many of the most prominent portrait photographers of the early twentieth century. His friend, the bookseller turned photographer Frederick Henry Evans, whom Shaw praised as an artist working at the 'extreme margin of photographic subtlety', photographed him on several occasions, presenting the results in the characteristically muted tones of the platinum print, of which he was an acknowledged master.

Frederick Henry Evans

Three portraits of George Bernard Shaw, 1900–1

Platinum prints, each about 23.5 x 9.5 cm

Add. 50582 (4–6)

Étienne Carjat

Charles Baudelaire, c. 1862

Carbon print,
23.1 x 18.3 cm

Gaston Schéfer, *Galerie
contemporaine littéraire,
artistique* (Paris, 1876–84),
vol. 3, part 1

P.P.1931.peg

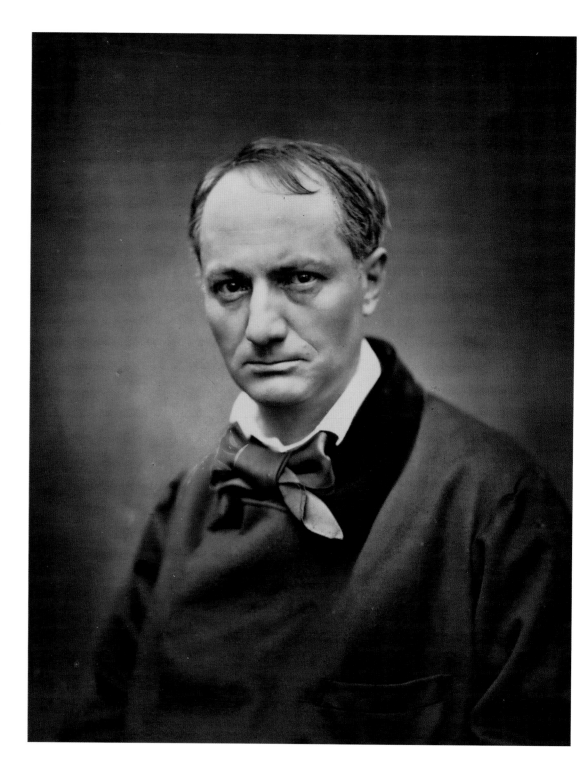

Mayall and Co.

The actress Mrs Patrick Campbell, 1893

Carbon print,
24.8 x 18.3 cm

Charles Eglinton (ed.),
Men and women of the day
(London, 1890–3), vol. 6,
1893, plate 23

10804.i.3

Portraits from the other side

Spiritualism was popular through much of the mid- to late Victorian era. From the late 1860s, the supposed 'truth' of the photograph was swiftly appropriated by mediums to demonstrate the reality of contact with the spirit world. Despite numerous attempts – and several court cases – to expose the fraudulence of these photographs, they continued to be produced in substantial numbers until well into the twentieth century. In England in particular, the carnage of the First World War led to a revival of interest. Among the most productive of the spirit photographers of the early twentieth century was Ada Emma Deane, who produced close to 2,000 spirit photographs during her career. Despite the amateurish nature of many of these clearly manipulated images, their practitioners attracted powerful supporters, among them the writer Arthur Conan Doyle, who remained one of Deane's staunchest defenders. Perhaps her most famous and controversial photographs were those purporting to show the presence of dead soldiers at the Armistice Day commemoration in Whitehall.

Ada Emma Deane

Photographs taken before and during the two minutes' silence at the Cenotaph, Whitehall, London, 1922

Gelatin silver prints, each 7.5 x 9.9 cm

Cup.407.a.1 (232)

Unknown photographer

Ada Emma Deane, spirit photographer, with camera and extra, c. 1922

Gelatin silver print, 9.8 x 7.4 cm

Cup.407.a.1 (139)

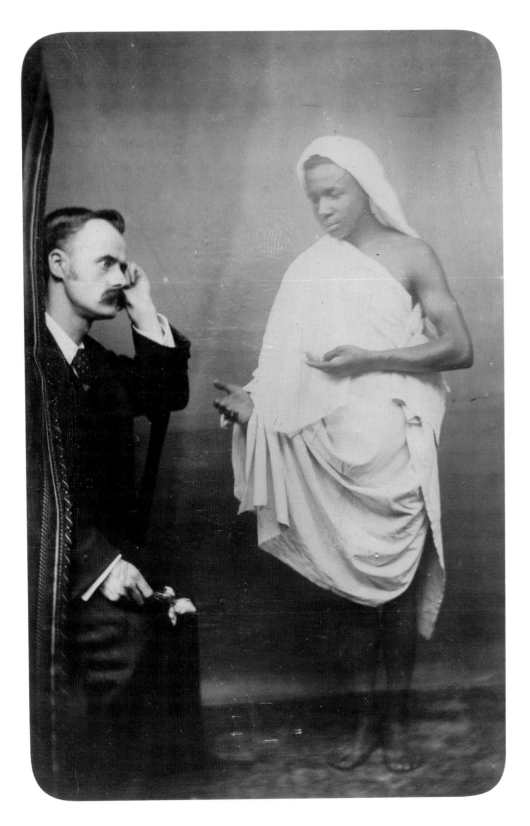

Richard Boursnell

Mr John Dewar of Glasgow with Indian spirit, 1896

Albumen print,
12.9 x 8.4 cm

Cup.407.a.1, supplementary
volume (51)

5
IN THE NAME
OF SCIENCE

The Victorian obsession for ordering the world permeated almost every aspect of scientific, political and sociological endeavour. Photography was only one of the tools which emerged in the nineteenth century, through which scientists attempted to codify and describe universal laws and to document the physical world, from microscopic organisms to astronomical bodies. But it rapidly became an indispensable assistant to existing and new scientific disciplines from geology and biology, to chemistry, physics and medicine.

The amateur and personal enthusiasms of antiquarian research were inadequate to organise the seemingly unmanageable explosion of knowledge and data emerging from all corners of the globe. Photography seemed to offer a powerful objective tool of description and analysis. Henry Talbot emphasized the scientific as well as the artistic uses to which photography might be applied and both he and the early daguerreotypists used photography to reveal the wonders of the microscope. The botanist Anna Atkins demonstrated photography's convenience for amassing a rich archive of specimens in her cyanotype photograms of marine plants. Created over a ten-year period between

1843 and 1853, her privately published *Photographs of British algae: cyanotype impressions* contains nearly 450 examples, although these are now more valued perhaps for their abstract elegance than their scientific usefulness.

In medicine, photography was seen by the 1860s as an indispensable tool for diagnostic illustration, anatomical training and research. The supposed manifestation of mental states through an individual's physical expressions and demeanour were examined and analysed by investigators such as Guillaume Duchenne de Boulogne and others. In the last decade of the century, Wilhelm Röntgen's discovery of X-rays brought a new dimension of hitherto invisible structures into photographic visibility. While a risky craze in amateur X-ray photography soon subsided, what was to become a tool of immense practical utility also revealed a world of startling beauty.

Experimental projects for photographing prison inmates had been intermittently undertaken in many European countries since the 1840s, but only became widely standardised in the early 1880s. In 1883, the French police official Alphonse Bertillon introduced an immensely thorough anthropometrical system which measured a range of key points in the human form. In conjunction with photographs, it was believed that this supplied a uniquely accurate means of identifying recidivists. Although the system of 'Bertillonage' was always subject to human error and was to be augmented by fingerprinting, its influence was widespread, notably in the work of Francis Galton, the founder of eugenics.

The Victorian zeal for creating taxonomic archives was also enthusiastically, and in many cases disturbingly, applied to ethnology, which saw its institutional beginnings in the 1860s. Here photography – often in conjunction with anthropometric measurements and other data – was seen as an ideal tool for the comparative study of different ethnic groups, and as ammunition for various parties in the controversies which raged around competing theories of human origins. In an age which increasingly embraced Darwin's theories and Herbert Spencer's ruthless formulation of 'the survival of the fittest', photography was seen as a means of preserving at least the physical trace of races left behind in the march of human progress and doomed to extinction.

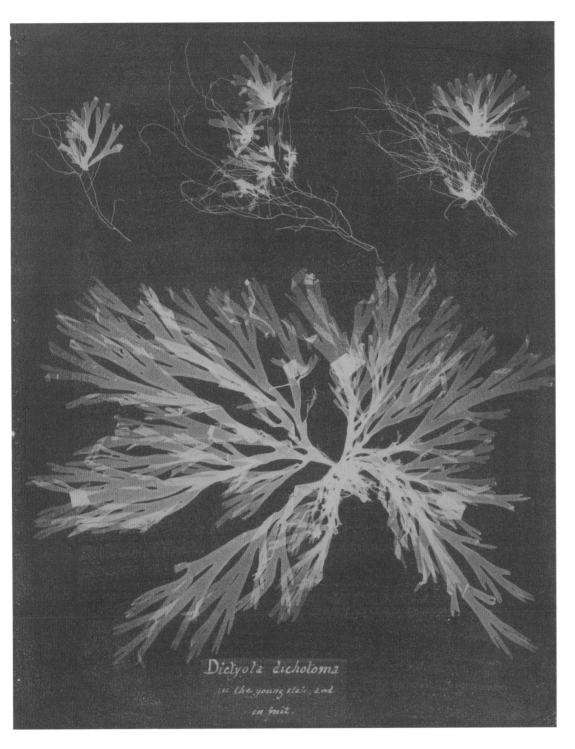

Dictyota dicholoma

in the young state, and

in fruit.

Anna Atkins

Dictyota dichotoma, *in the young state and in the fruit, 1843–53*

Cyanotype photogram, 25.8 x 20.5 cm

Anna Atkins, *Photographs of British algae. Cyanotype impressions* (1843–53), plate 55

C.192.c.1

Ernest Heeger

Ovipositor of the hymenopter
Ceraphron elegans, *c. 1859*

Salted paper print,
20.3 x 13.7 cm

Ernest Heeger, *Album microscopisch-photographischer Darstellungen* (Vienna, 1860–3), plate 10

7297.g.4

Revealing new worlds

By the mid-nineteenth century the microscope had become a tool of serious scientific research. From the 1830s, cheaply produced instruments became increasingly available and provided an intellectually rewarding recreational activity in Victorian society. The potential application of the microscope to photography quickly became apparent to Henry Talbot, who experimented with the production of photogenic drawings made through the solar microscope from the mid-1830s. But the superior detail achievable by the daguerreotype meant that for several years, continental practitioners using this process produced more outstanding results in photomicrography than their British contemporaries. As early as 1844–5 Alfred Donné and Léon Foucault issued their *Cours de microscopie complémentaire des études médicales*, containing engravings made from daguerreotype photomicrographs.

The advent of the wet collodion process overcame many of the problems of producing sharp and detailed negatives for widespread distribution, both in scientific circles and for the edification of a lay audience. The new worlds made visible by the microscope and the camera catered as much to a boundless popular appetite for new forms of visual experience as for programmes of education and self-improvement. Such 'perfect transcripts of Nature', in the words of the unknown author of *The wonders of the microscope*, further served to reveal the 'exquisite and surprising manifestations of divine contrivance'.

Unknown photographer

Photomicrograph of the tongue of the common cricket, c. 1859

Albumen print, 9 x 9 cm

The wonders of the microscope photographically revealed by means of Olley's patent micro-photographic reflecting process (London, 1857–61), part 5

7004.c.24

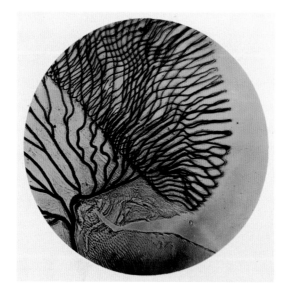

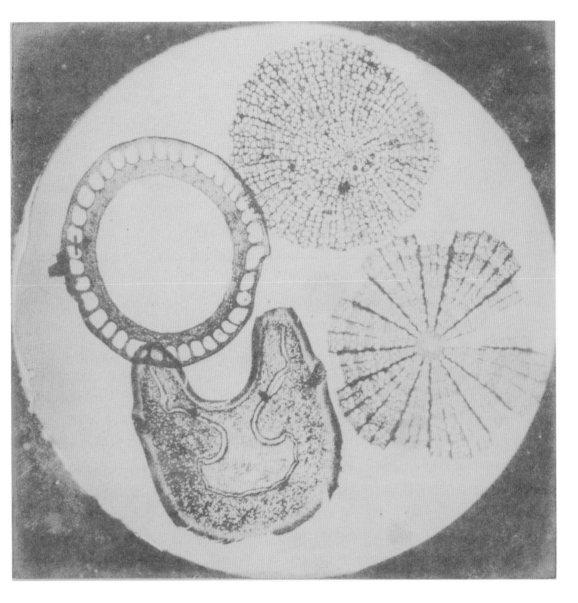

William Henry Fox Talbot

Diatoms, photographed in the solar microscope, c. 1839

Salted paper print from a photogenic drawing negative, 10.8 x 10.8 cm

Talbot Photo 2 (722)

Bisson Frères

Skulls of an adult and juvenile gorilla from Gabon, 1854

Salted paper print, 20.3 x 19.5 cm

Louis Rousseau and Jacques Devéria, *Photographie zoologique* (Paris, 1854), plate 15

1822.b.2

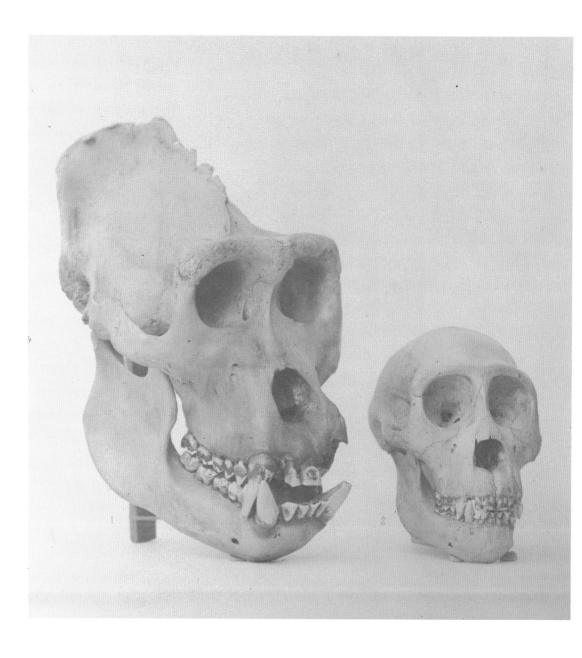

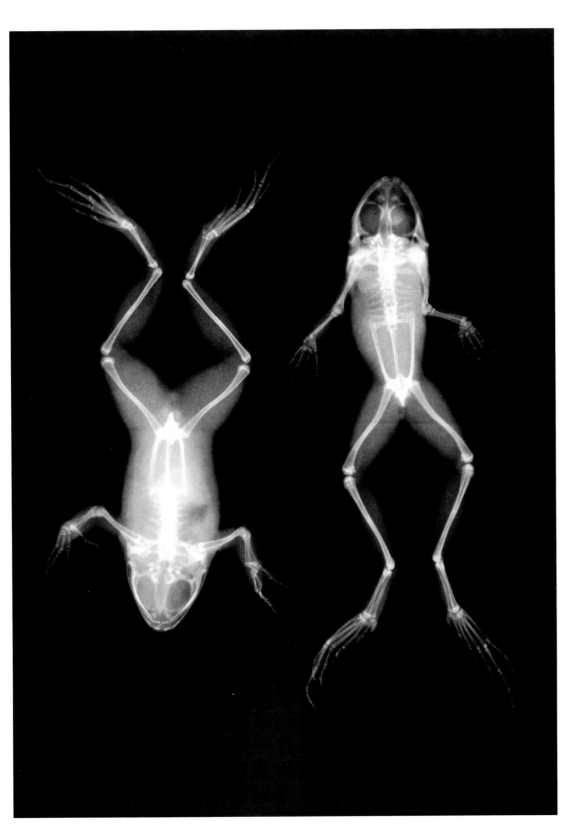

Josef Maria Eder and
Eduard Valenta

*X-ray photograph of frogs,
c. 1896*

Photogravure,
22.7 x 16.5 cm

Josef Maria Eder and
Eduard Valenta, *Versuche
über Photographie mittelst
der Röntgen'schen Strahlen*
(Vienna, 1896), plate 12

1818.c.4

Exploring other worlds

'My own dearest one – I have seen such sights!' is the breathless opening of a letter written by Nevil Story-Maskelyne to his fiancée Thereza (herself a noted amateur photographer and astronomer) in December 1857, describing a night spent viewing the moon and planets through the telescope of Warren de la Rue. As with the microscope, optical improvements in telescope design revealed new and beautiful worlds to be captured by the camera.

Long exposure times, which required accurate tracking by the telescope, at first hindered effective lunar photography, a drawback illustrated by the unsharp results of Story-Maskelyne's own efforts. Many of the issues associated with astronomical photography were to be solved by technological developments and faster exposures, although it was also found that extended exposures yielded the benefit of bringing hitherto invisible objects to light. But for the first decades of the medium, the sun and moon remained the main celestial objects of photographic attention. The difficulties of creating accurate and detailed records are implicit in the photographs in James Nasmyth and James Carpenter's *The moon, considered as a planet, a world and a satellite* (1874), whose astonishingly convincing images are in fact the result of photographing painstakingly constructed and skilfully lit plaster models. The culmination of lunar photography came at the very end of the century, in the massive photogravure plates that comprise Maurice Loewy and Pierre Henri Puiseux's *Atlas photographique de la lune*, which was published between 1896 and 1910 and remained the definitive work for over half a century.

Nevil Story-Maskelyne

Photograph of the moon, 1857

Gelatin silver print (printed later), 15.1 x 10.6 cm

Photo 1194/8 (1)

James Nasmyth and James Carpenter

Ptolemy, Alphons, Arzachael, etc., c. 1874

Woodburytype, 13.5 x 9.8 cm

James Nasmyth and James Carpenter, *The moon, considered as a planet, a world, and a satellite* (3rd edition, London, 1885), plate 13

8563.e.22

Charles Le Morvan

*The moon: with Schickhard and Gassendi craters,
23 July 1897*

Photogravure, 77 x 124 cm

Maurice Loewy and
Pierre Henri Puiseux, *Atlas
photographique de la lune*
(Paris, 1896–1910), plate 30

14001.s.3

Time and motion

Calvert Jones's 1846 study of the loggia beside the Uffizi in Florence, with its ghostly figures who have walked in and out of the frame during the lengthy exposure, epitomizes the abiding problem of much early photography. The pursuit of the 'instantaneous' image – whether through faster lenses, more sensitive plates or improved chemistry – became almost an end in itself, whatever its undeniable benefits to both science and art.

By the 1850s, the use of improved lenses with small-format plates could in fact produce views which effectively froze the movement of walking figures and carriages, giving a reasonably natural and unposed account of daily life. Yet, for most photographers, working with large-format cameras, the difficulty of creating sharp images without inconveniently long exposures remained unresolved for decades. Scenes involving action and movement were commonly arranged in static and unconvincing tableaux; and while the exposure of Henry Peach Robinson and Nelson King Cherrill's 1870 sea view largely succeeds in halting the movement of the waves, the birds in flight have clearly been montaged onto the view.

Ironically, the photographic quest for preserving a frozen instant of time, most famously investigated by Eadweard Muybridge (and his lesser-known French contemporary Étienne-Jules Marey), pointed the way to moving film, which was to celebrate its indivisible fluidity. Muybridge's obsessive photographic archive of movement studies – its subjects ranging from the banal to the bizarre – was published in 11 massive volumes in 1887 under the title of *Animal locomotion*, its 781 collotype plates containing over 20,000 individual images.

Eadweard Muybridge

Baboon walking on all fours, 1872–85

Collotype, 18.8 x 40.5 cm

Eadweard Muybridge, *Animal locomotion: an electro-photographic investigation of consecutive phases of animal movement* (11 vols., Philadelphia, 1887), vol. 11, plate 748

11.Tab.a

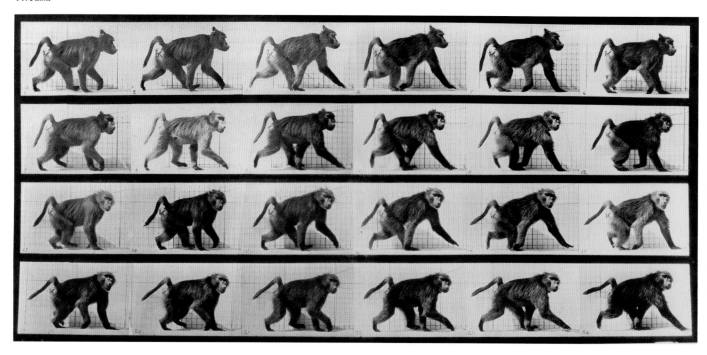

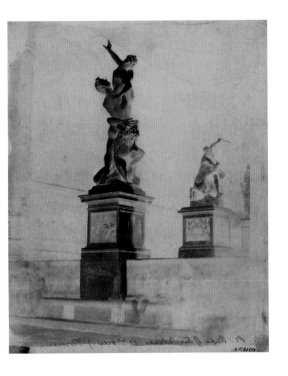

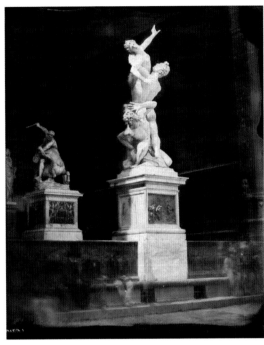

The Rev. Richard Calvert
Jones

Florence, 1846

Calotype negative
and modern print,
21.4 x 15.7 cm

Talbot Photo 1 (205)

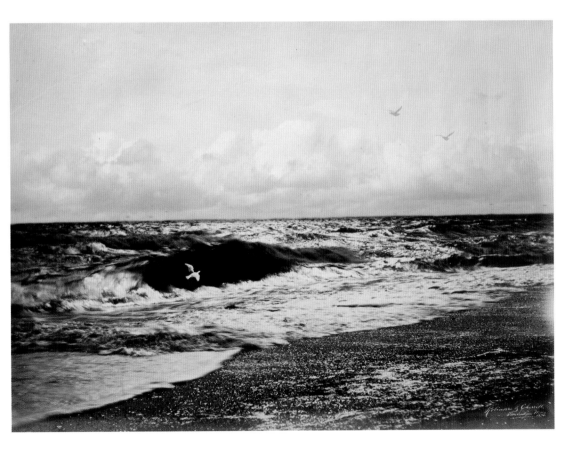

Henry Peach Robinson
and Nelson King Cherrill

*'The beached margent of
the sea,' 1870*

Albumen print,
28.1 x 38.4 cm

Photo 1168/1 (159)

Case studies

In addition to its relatively straightforward uses as a documentary tool to record anatomical features or pathological conditions, the distinguished French neurologist Guillaume Duchenne de Boulogne conceived a more ambitious role for photography, using as his subjects mental patients in the Salpêtrière Hospital in Paris. Here between 1854 and 1856 he created a series of portraits to demonstrate how the emotions could be categorized in terms of the muscular groups which gave physical expression to feelings such as joy, love, anger and despair. Using a specially designed method of electrical stimulation to activate individual facial muscles, he demonstrated how these could be manipulated to display particular states. Many of the photographs were taken in association with Adrien Tournachon – brother of the more famous photographer Nadar – and consciously employ a striking artistry in their lighting and posing. His work was much admired by Charles Darwin, who used a number of Duchenne's photographs in *The expression of emotions in man and animals* (1872).

Duchenne's work – groundbreaking despite the subjectivity of many of its conclusions – was to be more questionably continued in the theatrical and stylised depictions of mental illness produced by Henri Dagonet and in the photographic studio established at Salpêtrière itself, by Désiré-Magloire Bourneville and Paul Regard.

Unknown photographer

Hysterical epilepsy, terminal period: ecstasy, c. 1876

Albumen print,
9.4 x 6 cm

Désiré-Magloire Bourneville and Paul Regard, *Iconographie photographique de la Salpêtrière* (Paris, 1876–7), plate 22

7660.dd.4

Unknown photographers

Studies of megalomania, 1870s

Woodburytype,
16.7 x 10.4 cm

Henri Dagonet, *Nouveau traité élémentaire et pratique des maladies mentales* (Paris, 1876), plate 4

07660.k.27

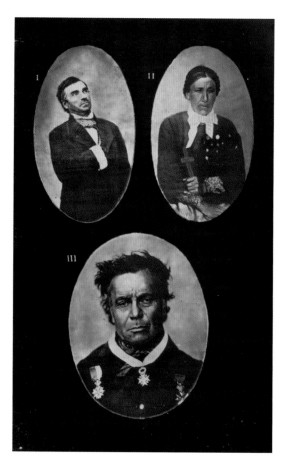

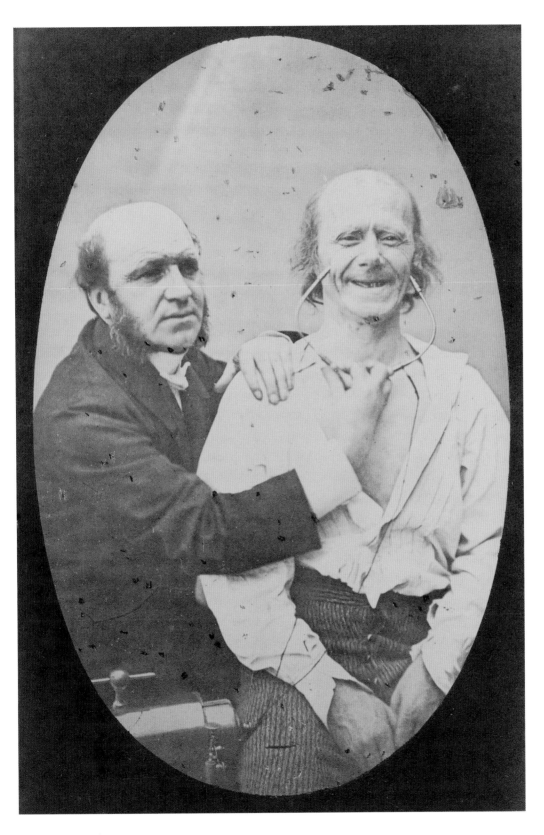

Guillaume Duchenne
de Boulogne and Adrien
Tournachon

*Example of an electro-
physiological experiment
made by the author, c. 1854*

Albumen print,
16.5 x 10.6 cm

Guillaume Duchenne de
Boulogne, *Mécanisme de
la physionomie humaine*
(Paris, 1862), frontispiece

7410.e.17

Johannes Ganz

Stereoscopic photographs of medical conditions, c. 1867

Albumen prints, each 7.4 x 6.8 cm

Thomas Billroth, *Chirurgische Klinik in Zurich: stereoscopische Photographien von Kranken* (Zurich, 1867)

7481.aa.39

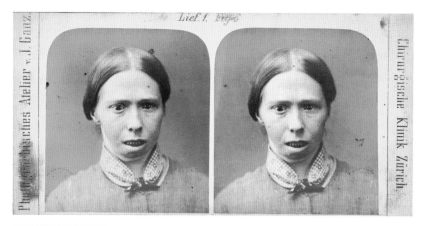

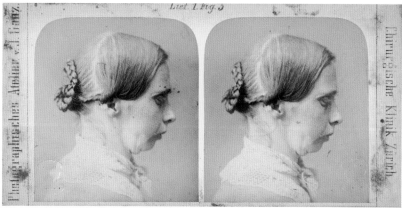

J. Albert

Bony structure of the cochlea of a newborn baby, c. 1866

Albumen print,
17 x 13.1 cm

Nicholas Rudinger,
Atlas des menschlichen Gehörorganes (Munich, 1866–75), plate 5

7610.h.7

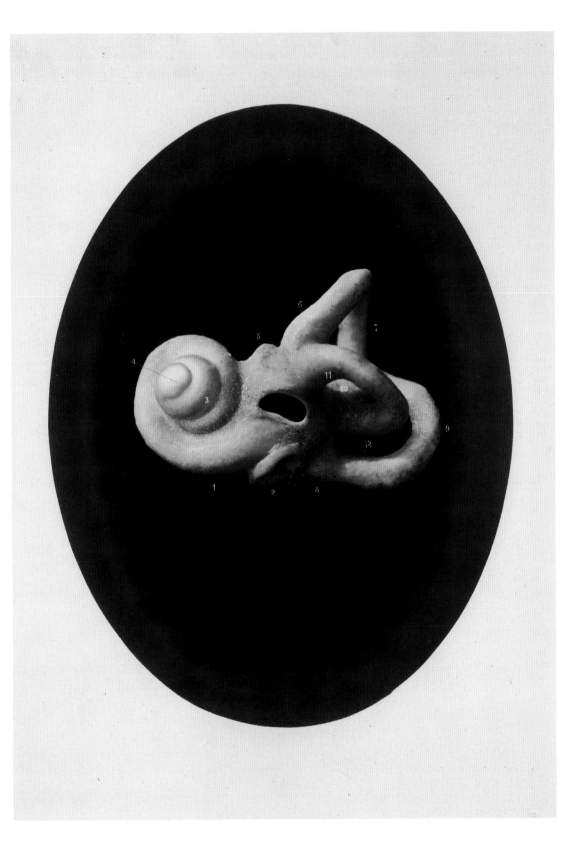

Alphonse Bertillon

Portrait of the face of 'Y',
with and without beard,
c. 1890

Half-tone reproductions,
with printed overlay,
each 7.6 x 5.5 cm

Alphonse Bertillon,
La Photographie judiciaire
(Paris, 1890), plate 4,
and German edition,
Die gerichtliche Photographie
(Halle, 1895)

8909.bb.48; 8909.k

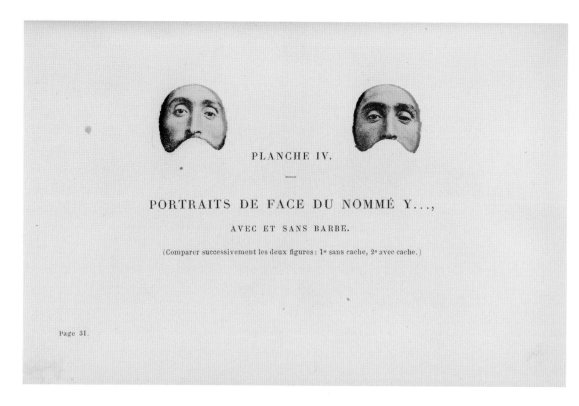

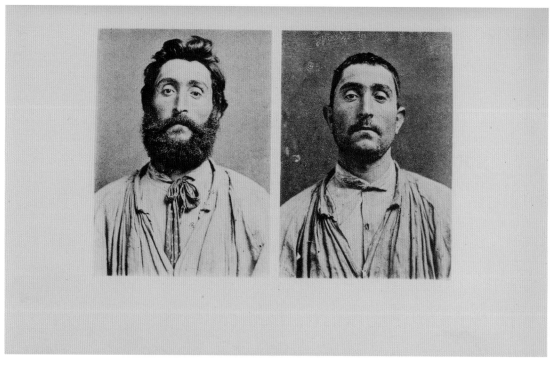

Planche 33.

Tableau synoptique des formes de nez.

1.— Nez à profil cave - relevé.

4.— Nez à profil rectiligne - relevé.

7.— Nez à profil convexe - relevé.

2.— Nez à profil cave - horizontal.

5.— Nez à profil rectiligne - horizontal.

8.— Nez à profil convexe - horizontal.

3.— Nez à profil cave - abaissé.

6.— Nez à profil rectiligne - abaissé.

9.— Nez à profil convexe - abaissé.

Alphonse Bertillon

Synoptic table of forms of the nose, c. 1893

Collotype, 18.4 x 12 cm

Alphonse Bertillon, *Identification anthropométrique. Instructions signalétiques ... Album* (Melun, 1893), plate 33

10008.ppp.31

Surveying mankind

The study of human origins and diversity – and its profound implications for theories of racial superiority in the nineteenth century – was vastly stimulated in an era of colonial expansion. In photography it resulted in the compilation of huge and often indiscriminate bodies of material, which sought to provide the visual data for a comprehensive comparative analysis of human variety.

Such surveys took a variety of forms. Travellers like Richard Buchta returned to Europe with portraits of their subjects posed according to accepted conventions, providing a full face and profile view (much in the manner of police identification photographs). More wide-ranging and ambitious schemes proliferated: the hundreds of photographs used in Carl Dammann's 1873 *Anthropologisch-ethnologisches Album* were acquired from disparate unacknowledged sources, including commercial photographers, scientific colleagues in the field and missionary societies. In the isolated Andaman Islands, the colonial official Maurice Vidal Portman embarked in the 1890s on an obsessive photographic survey of the inhabitants, accompanied by anthropometric measurements. Undertaken in the belief that such an exhaustive visual record would supply a bank of data, which would remain available for study after the inevitable extinction of the tribes, it has proved of limited scientific worth. Compared to Edward Sheriff Curtis's more sympathetic studies in *The North American Indian* (1907–30), the disturbing impact of the work of Portman and others now seems a sinister and misguided illustration of the often tragic collision of cultures in the age of imperialism.

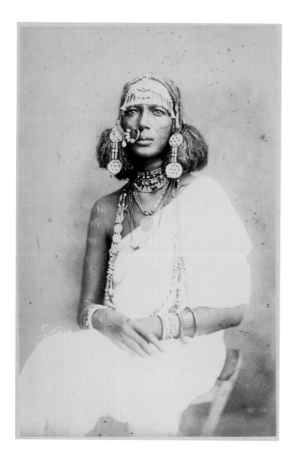 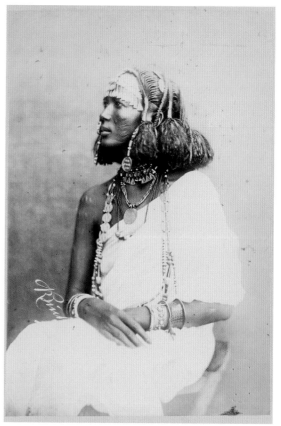

Richard Buchta

Arab woman of the Sudan, *1879*

Albumen prints, each 14.2 x 9.3 cm

Richard Buchta, *Die oberen Nil-Länder. Volkstypen und Landschaften* (2 vols., Berlin, 1881), vol. 1, plates 11 a–b

1789.a.13

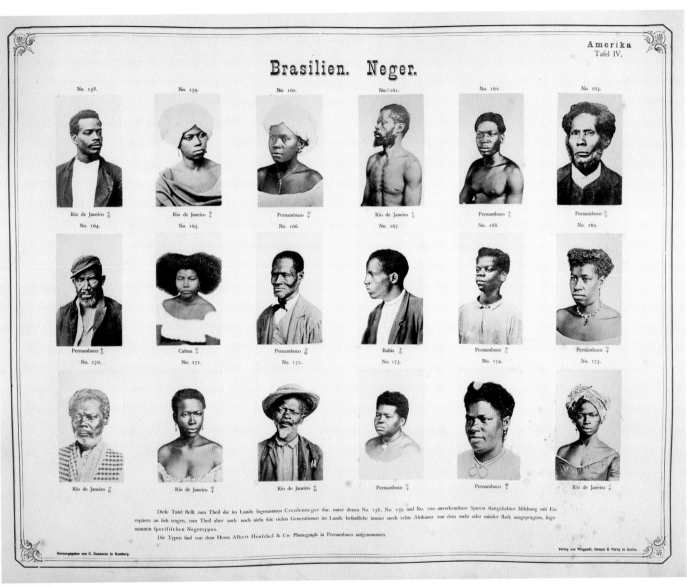

Brasilien. Neger.

Amerika
Tafel IV.

Unknown photographer(s)

*Negro types, Brazil,
1860s–70s*

Albumen prints,
sheet size 48 x 60 cm

Carl Dammann,
*Anthropologisch-
ethnologisches Album in
Photographien*
(Berlin, 1873), part 4,
plate 4

N.Tab.202/1

Maurice Vidal Portman

*Kéliwa, a woman of the
Tá-kéda tribe,
Andaman Islands, c. 1893*

Platinum print,
34.8 x 25.7 cm

Photo 188/11 (20)

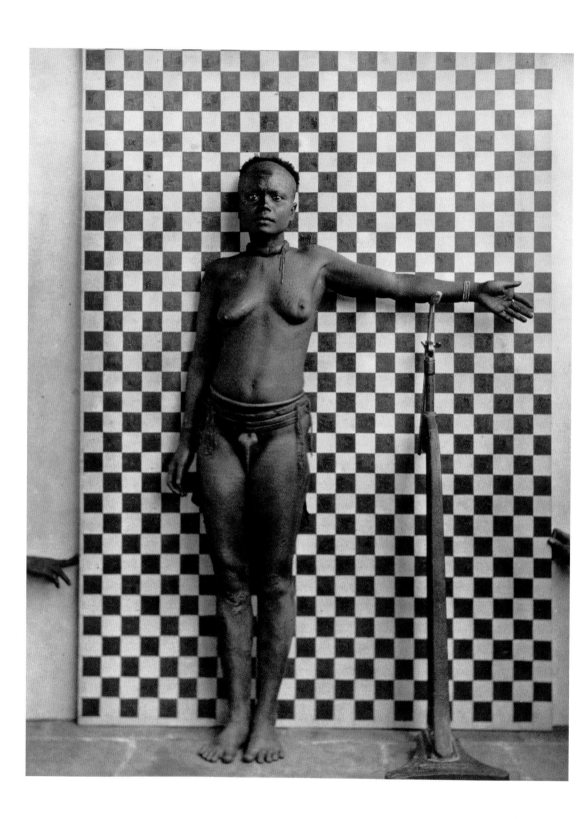

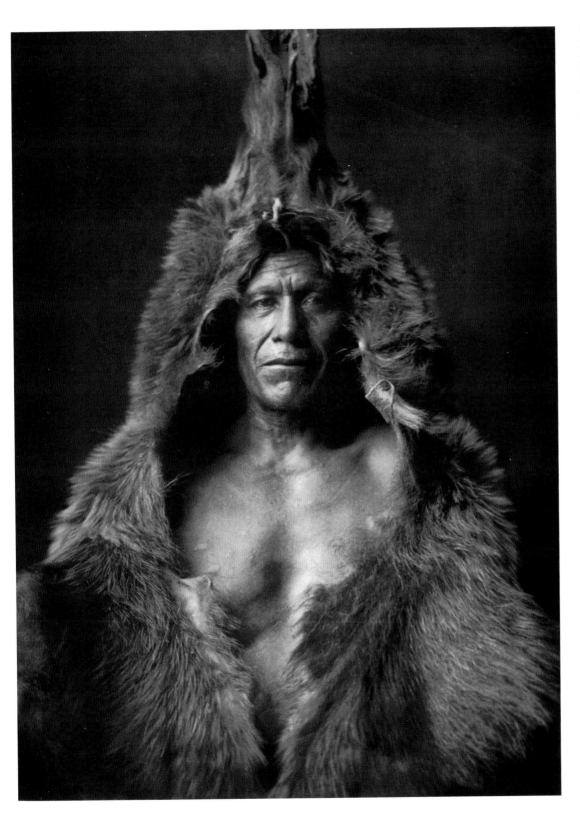

Edward Sheriff Curtis

Bear's Belly – Arikara, 1908

Photogravure,
40.2 x 30.1 cm

Edward Sheriff Curtis,
The North American Indian
(20 vols. and 20 portfolios,
Cambridge, Mass., 1907–30),
portfolio 5, plate 150

L.R.298.b.2

6
MAKING
THE
MODERN WORLD

Industrial and technological developments of the nineteenth century were powered by the might of iron and steam, with Britain producing half of the world's pig iron by 1848. Massive programmes of destruction and construction transformed cities, such as Haussmann's Paris, realising a new vision of urban life, while shipping lines, railways, canals and public works created an infrastructure for the creation of new markets and the movement of raw materials. In its documentary role, the photograph played its part in recording and celebrating this expansive age.

While the limitations of large-format negatives demanded exposures that resulted in static scenes, this did not prevent photographers from infusing a sense of drama and intensity into their work. The play of shadow and light, the use of composition and perspective to exploit the abstract possibilities of architectural form, were all employed to evoke wonder at new feats of engineering and to express the nobility of industrial enterprise.

Perhaps the first extensive photographic documentation of the progress of the construction of a single building was Philip Henry Delamotte's detailed record of the re-erection of the Crystal Palace exhibition buildings at Sydenham

during 1852–4. Delamotte's photographs of the rise of Joseph Paxton's elegant structure were also interspersed with more intimate portraits of the army of labourers which made it possible, the published version culminating in a view of Queen Victoria opening the 'People's Palace' in June 1854. Delamotte's work was to form the pattern for many subsequent visual narratives of architectural and industrial projects. Noteworthy examples include William Notman's record of the construction of the Victoria Bridge in Montreal, and these were generally produced by professional photographers for commercial sale. Initially more concerned with presenting a heroic vision of the modern industrial age, they increasingly came to serve a more mundane function as visual records for engineers and architects. The compendium of photographs of canals, harbours, lighthouses, roads and railways which illustrate the massive five-volume *Les Travaux publics de la France* (1883), served as illustrations to the descriptive text, rather than as the prime focus of the work. By the end of the century, most major civil engineering projects were accompanied by detailed photography, produced essentially as a technical record or to illustrate technical issues.

If industrial progress represented the Victorian world at its most positive, it also fuelled the destructive impact of the first great wars of the modern age, both in the swift movement of armies and the increasing sophistication and killing power of armaments. Although for most of the nineteenth century photography was unable to capture the fast-moving reality of the battlefield, this did not deter photographers, who saw commercial opportunity in supplying images of war, either for sale as original prints or for reproduction in the popular press. The Crimean conflict was the first war to attract extensive photography, most notably in the work of Roger Fenton. The photographic entrepreneur Mathew Brady managed a whole team of photographers during the American Civil War, while Felice Beato made a speciality of the subject, circling vulture-like for three decades over European colonial conflicts in Asia. If photography lacked the means to show the heat of battle, the image of its silent aftermath could still bring home, in the words of the photographer Alexander Gardner, 'the blank horror and reality of war, in opposition to its pageantry'.

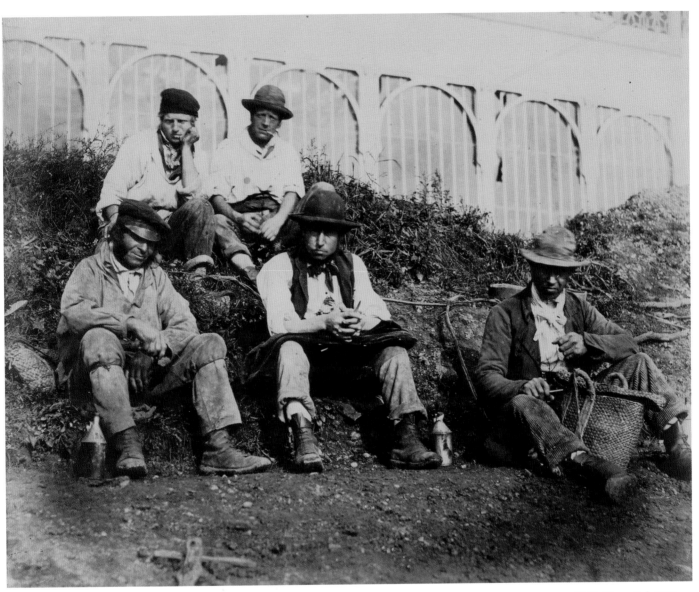

Philip Henry Delamotte

Breakfast time at the Crystal Palace, Sydenham, 1852–4

Albumen print,
22.6 x 28.2 cm

Philip Henry Delamotte,
Photographic views of the progress of the Crystal Palace, Sydenham. Taken during the progress of the works, by desire of the Directors ([London,] 1855), plate 26

Tab.442.a.5

William Notman

Construction of the Victoria Bridge, Montreal: dredging machine, September 1858

Albumen print,
19.8 x 28.1 cm

William Notman,
Victoria Bridge, Montreal
([Montreal, 1860])

C.161.g.2 (plate 11)

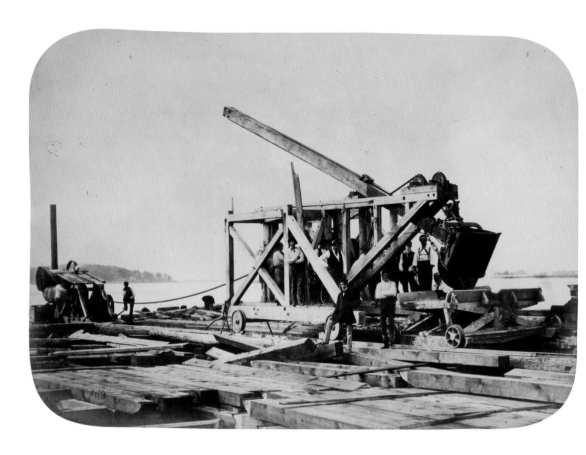

William Notman

Construction of the Victoria Bridge, Montreal: men destroying crib, 1858–9

Albumen print stereographs,
each 7.3 x 6.8 cm

William Notman,
Victoria Bridge, Montreal
([Montreal, 1860])

C.161.g.2 (plate 66)

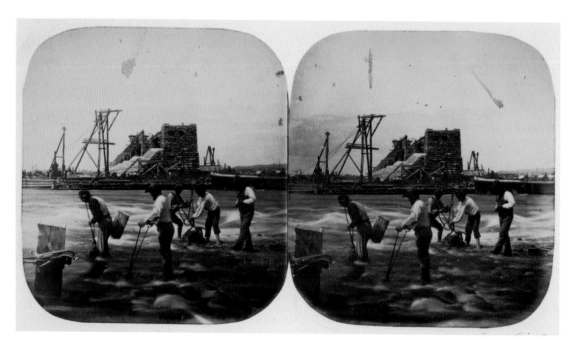

Unknown photographer

*The pont d'Arcole, Paris,
c. 1870s*

Carbon print, 24 x 32.9 cm

Felix Lucas and Victor
Fournie, *Les Travaux publics
de la France ... Tome premier:
routes et ponts* (5 vols., Paris,
1883), vol. 1, plate 35

1730.c.5

Henry Moulton

*Digging out guano, Chincha
Islands, Peru, c. 1863*

Albumen print,
17.7 x 22.4 cm

Alexander Gardner,
*Rays of sunlight from South
America* (Washington DC,
[*c.* 1865]), plate 38

1784.a.14

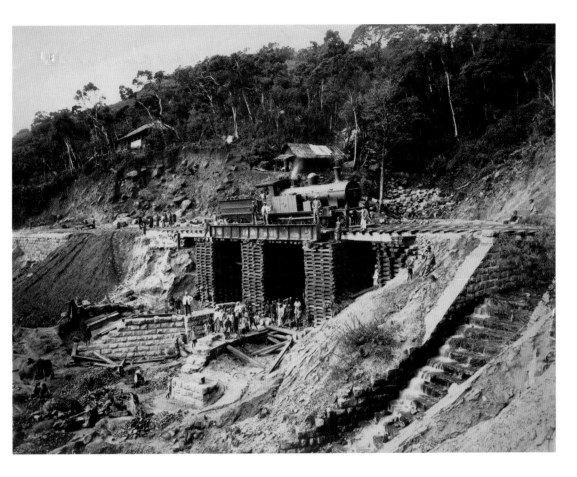

**William Louis Henry
Skeen & Co.**

*Temporary bridge and culvert
on the Haputale Railway,
Ceylon [Sri Lanka],
June 1893*

Albumen print,
21 x 27.6 cm

Photo 1178 (1)

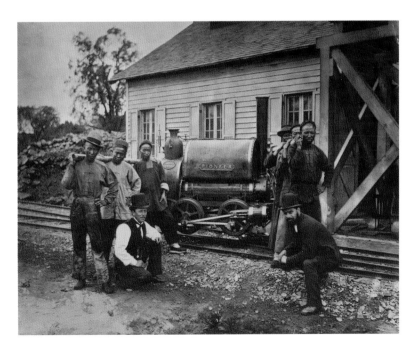

Unknown photographer

*Arrival of the 'Pioneer'
at Shanghai, the first railway
locomotive in China, 1876*

Woodburytype,
9.4 x 11.7 cm

Richard C. Rapier,
*Remunerative railways
for new countries*
(London, 1878), plate 2

8235.k.6

Unknown photographer

Sinking last blocks, closing lines of foundations in dam at Dehri, Bihar, India, June 1872

Albumen print, 25.8 x 34.5 cm

Photo 96/2 (44)

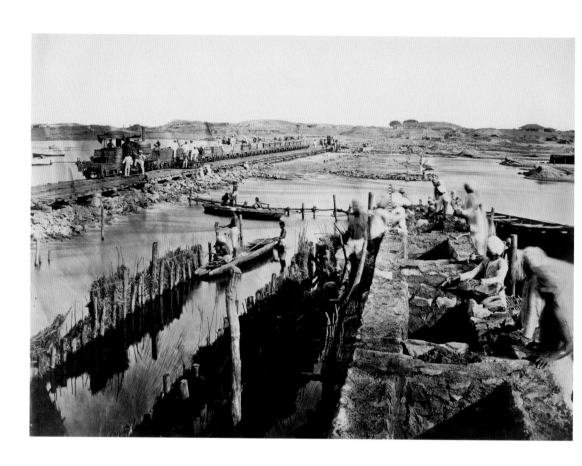

Unknown photographer

Fouracres excavator used in sinking blocks for dam foundations, Bihar, India, April 1871

Albumen print, 19.2 x 24.1 cm

Photo 96/2 (70)

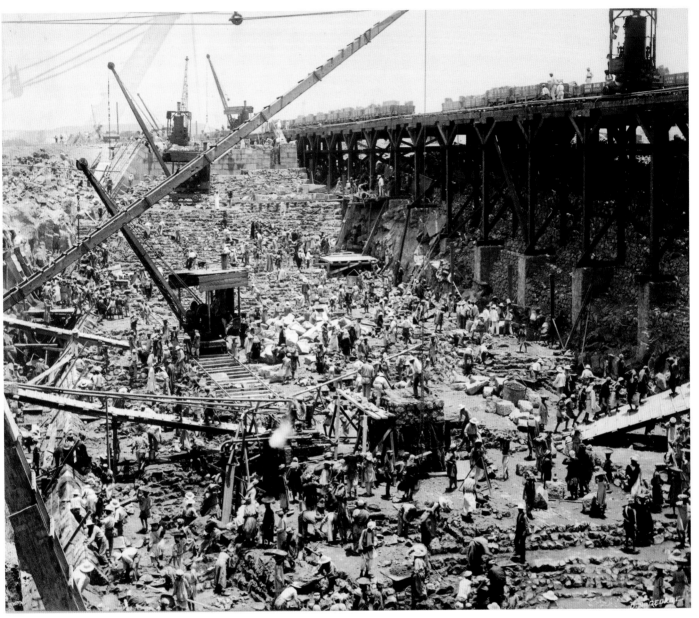

D.S. George

Construction of the Aswan Dam, masonry commencing in the western channel, 1898–1900

Platinum print,
24 x 28.7 cm

Photo 430/64 (8)

J.C. Burrow

*The Man Engine at
Dolcoath Mine, c. 1893*

Woodburytype,
14.7 x 9.9 cm

J.C. Burrow, *'Mongst
mines and miners*
(London, 1893), plate 2

C.194.b.213

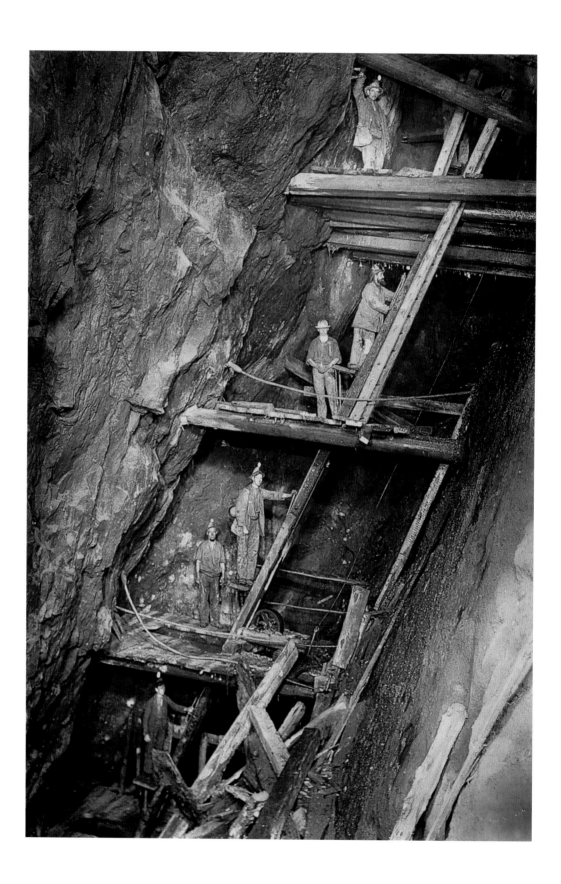

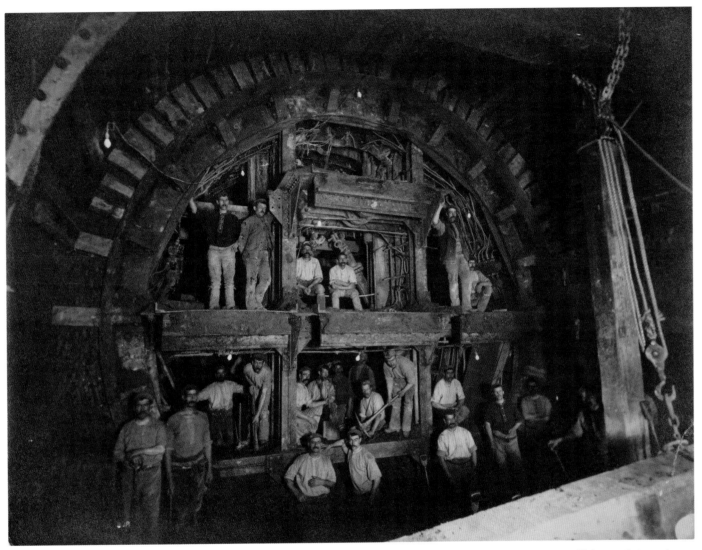

Unknown photographer

*Construction of the Central
Line of the London
Underground, 1898*

Gelatin silver print,
15.5 x 20.4 cm

Photo 1132/1 (1)

The image of war

If the casualties of war are curiously absent from Roger Fenton's Crimean photographs, such evasions were soon abandoned for a more forthright engagement with the horrors of the battlefield. The photographers who covered the American Civil War did not shrink from confronting their viewers with the human carnage left in the wake of battle. When these were the casualties of colonial campaigns, this became less a humanitarian than an aesthetic challenge: Felice Beato is recorded by a contemporary as striding excitedly on the ramparts of the recently captured Taku Fort in China in 1860, exclaiming on the beauty of a group of its dead defenders and requesting that it should not be disturbed until he had photographed it. And when the accepted narrative demanded it, he was not alone in rearranging a scene in the interests of dramatic and emotional resonance. In contrast, much of the work of German photographers in the Franco-Prussian War of 1870 seems designed to underline the efficiency of that swift campaign, with significant emphasis on the efficiency of hospital and transport arrangements.

Limitations of technology, the demands and expectations of intended audiences, and the moral lessons that the photograph was designed to illustrate, all played – as they continue to do – as great a part as 'truth' in the recording of nineteenth-century war.

Henry Hering

Sale catalogue of Felice Beato's views of the Indian Mutiny and the Anglo-Chinese War (London, 1860)

Photo 6 (13)

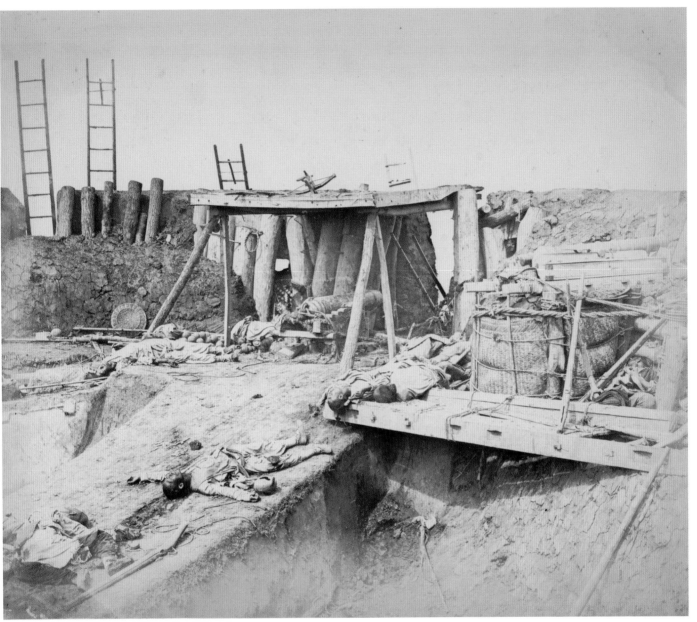

Felice Beato

Interior of the north Taku Fort, taken immediately after its capture, 21 August 1860

Albumen print,
25.2 x 29.5 cm

Photo 353 (8)

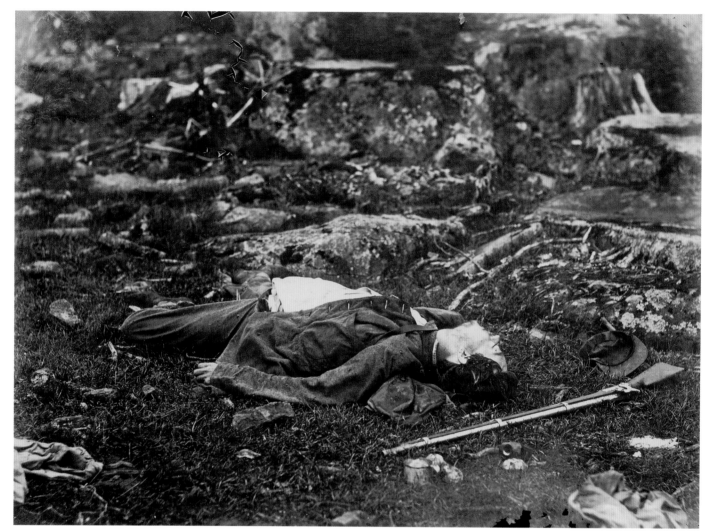

Alexander Gardner

A sharpshooter's last sleep,
Gettysburg, July 1863

Albumen print,
17.6 x 22.6 cm

Alexander Gardner,
Gardner's photographic
sketchbook of the war
(2 vols., Washington DC,
1866), vol. 1, plate 40

1784.a.13

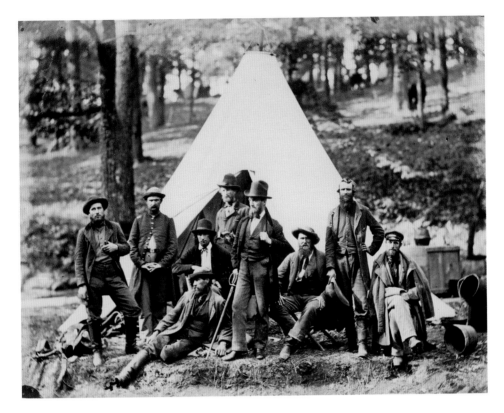

Alexander Gardner

Guides to the Army of the Potomac, Berlin, Virginia, October 1862

Albumen print, 17.4 x 22.7 cm

Alexander Gardner, *Gardner's photographic sketchbook of the war* (2 vols., Washington DC, 1866), vol. 1, plate 28

1784.a.13.

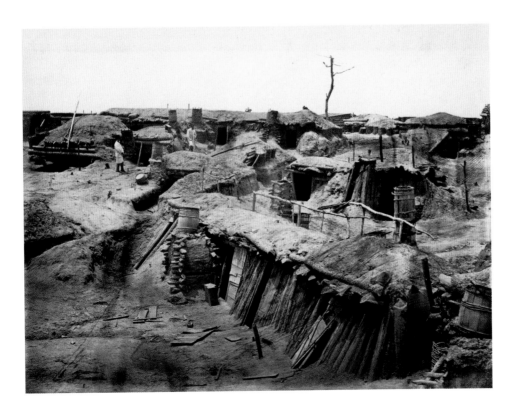

Timothy O'Sullivan

Quarters of men in Fort Sedgwick. Generally known as Fort Hell, May 1865

Albumen print, 17.3 x 22.8 cm

Alexander Gardner, *Gardner's photographic sketchbook of the war* (2 vols., Washington DC, 1866), vol. 2, plate 83

1784.a.13

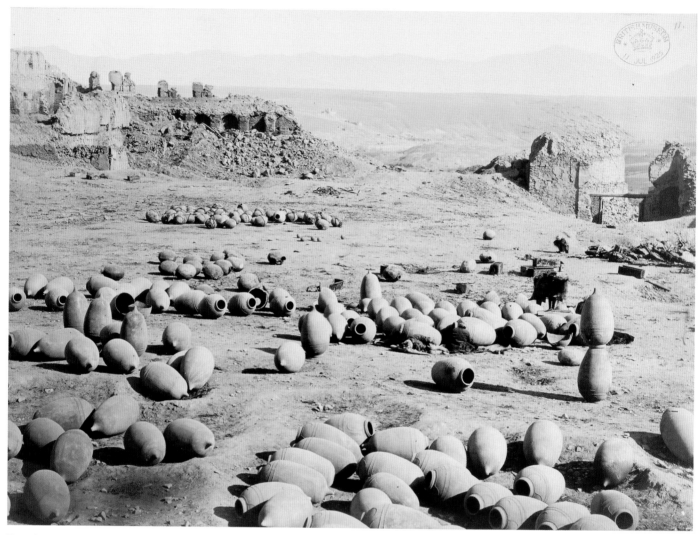

Bengal Sappers and Miners photographer

Magazine in the Upper Bala Hissar, Kabul, 2nd Afghan War, 1880

Albumen print, 20.4 x 28 cm

Maps 51850/10 (plate 11)

THE
NEWS OF THE CAMP.

A JOURNAL OF FANCIES, NOTIFICATIONS, GOSSIP, AND GENERAL
CHIT CHAT, PUBLISHED IN THE MILITARY CAMP OF HER
MAJESTY'S FORCES DEFENDING THE BELEAGURED
INHABITANTS OF PRETORIA.

EDITED BY

CHARLES DU-VAL AND CHARLES DEECKER.

MOTTO.—"CRIBBED, CABINED, CONFINED, BOUND-IN."

"NEWS OF THE CAMP" EDITORIAL AND PRINTING OFFICES.
(From a Photograph by H. F. Gros, Pretoria.)

PRINTED AT THE MILITARY CAMP, PRETORIA, DURING THE TRANSVAAL WAR OF 1880-81.

H.F. Gros

*Editorial and printing offices
of 'The News of the Camp',
Siege of Pretoria, 1880*

Albumen print,
13.8 x 18.9 cm

Charles Du Val and Charles
Deecker, *The news of the
camp* (Pretoria, 1880)

L.R.27.b.16

Ernest Lucke

*Hospital of the Bavarian
Division, Höhenheim,
Strasbourg, Franco-Prussian
War, 1870*

Albumen print,
19.8 x 26.6 cm

Maps 8.e.1 (21)

Ernest Lucke

*St Cloud from the Seine,
Franco-Prussian War, 1870*

Albumen print,
21.1 x 26.5 cm

Maps 8.e.1 (44)

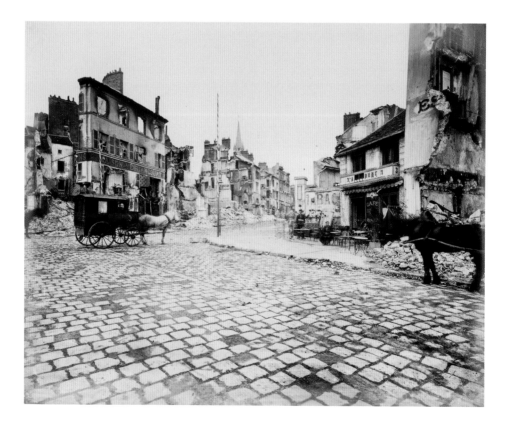

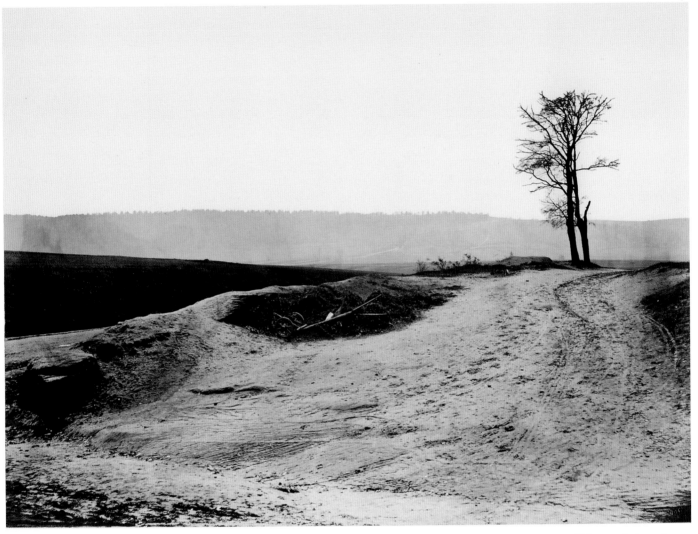

Unknown photographer

*The Heights above
Saarbrücken, captured
6 August 1870*

Albumen print,
22.1 x 30 cm

Maps 184.p.1 (8)

7

THE WAY
WE LIVED THEN

Throughout the nineteenth century, Britain experienced
mass urbanisation as people moved from rural areas
into cities and manufacturing districts in search of
employment. Some sections of the labouring classes
started to experience better standards of living and higher
wages. Working hours for many decreased. New-found
leisure time and increased mobility were prized by
workers. The growth of team sports like football reflected
urban communal solidarity, while day trips to seaside
resorts, facilitated by an expanding network of cheap
railway travel, grew increasingly popular. But for many,
industrial growth exacted its own price in terms of social
stresses, dislocation and poverty.

Early photography did little to address these issues,
indeed for many years it either actively avoided them
or retreated into a sentimentalised pastoral past. Once
reformers began to investigate the links between living
conditions and social behaviour, photography's potential
to influence public and political opinion became apparent.
Although Henry Mayhew's *London labour and the London
poor*, published in 1851, had included engravings based
on daguerreotypes, the crudity of their copying largely
destroyed their photographic impact. The first major
photographic attempt to document these working-class
communities was John Thomson's *Street Life in London*,
modelled on Mayhew's pioneering work and written in
collaboration with the journalist Adolphe Smith. Published
in instalments in 1877–8, and again in abridged form as

Street Incidents in 1881, the work contained 36 photographic
portraits and scenes in which the subjects are presented as
representative types, but individualised through the personal
histories described in the accompanying text. The results
of Thomson and Smith's forays into these largely uncharted
territories were imbued with deeply moralistic undertones
on the virtues of thrift, duty and industriousness. As the
journal *The Graphic* noted, the photographs represented a
compelling vehicle whereby 'the manifold industries of the
poor of our great City are transferred from the street to
the drawing room'.

In general, however, from the 1860s the physical
fabric of cities changing under the pressures of commercial
development and social improvement received more
detailed attention than their inhabitants. Between 1868
and 1877, Thomas Annan was commissioned by the
Glasgow Improvement Trust to record the city's notorious
slums before they were demolished. The poor themselves
occasionally make their appearance in these powerful views,
either as incidental figures or in posed groups, but the
overall effect is often undeniably picturesque. Indeed, the
photographs of his lesser-known contemporary Archibald
Burns, who undertook an analogous commission for the
Edinburgh Improvement Trust, were published in 1871
under the title, *Picturesque 'bits' from old Edinburgh*. In
London, meanwhile, the threat to the historic structure
of the city in the face of commercial development led to
the formation of the Society for Photographing the Relics
of Old London, which from 1875 to 1886 produced an
architectural record of a rapidly disappearing world.

While the record photographs of prisoners, asylum
inmates and workhouses provide compelling evidence
of social deprivation, these were generally created as
administrative records, although often harnessed to their
own agendas. The philanthropist Thomas Barnardo, for
instance, was accused of over-emphasising the differences
between the 'before and after' pictures of Barnardo's
children taken in the 1870s, in order to illustrate the
improving effect of his organisation's work. If photography
was to become an increasingly important tool of social
education and reform in the twentieth century, its
beginnings in the nineteenth can at best be described
as modest.

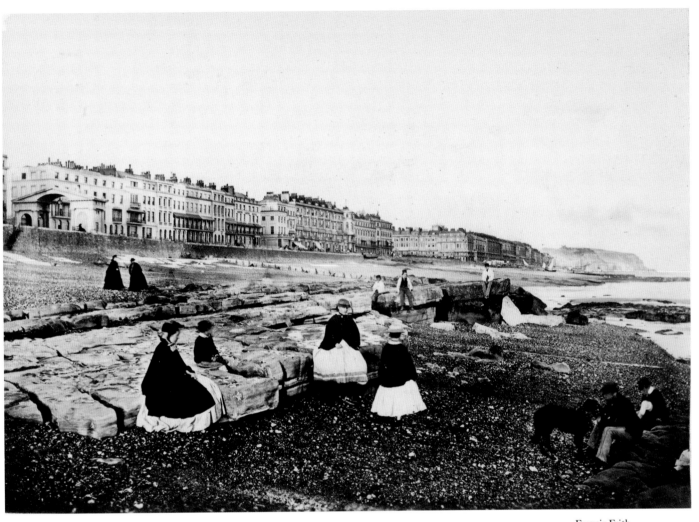

Francis Frith

*Hastings from the beach –
low water, c. 1864*

Albumen print,
11.2 x 16 cm

Francis Frith, *The gossiping
photographer at Hastings*
(Reigate and London,
1864), plate 6

Cup.410.g.108

Archibald Burns

Clockwise from left
Edinburgh views: Allan Ramsay's shop, High Street; Timber-fronted houses, Cowgate; 'Bit' in Bull Close, Cowgate; Advocate's Close, High Street, c. 1868

Albumen prints, each 10.5 x 8.5 cm

Thomas Henderson, *Picturesque 'bits' from old Edinburgh* (Edinburgh and London, 1868), pp. 18, 46, 50, 14

10370.bbb.30

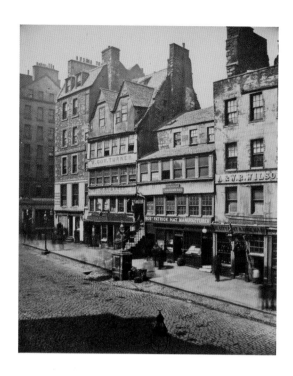

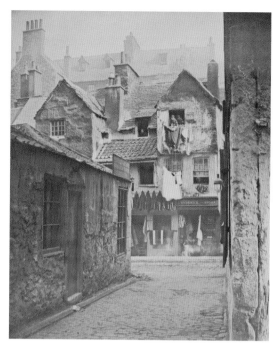

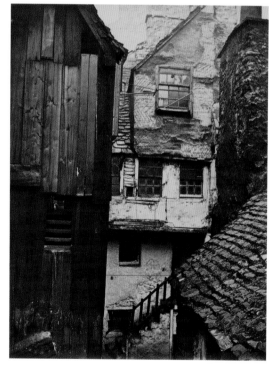

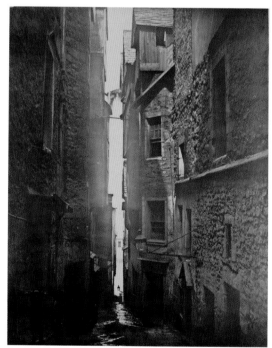

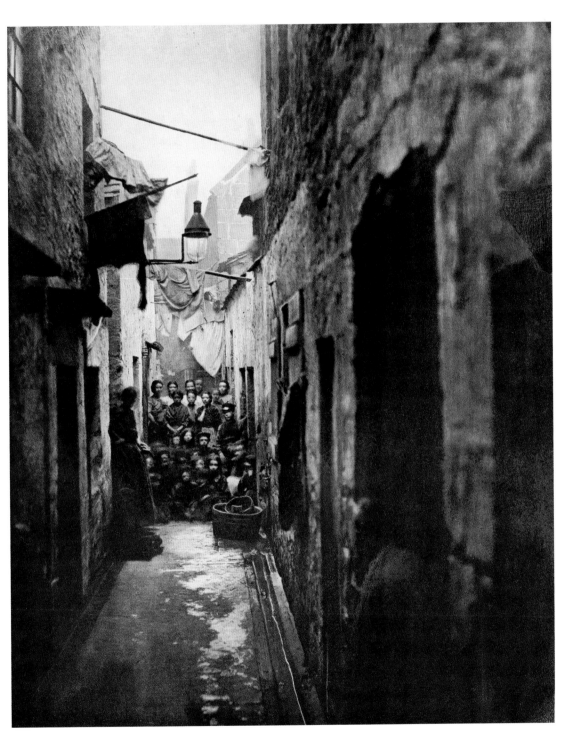

Thomas Annan

Close No. 118, High Street, Glasgow, 1868

Photogravure, 21.8 x 17.6 cm

William Young, *The old closes and streets of Glasgow* (Glasgow, 1900), plate 6

L.R.404.g.8

Henry Dixon and Son

*Shop in Macclesfield Street,
Soho, London, 1883*

Carbon print, 17.9 x 22.6 cm

Alfred Marks, *Society for
photographing the relics of
old London* (2 vols., London,
1875–86), vol. 2. plate 84

Tab.700.b.3

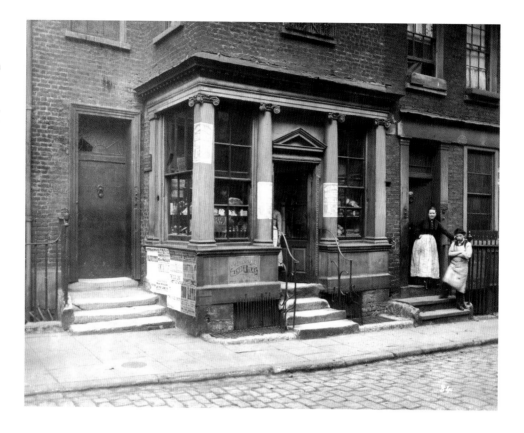

Henry Dixon and Son

*Old houses, Aldgate, London,
1883*

Carbon print, 21.2 x 17.5 cm

Alfred Marks, *Society for
photographing the relics of
old London* (2 vols., London,
1875–86), vol. 2, plate 77

Tab.700.b.3

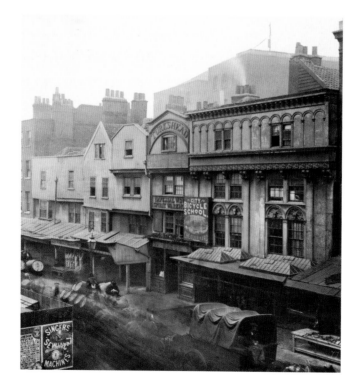

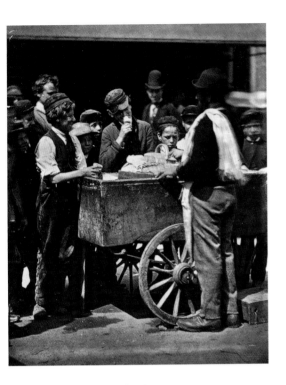

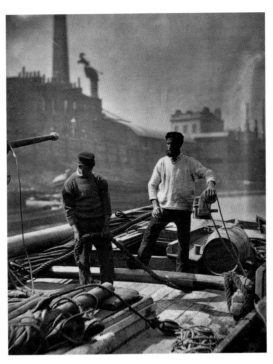

John Thomson

Clockwise from left
*Halfpenny ices; Workers on
the 'Silent Highway';
The 'Crawlers'; Cast-iron
Billy, 1876–7*

Woodburytypes, each
about 11.5 x 9 cm

John Thomson, *Street
incidents* (London, 1881),
plates 4, 8, 15, 7

RB.23.b.6198

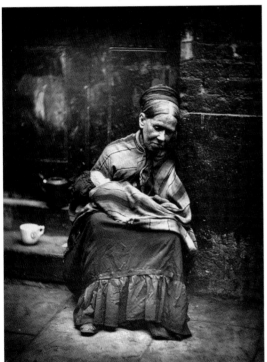

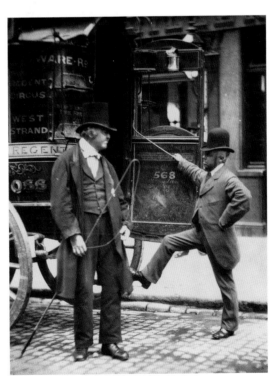

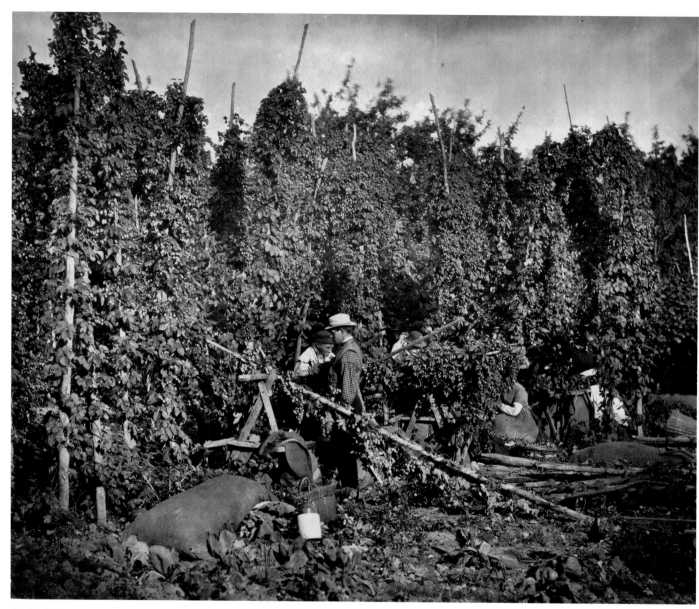

Stephen Thompson
Hop-picking in Kent, c. 1875
Carbon print, 15 x 18.2 cm
Stephen Thompson,
Studies from nature
(London, 1875–6), plate 15
1758.b.6

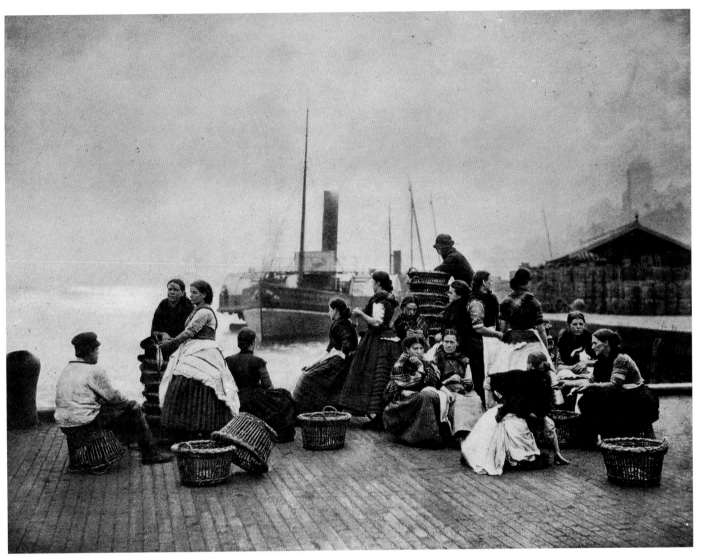

Lydell Sawyer
Waiting for the boats,
c. 1890

Photogravure,
13.6 x 17.9 cm

William A. Boord, *Sun*
artists (London, 1890),
part 4

1757.b.14

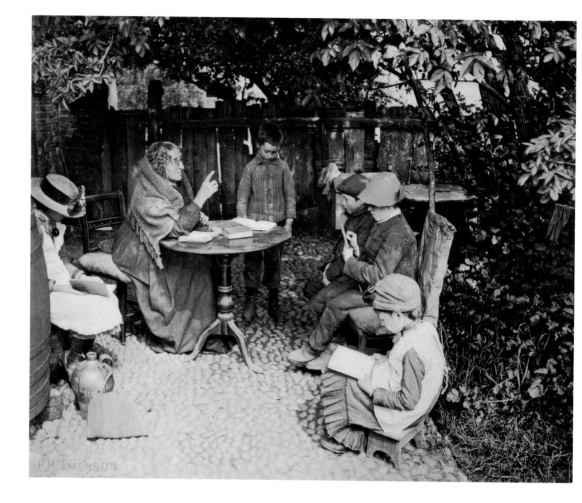

Peter Henry Emerson

A dame's school, c. 1887

Photogravure,
23.4 x 28.5 cm

Peter Henry Emerson,
*Pictures from life in field
and fen* (London, 1887),
plate 2

1760.e.4

Peter Henry Emerson (1856–1936)

Born in Cuba in 1856, Emerson attended school in England before qualifying as a doctor. He took up photography in 1882 and established his reputation in 1886 with the publication of his first major work, *Life and landscape on the Norfolk Broads*, illustrated with platinum prints and with a text written in collaboration with the artist Thomas Frederick Goodall. Over the following decade, he was to produce a series of photographic books and portfolios, mainly printed in photogravure and centred on East Anglian subjects.

East Anglia, with its meandering waterways, bountiful hay fields and traditional skills connecting the people with the land, was the subject of Emerson's work for the best part of a decade. Blending social documentary with a highly individual concept of photographic naturalism, he sought to capture and preserve a way of life threatened by industrial development, rural displacement and the increasing popularity of tourism in East Anglia. Despite his combative character and often contradictory pronouncements, Emerson's work and writings were hugely influential on photographic styles and ideas in the late nineteenth century.

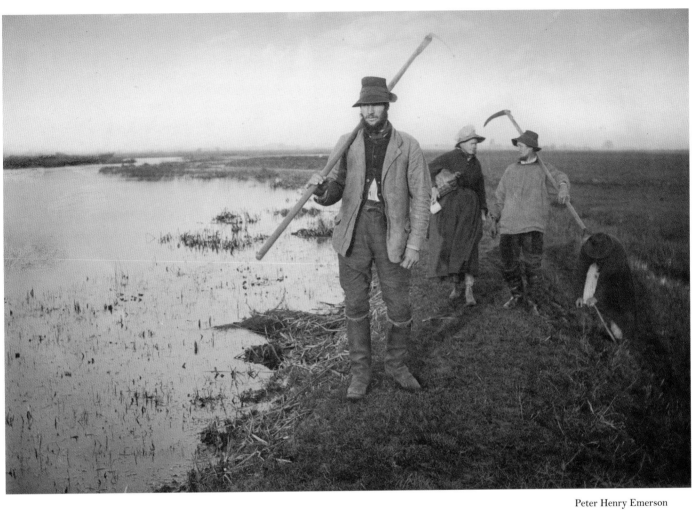

Peter Henry Emerson

Coming home from the marshes, c. 1886

Platinum print,
19.9 x 29.1 cm

Peter Henry Emerson,
Life and landscape on the Norfolk Broads
(London [1886]), plate 1

C.141.dd.8

8

FIN DE SIÈCLE

Debate about photography's status as an art form or no more than a mechanical recording device had been widespread since the birth of the medium. By the end of the nineteenth century, such arguments were brought into sharper focus by the growth of amateur photography. Particularly after the formation of George Eastman's Kodak Company in the late 1880s, photography no longer required great technical skill or elaborate equipment. From this time on, and with growing momentum in the twentieth century, the camera became an accepted and affordable part of family life, creating a repository of shared memory and informally celebrating both the mundane and the significant.

The same period saw the rise of the Pictorialist movement, which represented a self-conscious attempt to present photography as an expressive art. In many respects, its ethos echoed divisions which had first emerged in the 1840s, between commercial photographers and the amateur calotypists who practised the medium as an artistic avocation. While most of the adherents of pictorialism were self-consciously 'amateur' photographers, the movement also reflected a growing insecurity about photography's status. The pictorialist's fondness for complex craft techniques, often involving heavy reworking of both negative and print, was in part a strategy designed to separate expressive photography and its aesthetic from a growing army of 'snapshooters'.

Both in Europe and America Pictorialism spawned like-minded groups who seceded from traditional photographic associations. In England, the Brotherhood of the Linked Ring was established in 1892 by photographers who had resigned from the Photographic Society of Great Britain to further the cause of 'art' photography. Its esoteric and Masonic-sounding title signalled a self-conscious exclusivity, while its 'salon' exhibitions in the 1890s sought to ally it to high artistic purpose. In America, similar aims were pursued by the Photo-Secession, founded by Alfred Stieglitz in 1902 and inspired by the aims of the Linked Ring.

At its finest – and many of its adherents were masterly technicians – Pictorialism achieved a lyrical and uniquely atmospheric evocation of mood and place. But it was all too prone to degenerate into coy sentimentality, furtive eroticism and the painterly depiction of hackneyed scenes of rural life, lacking the intellectual and visual rigour which Emerson had brought to similar themes in the 1880s.

Pictorialism survived in diluted form in the exhibitions of photographic societies for many decades, but its hermetic concerns and artistic pretensions became increasingly exhausted and irrelevant in the first decade of the twentieth century. In the face of fading public interest, the Linked Ring was dissolved in 1910. In America the influential journal *Camera work*, outlet for the Photo-Secession movement, survived until 1917, but it had already outlived the heyday of pictorialism, as photographers became absorbed by the increasing formalism and abstraction of new artistic currents.

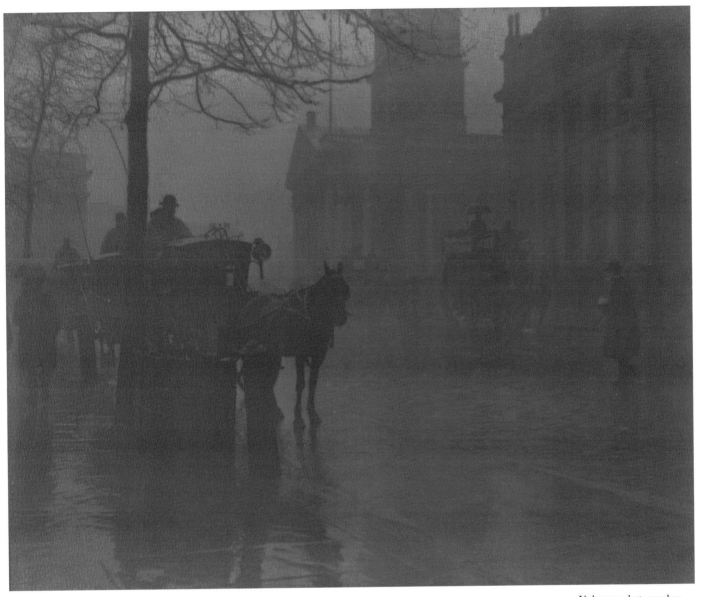

Unknown photographer

Trafalgar Square looking towards St Martin-in-the-Fields, London, 1907

Gelatin silver print, 28.8 x 35.6 cm

Photo 1205 (7)

Paul Martin

*Light and shade in Leicester
Square, c. 1896*

Photogravure, 7 x 9.6 cm

*Pictorial photographs.
A record of the photographic
salon of 1896* (London,
1896), plate 8

K.T.C.9.b.16.

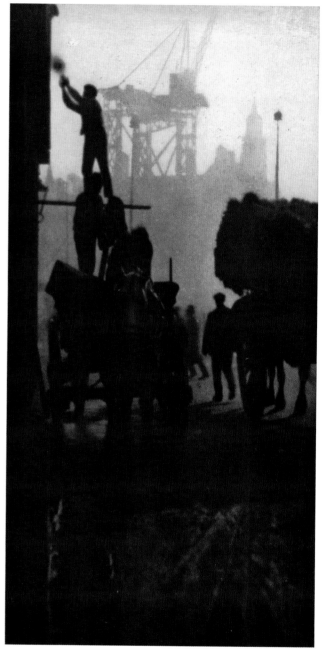

Alvin Langdon Coburn

*Kingsway, London,
c. 1909*

Photogravure,
22 x 10.9 cm

A.L. Coburn and
Hilaire Belloc, *London*
(London, 1909), plate 4

L.R.404.n.9

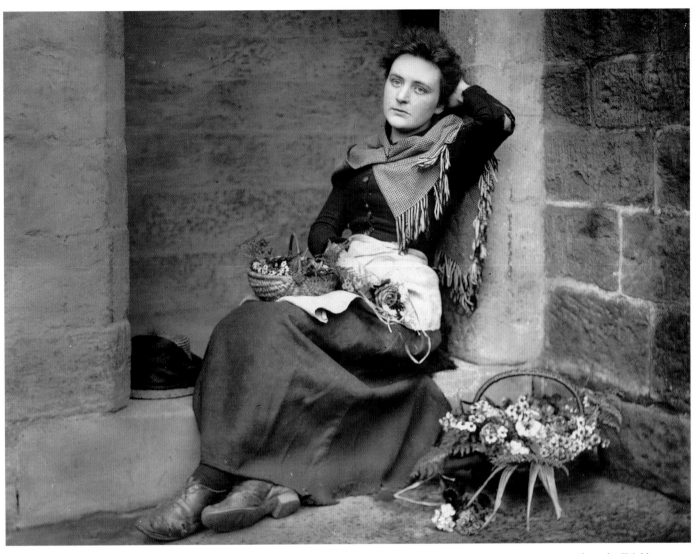

Alexander Keighley

Times is bad, c. 1890

Carbon print,
14.6 x 19.4 cm

*The amateur photographer
prize pictures, No. 1*
(London, 1890), plate 3

8908.c.19

Paul Bergon

Belle de Rêve, c. 1897

Photogravure,
19.5 x 9.8 cm

*Pictorial photographs.
A record of the Photographic
Salon of 1897* (London,
1897), plate 16

K.T.C.9.b.16

Frederick Henry Evans

*A portrait study at home,
c. 1897*

Photogravure,
16.6 x 12.5 cm

*Pictorial photographs.
A record of the Photographic
Salon of 1897* (London,
1897), plate 8

K.T.C.9.b.16

Antoine Claudet

Stereoscopic daguerreotype portrait of Mrs Clara Nicholson, c. 1855

Hand-coloured daguerreotypes, each 6.7 x 5.8 cm

Photo 246 (1)

Double vision: the stereoscopic view

The stereoscopic view operates on the principle that two images of a subject, taken from viewpoints approximately the same distance apart as human eyes will, when viewed with a suitable apparatus, merge into a startlingly realistic imitation of three-dimensional vision. Sir Charles Wheatstone established these principles in the early 1830s, but it was the advent of photography which created an enduring demand for the stereograph.

Stereoscopic daguerreotypes were being made soon after the announcement of the process and by the early 1850s twin-lens stereo cameras began to be manufactured. In addition to loose prints, hundreds of books of architecture and travel containing stereoscopic views were published in the 1850s–60s, while the format was also put to scientific use in such fields as medical illustration. The vogue for the stereograph waned during the later decades of the century, but the early 1900s saw a huge resurgence in its popularity, with subjects ranging from humorous or sentimental scenes to educational collections of travel views. The American firm of Underwood & Underwood is particularly associated with the latter, publishing a huge 'library' of boxed sets of travel views, accompanied by lengthy descriptive texts and detailed maps.

Although the early twentieth century remains the high point of the stereograph, it has since been periodically introduced to new audiences and has proved itself one of the most resilient of photographic formats.

H. Taylor

Fishwives selling conger eels, Lannion, 1858

Albumen prints, each 7.4 x 7.1 cm

John Jephson, *Narrative of a walking tour in Britanny*
(London, 1859), stereograph 17

10172.d.13

H. Taylor

Curious menhir on the plain of Menec, near Carnac, 1858

Albumen prints, each 7.7 x 7.1 cm

John Jephson, *Narrative of a walking tour in Britanny*
(London, 1859), stereograph 58

10172.d.13

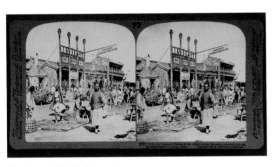

Underwood & Underwood

*YMCA rooms for soldiers of the Allied Armies – formerly a
notorious dive – on the busiest street of Peking, China, 1900*

Gelatin silver prints, each 8.1 x 7.7 cm

Photo 1188 (77)

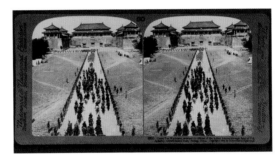

Underwood & Underwood

*Count von Waldersee, escorted by officers of Allied Armies through
lines of U.S. Infantry, towards Sacred Gate, Peking, China, 1900*

Gelatin silver prints, each 8.1 x 7.7 cm

Photo 1188 (80)

Erdmann & Schanz

Getting her hair banged, c. 1910

Gelatin silver prints, each 8 x 7 cm

Photo 1207 (24)

Erdmann & Schanz

Getting his hair banged, c. 1901

Gelatin silver prints, each 8 x 7 cm

Photo 1207 (25)

Photography for all: 'You press the button, we do the rest'

Although the simplification of processes and cameras gathered pace in the last decades of the nineteenth century, it was only with the release of George Eastman's Kodak camera of 1888 that the mass democratisation of photography became truly possible. Although portable and easy to use, Eastman's cameras were not in themselves revolutionary in design. What was new was Eastman's application of modern industrial processes to the photographic market, incorporating mass production, international distribution and relentless advertising. The company slogan, 'You press the button, we do the rest,' brilliantly promoted photography as a simple pleasure available to all. The figure of the 'Kodak Girl' in her striped dress, introduced in 1910, targeted a growing female market, while the company name of Kodak itself was deliberately created as a meaningless but easily memorable word.

By the turn of the twentieth century, the Eastman Kodak Company had established distribution outlets in all the major European countries and the following years saw expansion into South America, Asia and Australasia. For much of the twentieth century, and up to the advent of digital photography, Kodak remained a major supplier of affordable cameras and photographic services to a huge popular market, and can take much of the credit for making photography an integral part of the life of every sector of society.

L. Hillier

*Shrimp fisher (entry in
Eastman Plate Competition,
September 1908)*

Gelatin silver print,
9.9 x 7.5 cm

Kodak Archive A.1997
(52b)

John Hassall

*'Got Him!' Kodak advertising
artwork featuring the Kodak
Girl, c.1912*

Pencil, ink and watercolour,
71 x 50 cm

Kodak Archive Poster 1

Unknown photographer

*Printing Kodak negatives
by sunlight, Building 2,
Harrow, 1891*

Toned silver gelatin
print (printed later),
18.9 x 24 cm

Kodak Archive A.1787

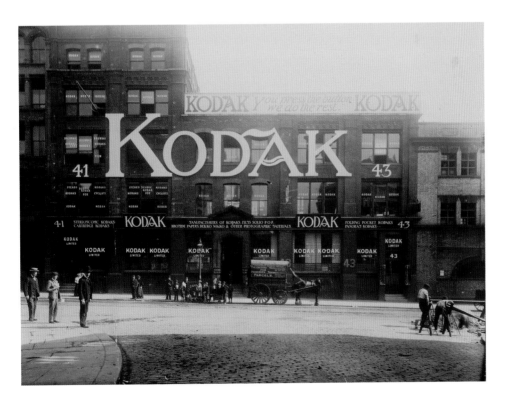

Unknown photographer

*Kodak Head Office, 41–43
Clerkenwell Road, London,
c. 1902*

Printing-out paper print,
15.5 x 20.4 cm

Kodak Archive

Glossary

The nineteenth century saw the development of a bewilderingly complex range of photographic and photomechanical processes. The following glossary provides only the briefest summary of those encountered in the present book. For those wishing to explore this subject in greater detail, the following works can be recommended: Brian Coe and Mark Haworth-Booth, *A guide to early photographic processes* (1983), Gordon Baldwin, *Looking at photographs: a guide to technical terms* (1991), Richard Benson, *The printed picture* (2008). The last, in particular, is informed by a practical working knowledge of many of the historic processes and carries the story through to modern printing techniques.

Albumen print

Introduced by Louis-Désiré Blanquart-Évrard in 1850, the albumen print remained in general use until the end of the nineteenth century. The paper was coated with a thin layer of egg-white and salt, and sensitized with silver nitrate prior to printing. Like the SALTED PAPER PRINT, the visible image of the albumen print was produced by exposure through the negative to sunlight alone, rather than by chemical development. In contrast to the salted paper print, which it superseded, the image lay on the surface of the paper, was capable of capturing a wealth of sharp detail and had a characteristically glossy sheen. Albumen prints were commonly toned with a gold solution which, in addition to providing some protection from fading, could impart a range of tones, from rich sepia to purplish-black.

Ambrotype (collodion positive)

The collodion positive process was first suggested by Frederick Scott Archer, inventor of the wet COLLODION PROCESS, in 1852. An under-exposed collodion glass negative, when painted black on the reverse, or mounted against a black background, appears as a positive image. Most often used for portraiture, the collodion positive was generally mounted and cased in the same way as a daguerreotype, with which they are often confused and to which they formed a cheaper alternative. Their production became less common after the 1860s.

Calotype process

A refinement of the PHOTOGENIC DRAWING, the calotype process was discovered by Henry Talbot in 1840 and patented by him in 1841. The essential difference between the two was Talbot's discovery that the latent image produced by even a short exposure of the sensitized paper could subsequently be developed into a visible negative with a solution of gallic acid and silver nitrate. The reduced exposure times that this allowed produced a practical process which remained in use (principally among amateurs) until the end of the 1850s. Negatives were commonly waxed after development to increase transparency for printing. The term calotype is also often used to refer to prints made from calotype negatives, but these SALTED PAPER PRINTS were generally made by the original photogenic drawing process (i.e., printed out by the action of light alone, rather than developed).

Carbon print

The carbon process, invented in the 1850s and perfected by J.W. Swan in 1864, relies, like a number of photomechanical processes, on the property of bichromated gelatin to harden upon exposure to light. The pigmented gelatin tissue was exposed under a negative and subsequently washed to remove the unhardened gelatin. Carbon images could be attached to many surfaces as well as paper, including glass and metal. It was, however, most widely used in the nineteenth century for book illustration and fine art reproductions – carbon prints are often mistaken for original photographs. The carbon print was so-called because carbon black was the original pigment employed, but it could in fact be produced in a wide range of colours. It can generally be distinguished by its lack of fading and sometimes a visible relief between dark and light areas. It is often difficult to distinguish from the related WOODBURY-TYPE process.

Collodion process

The wet collodion negative, introduced by Frederick Scott Archer in 1851, had largely ousted the CALOTYPE by 1860 and remained the most widely used negative process for the next twenty years. A sheet of glass was coated with a solution of collodion (guncotton dissolved in ether) and sensitized with silver nitrate. The plates rapidly lost sensitivity as they dried and it was therefore necessary to coat, expose and develop the negative before this happened. Despite these inconveniences (and the amount of chemicals and equipment required), the process delivered very highly detailed images and sharply reduced exposure times. Although dry collodion plates were introduced in the mid-1850s, these demanded much longer exposures and wet collodion remained popular until the introduction of gelatin dry plates in the late 1870s.

Collotype

In the photomechanical collotype process, introduced in the 1860s, a glass (or sometime metal) plate was coated with light-sensitive bichromated gelatin, which was then exposed under a negative. This exposure selectively hardened the gelatin according to the density of the negative. The plate was subsequently washed in cold water, which removed the unexposed gelatin and produced a reticulated pattern in its surface, which would hold the ink droplets in subsequent printing. Under magnification, the surface of the collotype print presents a characteristic irregular grain pattern. The process is still occasionally used today, particularly for the fine reproduction of works of art.

Cyanotype

One of the simplest photographic printing processes, and immediately identifiable by its rich Prussian blue tone, the cyanotype was invented by Sir John Herschel in 1842 and used iron salts to create a light sensitive solution which was brushed on to paper. This was then exposed by direct contact with an object or negative. The print was fixed simply by washing in running water. Its most famous use was by Anna Atkins in her *British algae* in the 1840s, but it was also popular with amateurs from the 1880s.

Daguerreotype

The results of Louis-Jacques-Mandé Daguerre's researches were made public under the name daguerreotype in January 1839. During the period of its popular use, the daguerreotype was most often used for portraiture. The polished silver surface applied to a copper plate was made light sensitive with fumes of iodine, producing a coating of silver iodide. The plate was exposed in the camera and the resulting latent image developed with fumes of mercury vapour, to produce

a highly-detailed visible image. The vulnerable, mirror-like surface was generally protected by a cover glass and mounted in a case. The daguerreotype produced a unique image, which could not be reproduced at will, as could the various negative-positive processes, but it remained in use until around 1860.

Gelatin silver print

Papers using silver bromide on a gelatin base for producing prints came into general use in the 1880s and have survived in modified form up to the present. Prints on this paper were developed out (rather than simply exposed to light for the creation of the image) and their speed was such that enlarging negatives by projection became much more practical. The developed image was a neutral black and white, but in the nineteenth and early twentieth centuries, such prints were commonly chemically toned to produce a variety of colours.

Photochrome

A sophisticated photomechanical colour printing process developed by Léon Vidal in the 1870s. The process involved a three-colour separation printed over a WOODBURYTYPE black layer. Mainly used for the illustration of *objets d'art*, this complex process produced a remarkably realistic reproduction of metals such as gold and silver. It should not be confused with a number of other processes also marketed under the same name later in the nineteenth century.

Photogalvanograph

A photomechanical process developed by Paul Pretsch, the photogalvanograph was a variant of Talbot's photographic engraving process (whose priority was upheld in a court case). The initial engraving process was followed by the use of electricity to etch the copper plates for printing.

Photogenic drawing

Developed by William Henry Fox Talbot in the mid-1830s and publicly announced in 1839, the photogenic drawing process involved coating a sheet of paper with light sensitive salts, which could then be exposed either in a camera, or beneath objects (such as botanical specimens), resulting in a negative image, which could then be fixed. By printing this negative in contact with another sheet of prepared paper, a positive print resulted. The process was subsequently improved by Talbot's CALOTYPE PROCESS to produce a more practical photographic method.

Photoglyphic engraving

The basis of the PHOTOGRAVURE process, photoglyphic engraving was the second of Talbot's processes (patented in 1858) for reproducing photographic images in printer's ink. As with many photomechanical processes, it relied on the hardening of bichromated gelatin on exposure to light. A metal plate was coated in the gelatin and a transparent positive exposed in contact with it. The plate was then etched and dusted with a resin grain to create intermediate tones, which could then be inked and printed. Talbot produced several thousand experimental photoglyphic engravings from the 1850s and advanced the process to a sophisticated state before his death.

Photogravure

This photomechanical etching process was developed from Henry Talbot's experiments in PHOTOGLYPHIC ENGRAVING in the 1850s and perfected by Karel Klic in 1879. Many complex variants have since been introduced, but the original process involved the use of a copper plate dusted with rosin dust, on which an exposed negative tissue of the sort used in the CARBON PRINT was laid. The plate was then etched, the selectively hardened layer of the tissue controlling the degree of penetration of the metal. The etched plate was then inked and printed in a conventional press. The process was used for high-quality reproductions from the mid-1880s.

Platinum print

Invented by William Willis, the platinum print became available for public use in 1879. The process employed light-sensitive iron salts and a platinum compound, the developed image displaying rich blacks and neutral grey mid-tones. The delicate separation of tones obtainable by the process made it particularly popular with fine art photographers, but its use declined rapidly after the First World War, owing to the sharp rise in the cost of the metal. The stability of the metal, compared to silver, means that platinum prints generally remain in excellent condition. Platinum prints in albums can often be identified by an orange-coloured offsetting on the facing page, created by iron salts leaching out from the print.

Printing out paper

Often known as P.O.P., this variant of the GELATIN SILVER PRINT was introduced in the 1880s. As the name suggests, the image was directly produced by the action of light, rather than by development. The harsh reddish image was generally gold toned to a more pleasing colour. P.O.P was the most popular of the commercially produced papers of the 1890s, and replaced the ALBUMEN PRINT for much amateur and professional work. It remained widely available until the 1920s.

Salted paper print

The salted paper print was made by treating paper with a salt solution and subsequently adding silver nitrate to produce light-sensitive silver chloride in the top surface of the paper. This procedure had formed the basis of Talbot's PHOTOGENIC DRAWING process and was subsequently used for making positive prints from CALOTYPE negatives. The chemicals were absorbed into the uncoated body of the paper which lacks the glossy surface characteristic of the ALBUMEN PRINT. They had largely been superseded by the end of the 1850s. Being printed through the fibre of the paper, rather than through a completely transparent medium such as glass (as in the COLLODION PROCESS), salted paper prints tend to show less sharply defined detail.

Woodburytype

This photomechanical process was patented by Walter Bentley Woodbury in 1865 and was widely used in book illustration up to the end of the nineteenth century. In essence, it is a refinement of the CARBON PRINT. The gelatin relief image of the carbon print was placed in a press in contact with a lead block, to produce a mould. This mould was then coated with pigmented gelatin, and printed onto a paper support. The huge pressure required to produce the lead mould meant that woodburytypes were rarely larger than eight by ten inches, and generally much smaller.

Further reading

ARNOLD, H.J.P., *William Henry Fox Talbot. Pioneer of photography and man of science* (Hutchinson Benham, London, 1977)

BAJAC, Quentin, *The invention of photography. The first fifty years* (Thames and Hudson, London, 2002)

BENSON, Richard, *The printed picture* (The Museum of Modern Art, New York, 2008)

CLARKE, Graham, *The photograph* (Oxford University Press, Oxford, 1997)

COE, Brian, *Cameras. From daguerreotypes to instant pictures* (Marshall Cavendish, London, 1978)

COE, Brian, and HAWORTH-BOOTH, Mark, *A guide to early photographic processes* (Victoria and Albert Musem, London, 1983)

DAVIES, Alan, and STANBURY, Peter, *The mechanical eye in Australia. Photography 1841–1900* (Oxford University Press, Melbourne, 1985)

DAVIES, Keith F., *Désiré Charnay, expeditionary photographer* (University of New Mexico Press, Albuquerque, 1981)

EDWARDS, Elizabeth (ed.), *Anthropology and photography, 1860–1920* (Yale University Press, New Haven and London, 1992)

FALCONER, John, *India. Pioneering photographers 1850–1900* (British Library, London, 2001)

FOSTER, Sheila J., HEITING, Manfred, and STUHLMAN, Rachel, *Imagining paradise. The Richard and Ronay Menschel Library at George Eastman House, Rochester* (George Eastman House, Rochester, New York, 2007)

GERNSHEIM, Helmut and Alison. *A concise history of photography* (Thames and Hudson, London, 1965)

GERNSHEIM, Helmut and Alison, *L.J.M. Daguerre. The history of the diorama and the daguerreotype* (Dover Publications, 1969)

HAMBER, Anthony J., *'A higher branch of the art'. Photographing the fine arts in England, 1839–1880* (Gordon and Breach, Amsterdam, 1996)

HARDING, Colin, *Classic cameras* (Photographers' Institute Press, London, 2009)

HOWE, Kathleen Stewart, *Félix Teynard. Calotypes of Egypt* (Hans P. Kraus Jnr., New York, 1992)

HOWE, Kathleen Stewart, *Revealing the Holy Land. The photographic exploration of Palestine* (University of California Press, 1997)

JEFFREY, Ian, *Photography. A concise history* (Thames and Hudson, London, 1981)

JOLLY, Martyn, *Faces of the living dead. The belief in spirit photography* (The British Library, London, 2006)

JONES, Bernard E., *The encyclopaedia of early photography* (Cassell, 1911, reprinted, Bishopsgate Press, London, 1981)

LYONS, Claire L. (*et al.*), *Antiquity and photography. Early views of ancient Mediterranean sites* (Thames and Hudson, London, 2005)

MARIEN, Mary Warner, *Photography. A cultural history* (Laurence King, London, 2002)

NICKEL, Douglas, R., *Francis Frith in Egypt and Palestine. A Victorian photographer abroad* (Princeton University Press, Princeton, 2003)

OVENDEN, Richard, *John Thomson (1837–1921) photographer* (National Library of Scotland, Edinburgh, 1997)

PEREZ, Nissan N., *Focus East. Early photography in the Near East (1839–1885)* (Harry N. Abrams, New York, 1988)

PINNEY, Christopher, *The coming of photography in India* (British Library, London, 2008)

ROSENBLUM, Naomi, *A world history of photography* (Abbeville Press, New York, 1984)

SCHAAF, Larry J., *The photographic art of William Henry Fox Talbot* (Princeton University Press, Princeton and Oxford, 2000)

STEVENSON, Sara, *The personal art of David Octavius Hill* (Yale University Press, New Haven and London, 2002)

TAYLOR, John, *The old order and the new. P.H. Emerson and photography 1885–1895* (Prestel, Munich, 2007)

TAYLOR, Roger, *Impressed by light. British photographs from paper negatives, 1840–1860* (Metropolitan Museum of Art, New York, 2007)

Index